In appreciation of
Volunteer Service to the
Morgan Hill Library:

Diane Dean

October 2010

Romanesque Art

Authors: Victoria Charles and Klaus H. Carl
Translator: All Global Solutions International, Inc.

Layout:
BASELINE CO LTD
33 Ter - 33 Bis Mac Dinh Chi St.,
Star Building; 6th Floor
District 1, Ho Chi Minh City
Vietnam

© 2008, Parkstone Press International, New York, U.S.A
© 2008, Confidential Concepts, worldwide, U.S.A

ISBN: 978-1-84484-460-9

Printed in China

Editor's Note:
Wherever the text refers to countries, the names of modern nations were used for
better understanding. Nevertheless, the people of the time were tribesmen,
generally spoke Latin and belonged to the Holy Roman Empire.

Victoria Charles and Klaus H. Carl

Romanesque Art

PARKSTONE
INTERNATIONAL

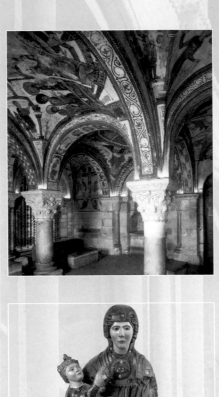

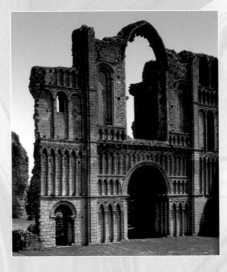

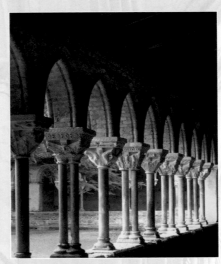

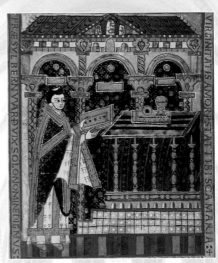

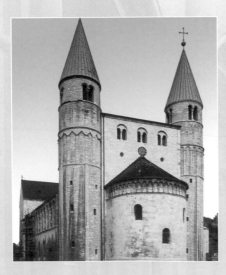

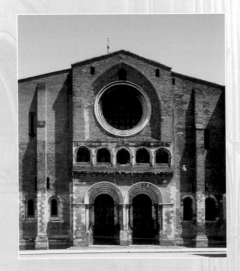

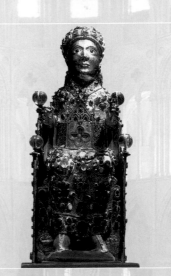

Contents

Introduction 7

I. The Romanesque System of Architecture 13

II. Romanesque Monuments in Central Europe 31

III. Romanesque Sculpture and Painting 125

Conclusion 193

Bibliography 196

List of Illustrations 197

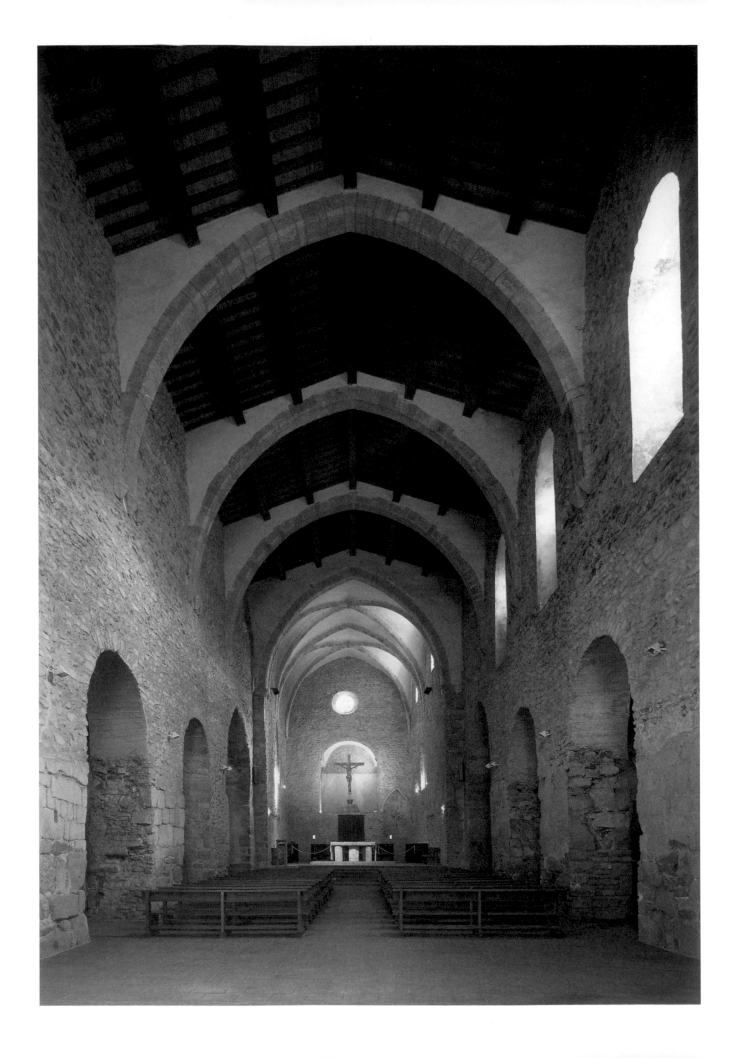

Introduction

Around the turn of the first millennium, the entire occident was encompassed by great religious, political and cultural uncertainty. With the collapse of the Roman Empire and the Barbarian Invasions from 375 A.D. to 568 A.D., Roman art, too, disappeared from Western Europe. Invasions by the Huns and Germanic tribes resulted in an artistic and political vacuum, in which a variety of Christian and pagan cultures collided. In the area of modern-day France, a blend of Roman, Germanic, Merovingian and Byzantine art developed. The Viking and Saxon tribes were masters of depiction of stylised animals and invented complex abstract knotting and weaving patterns; the Germanic tribes contributed their portable art and ornamentation.

Gradually, however, ancient Roman art was rediscovered. Emperor Charlemagne, who, around 800 A.D., made every effort to revive the Roman Empire and even considered himself the successor to the Western Roman Emperors, so furthered the interest in ancient art that it can be referred to as a "Carolingian Renaissance". He sent his people out to bring ancient artefacts back to his court, and there actually are some examples of Carolingian sculpture which, in a naive manner, emulate these models. At the same time, Carolingian portable art blossomed, and mainly produced ivory carvings and metalwork as well as a few small bronze statues. In architecture, the Roman style with its round arches, massive walls, and barrel vaults became established.

After the disintegration of the Charlemagne's global empire, the Germans emerged almost unscathed. On 8 August 870 A.D., the treaty of Meerssen (near Maastricht in the modern-day Netherlands) also conjoined them into a political unit, the Kingdom of the East Franks, which included the Bavarian, Frankish, Saxon, Swabian, Alamannic, and Lorrain Franconian tribes. During the war turmoil of the ensuing decades, however, this federation disbanded again. Only two tribes, the Franks and Saxons, stood so firmly together that after the death of the last Carolingian who was able claim the rule of the East Franks, they first elected as king Duke Conrad of Franconia, who subsequently died in 918 A.D., and after his death the energetic Duke Henry I of Saxony in 919 A.D. With him began the line of Saxon rulers, whose dynasty would hold the throne for more than a century. He succeeded in reuniting all German tribes, as under Charlemagne, and giving them an awareness of their national unity. Otto I, of course, the most talented and successful of the Saxon kings, also intended to achieve the revival of the Carolingian Empire as his highest political ideal. Like his role model Charlemagne, he sought to locate his centre of gravity in Rome. After Otto was crowned Emperor there in 962 A.D., he founded the Holy Roman Empire of the German Nation as the spiritual legacy of the

Nave, Abbey Saint-Michel-de-Cuxa, Codalet (France), c. 1035.

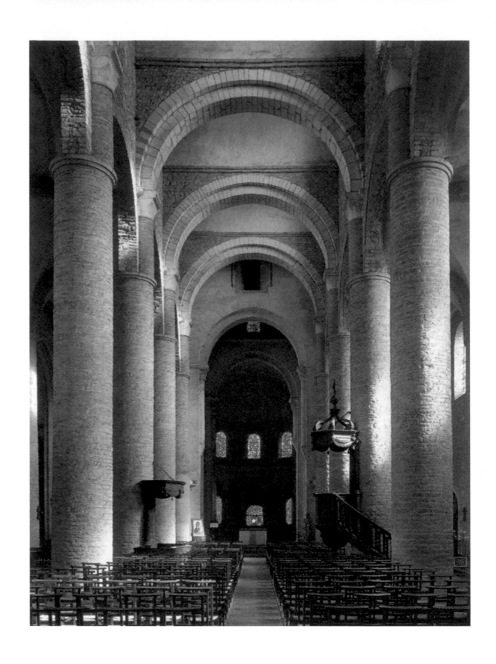

Nave, Saint-Philibert de Tournus,
Tournus (France), c. 1008-1056.

Eastern view of nave, Church of
St Cyriacus, Gernrode (Germany),
959-1000.

Roman and Carolingian empires. It lasted, if only in name, until 1806. Otto's coronation brought about a new stability in the arts, politics and economy, and thus the Ottonian style. Huge cathedrals were created, as well as monastic churches and other ecclesiastical structures. The secular world – knighthood was in its prime – showed its power by building castles and palaces.

Intense fighting accompanied the first two Saxon kings throughout almost all of their reigns. It finally ended in victory over the rivals within their own ranks and, in 955 A.D., in the battle of Lechfeld, where they were victorious over the tribes of Southeastern Europe, who had relentlessly been attacking the empire's borders.

In Germany, as the empire was henceforth known, a culture blossomed which also became the foundation for a new development in the fine arts. Architecture took the leading role, with such predominance that it gave direction to all the other arts. Even though it was still connected to the art of the Carolingian age, which had been modelled

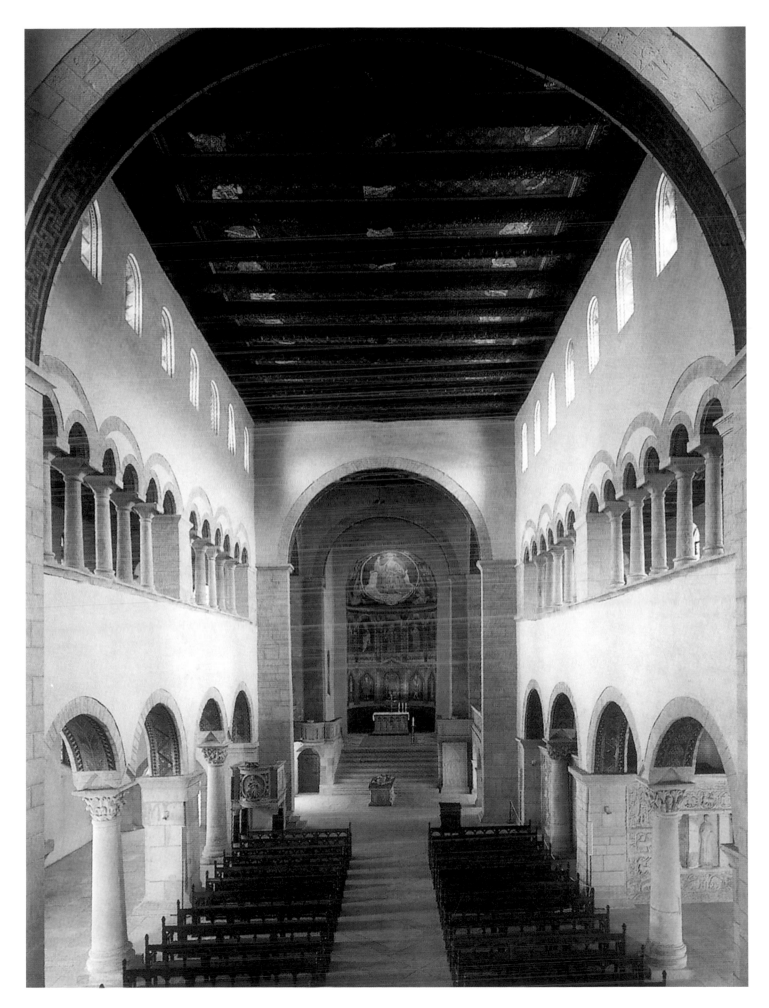

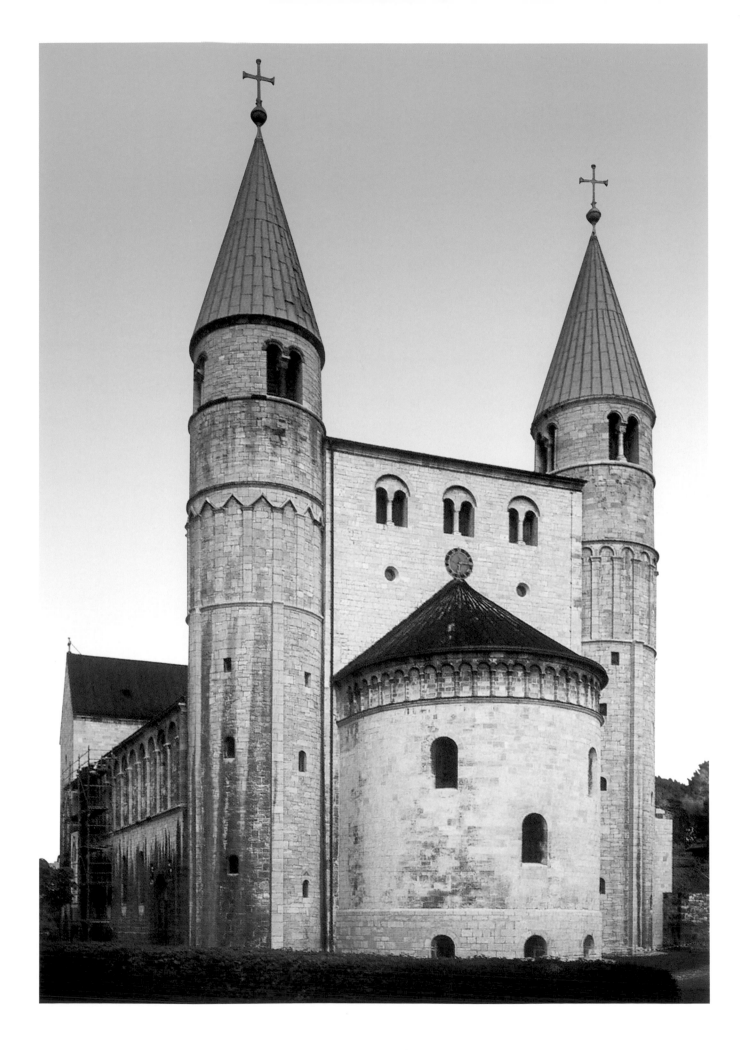

after Roman examples, under the Saxon kings it increasingly took on national characteristics, eventually penetrating the traditional forms and giving rise to a new, local art, as diverse as the characteristics of a landscape and its inhabitants. Since late Antiquity, monasteries, which covered Central and Western Europe in an ever denser network, were and continued to be the patrons of occidental culture.

Yet this art, which was predominant during the first half of the Middle Ages, approximately from the middle of the tenth until the beginning of the thirteenth centuries, was given the name Romanesque art. The term was introduced by a French scientist, Charles de Gerville, around 1818, based on its kinship to Roman architecture, with its round arches, piers, columns and vaults, and has been in general use since 1835. This designation was based on the factually incorrect assumption that this medieval art had developed from the Roman. It is a philological coinage and denotes works of architecture as well as of sculpture and painting. The term was also retained because it had become established and attained legitimacy as it kept alive the memory of the origins of the art. In other countries, too, such as in southwestern France and in parts of Italy, the Romanesque style appeared as a continuation of Ancient Roman art.

In Germany, the transition from the Pre-Romanesque to the Romanesque style took place between 1020 and 1030; in France around the year 1000. In Poland, the year 1038 with the coronation of Casimir I, the Restorer, is thus recorded. The Romanesque style has numerous special forms and regional expressions. Influences become apparent, such as those of Byzantine, Islamic, Germanic or Roman art. On German soil, Romanesque architecture also produced structures that are not only an expression of the peak of highest artistic accomplishment of the style, but also some of the most brilliant examples of art history in general. This unusual variety of creations was achieved because, unlike its successor, the Gothic style, it was not bound by any strict systems. In the different landscapes it took on its own expressions, which make up the inexhaustible attraction of the works of the Romanesque style. The same attitude which caused so many difficulties in politics for the Germans, that is the tenacious insistence on regional peculiarities and local customs, created an advantage in the art of the Romanesque age, which retained its creative originality until the very end. This given that it was initially interrupted in its development and finally completely dispelled by the Gothic style, which was introduced in France in the middle of the twelfth century. In England, the transition to the Gothic style can be dated back to around 1180 and in Germany to around 1235. Works of art from the Romanesque period can still be found today in France, not only but principally in Normandy, Auvergne and Burgundy. In Italy they are found mainly in Lombardy and Tuscany, in Germany in Saxony and the Rhine valley, as well as in some other European countries and in England and Spain.

Western door, Church of St Cyriacus, Gernrode (Germany), 959-1000.

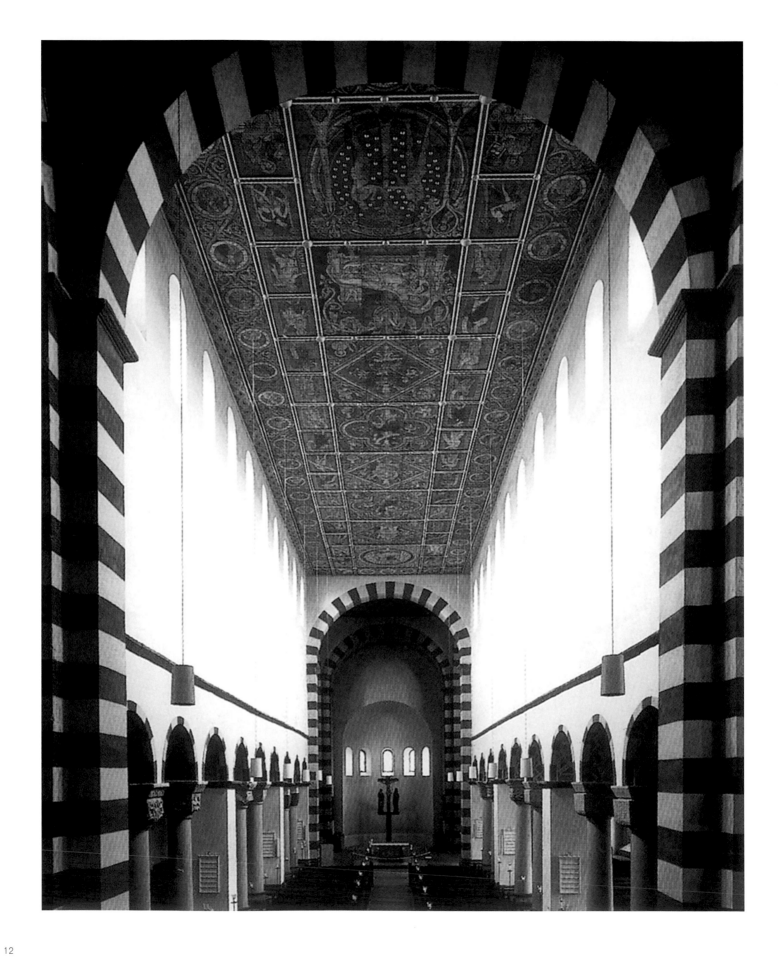

I. The Romanesque System of Architecture

Widely spread all over Christian Europe, the Romanesque style was the first independent, self-contained and unified style. Architecture dominated Romanesque art, and all other artistic movements such as painting and sculpture, which often demonstrated dramatic motifs, were subordinated. The Romanesque style is predominantly a certain use of forms, which branches out into different peculiarities. Nonetheless, most Romanesque structures have certain essential features in common, according to which a system of Romanesque architecture can be established.

Romanesque architecture can be divided into the Early, High and Late Romanesque periods, whereby the Pre- and Early Romanesque periods can also be subdivided according to dynasties; Merovingian (up to 750 A.D.), Carolingian (750-920 A.D.) under Charlemagne's rule, and Ottonian (920-1024 A.D.). In the different European countries, different starting dates are used to mark the beginning of the Romanesque period. Thus, the Anglo-Saxon period in England ends in 1066 with the Battle of Hastings. In Germany, the Romanesque period begins with the end of the Ottonian dynasty (1024), and in France the first vaulted buildings (Saint-Michel-de-Cuxa (p.6) in the Pyrenees and Saint Philibert in Tournus (p.8)) appeared.

The only structures that can initially be considered, however, are exclusively ecclesiastical buildings, since the Early Romanesque style everywhere in Europe was developed mainly by young monastic communities, as was intellectual and spiritual life in general. They are thus, in their majority, ecclesiastical art. The more the riches of the church grew, the more magnificent the structures became. The ecclesiastical building's basic form is the basilica with its often cross-shaped floor plan, whereby the choir and nave are located in the long arm, while the transept forms the short arm of the cross. The so-called overstorey or clerestorey windows are located in the nave above the side aisle roof.

The westwork was considered a symbol of secular power. Thus, it was where the Emperor was seated during mass. The choir represented ecclesiastical power. Secular buildings – castles, fortresses, princely palaces, *Pfalzen* (secondary seats of power) and urban residences – are only preserved from the end of the Romanesque period and only in very scarce numbers. The massive, well-fortified and fortress-like walls (particularly in the westwork), the round arches on windows and doors, the small windows, and, though only in the later periods, the cushion-cap capitals on top of often delicate columns are typical of Romanesque architecture. The most important achievement of Romanesque architecture is, without doubt, the vault.

Nave, St Michael's Abbey Church of Hildesheim, Hildesheim (Germany), 1010-1033.

The Early Romanesque period (from around 1024 until 1080) is characterised by flat, wooden coffered ceilings, which were in constant danger of fire. The walls made of smooth stone blocks were unadorned and more like those of a fortress than an ecclesiastical building. The first towers were attached to buildings often even their multiples. During the High Romanesque period (from around 1080 to 1190) groin vaults appeared as well as architectural ornamentation and free-standing figurative sculptures. The subsequent Late Romanesque period, which ended around 1235, preferred the variety of lavishly decorated structures and interiors. During the Late Romanesque period one can already find Gothic elements, such as pointed arches or ribbed vaults; the massive walls and small windows, however, remained. During this time, magnificent twin tower façades also appeared, as well as richly-formed crossing towers. The church of the Romanesque Middle Ages did not develop from the Carolingian central structures, but from the monastic churches, which had quickly become places of worship for the masses through the monks' culture of pastoral activities of encouragement and conversion.

The basilica form was also the foundation of the new system, but was often expanded and enriched by new forms. The old main elements – choir, nave and transept – were retained. The choir, however, was regularly enlarged by the insertion between the transept and the choir of a rectangular room, whose size corresponded largely to that of a square created by the intersection of the nave and transept, the crossing. In this manner, for example, a floor plan in the shape of the Latin cross, developed for the monastic plan of St Gall, appeared, which replaced the T-shaped floor plan and remained authoritative throughout the Middle Ages. The enlarged choir, whose expansion had become necessary due to the constant growth of the clergy and was thus marked as a preferred place for them, was separated from the crossing by several steps. This raising of the choir above floor level was also done for another reason. The Romanesque period had adopted the idea of the crypt from the Carolingian basilica, and it is present in all but a few churches of the Early Romanesque period.

Crypts were originally used to hold martyr relics, over top of whose resting places stone sarcophagi were erected. Later on, noblemen and other high-ranking individuals, such as founders and benefactors of churches, were also buried in crypts. Thus, for example, King Henry I of Saxony and his wife Mathilda have their final resting place in the crypt of the Stiftskirche (collegiate church) of Quedlinburg, which they had founded, in present-day Saxony-Anhalt. This crypt, which was later renovated, is one of Germany's two oldest crypts, the other being St Wiperti Church in Quedlinburg, which was also founded by Henry I and remained preserved in its original form. This quaint little town with a current population of nearly 25,000 used to be the capital of Germany at the time for more than 200 years, and is now part of UNESCO's World Cultural Heritage.

Relatively close in age is the crypt of the Stiftskirche (collegiate church) of Gernrode in the Harz region, built from 961, which retained its overall original character in all other parts also. From this structure, one can appreciate to what degree the spatial effect of the

South-East façade, St Michael's Abbey Church of Hildesheim, Hildesheim (Germany), 1010-1033.

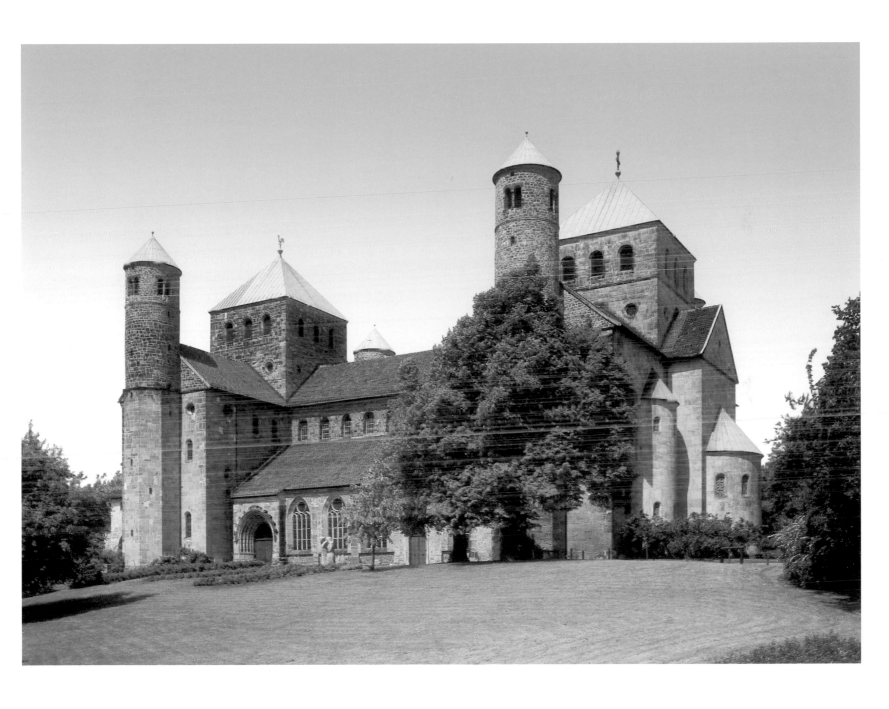

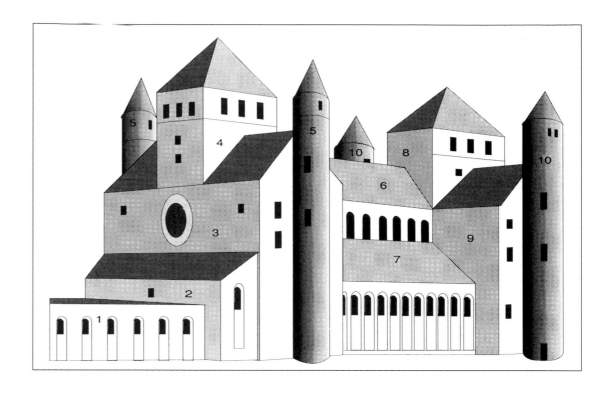

interior as well the monumentality of the exterior appearance of Romanesque architecture had already blossomed on German soil in the tenth century.

During the early period of the Romanesque style, church interiors were less ornate than their exteriors. Thus, for example, the exterior façade of the Stiftskirche of Gernrode (p.10), the most imposing building in Saxony at the time, is only made up of pilasters bearing round arches. These round arches with their painted ornaments or diverse stone inlays did not only serve a decorative purpose, but they also contributed to the building's structural stability. Two round towers with cone-shaped roofs frame the high-rising western façade, which is attached in its current form to an apse dating from the twelfth century. Initially, these towers were only used for the practical purpose of housing the bells and the stairs leading up to the bell cage, but they soon achieved artistic importance in church architecture. The master builder of the church in Gernrode was obviously very keen to connect the towers not only with the entire structure into a unified whole, but also to animate the massive walls with unique ornamentation. The towers are divided into tiers, where each one is different from the next in its structure. In doing this, one did not even pay particular attention to symmetry, since the second tier of one tower shows pointed arches in its arcades, and that of the other round arches. In contrast to the open arched windows of the upper tower tiers, through which the ringing of the bells was to echo through the lands, these closed arches are called "blind arcades".

The two towers framing the western façade were main elements of church architecture during the prime of the Romanesque style. In the course of the Gothic period, they developed into splendid specimens throughout ecclesiastical architecture, behind which the rest of the structure was sometimes even neglected. The western towers, however, did not remain alone even during the Romanesque period. Among the master builders a demand

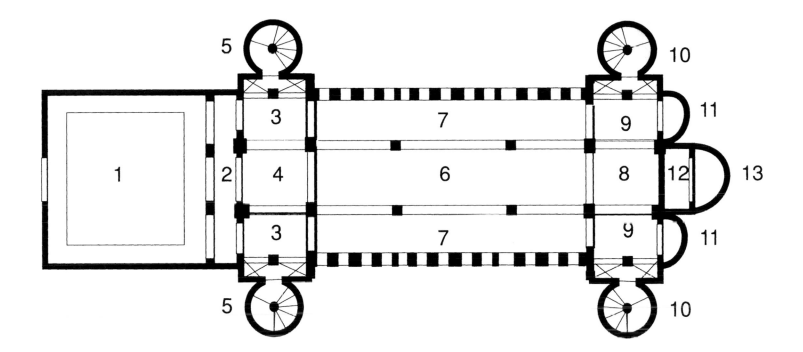

circulated, based on their early aesthetic considerations, to interrupt certain parts of the church roof, which usually appeared monotonous with its steeply rising gable forms, with tower-like structures and to thus denote these parts as extraordinarily pleasant and important. One location emerged as particularly suitable; the intersection of the nave and transept roofs above the crossing. In the older days, only a small tower lodged on the roof ridge, the so-called ridge turret, was installed, which was also still used later when lacking funds prevented the erection of a massive tower of imposing size.

In the Romanesque style's further development, the slender, delicate ridge turret turned into a short rectangular or octagonal tower, which was frequently topped off with a pyramid-shaped spire or simply closed off with a gable roof. As the master builders became more aware of how much the churches' artistic effect could be increased by the addition of towers, the more daring they became, whenever the means permitted it. The towers' original practical purpose was completely forgotten. The aesthetic function was chiefly considered; the heightening of the overall picturesque impression and the joy that was granted to the town's residents in particular by the wide views into the land. At the same time, however, the tall tower gave guards the opportunity to give early warning to the town about approaching enemies or predatory hordes. In addition to the set of towers framing the western façade and the crossing tower, further towers were added on both sides of the transept or the choir. In the prime of the Romanesque style in Germany, which is represented by the Cathedral in Limburg an der Lahn for example, even that number was found to be insatisfactory, and the transept gables were framed with two towers each, bringing the total number of towers to seven.

Neither did the ornamentation of the walls fall behind this increase in the richness of the exterior structure. The structuring of the walls by projection and pilasters was expanded

Horizontal plan, St Michael's Abbey Church of Hildesheim, Hildesheim (Germany), 1010-1033.

1. Porch/atrium
2. Narthex
3. Western façade
4. Tower crossing the West
5. Western turrets
6. Central nave
7. Collaterals
8. Tower crossing the East
9. Western transept
10. Turrets of the eastern transept
11. Apsidiole
12. Chancel
13. Apse

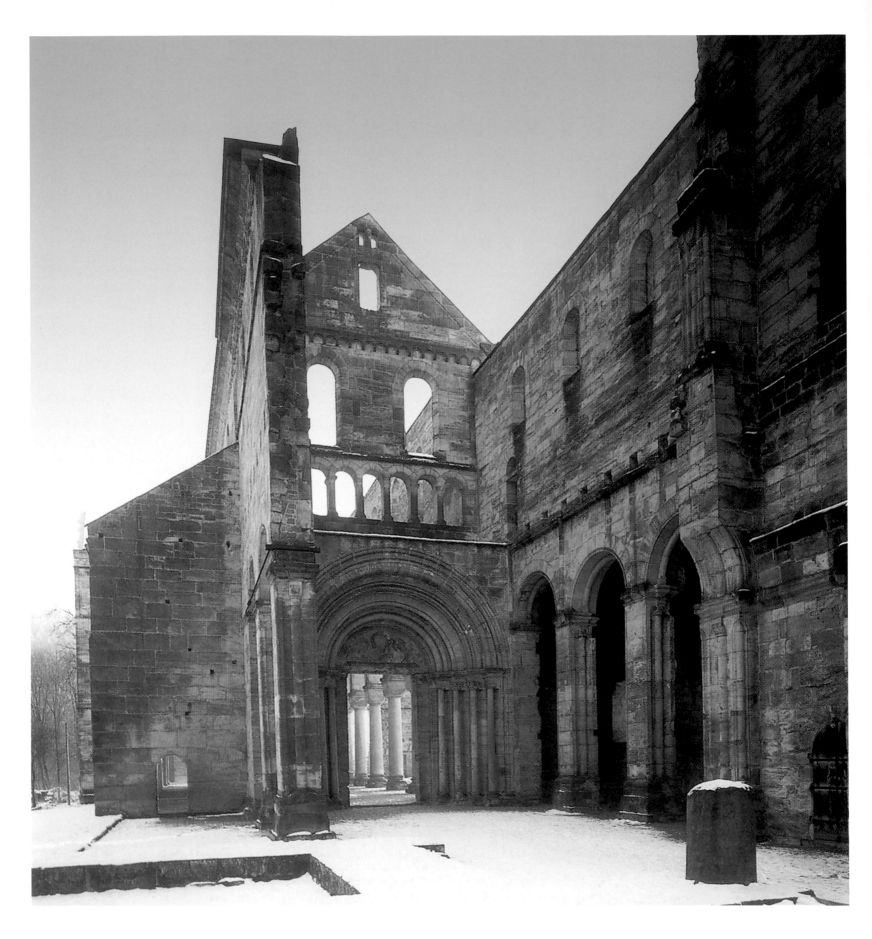

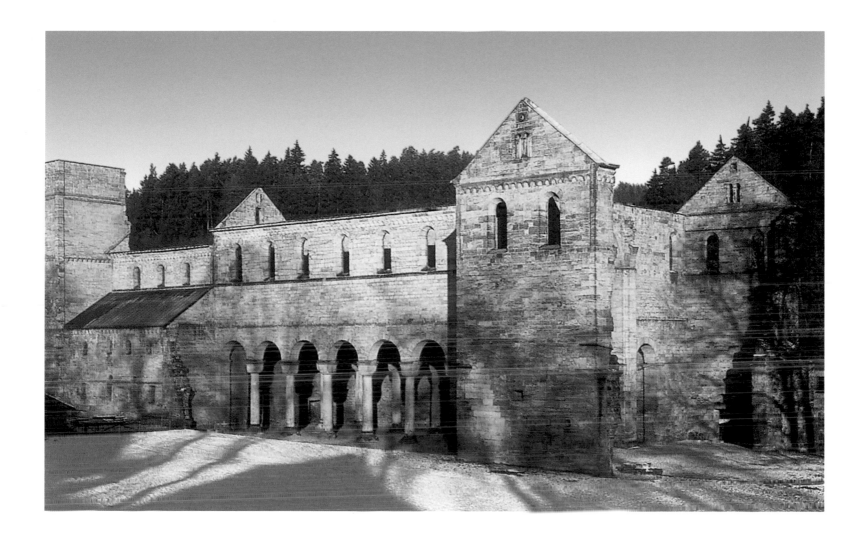

with round arch friezes; a sequence of small, semicircular arches, which initially only ran underneath the roof cornice, but later underneath all the cornices, in particular also those which separated the towers' individual tiers. During the later periods of the Romanesque style, decorative ornamentation was added on the exterior. It was, however, limited to initially simple portals, which then developed increasingly into magnificent examples of Romanesque sculpture. With the meaningful subject matter in their reliefs, they were intended to augment the churchgoers' reverent mood prior to entering the place of worship. The lateral walls of the portals, which were closed off with a rounded arch, were staggered or stepped off toward the interior and fitted with small columns and figures. The meaning behind these was connected with the relief image, which mostly decorated the arch area above the horizontal lintel; the tympanum. Gradually, this visual décor expanded into continuous stories from the Old and New Testaments. Certain doctrines and moral teachings, which could not be conveyed to the largely analphabet masses by the preachers' verbal attempts, became more commonly known and understood by viewing the readily accessible picture sequences on the portals. This pictorial language quickly became popular and was of great importance for the dissemination and reinforcement of religious ideas before the

Western portal with narthex, Abbey of Paulinzella, Rottenbach (Germany), 1105-1115.

South-East view, Abbey of Paulinzella, Rottenbach (Germany), 1105-1115.

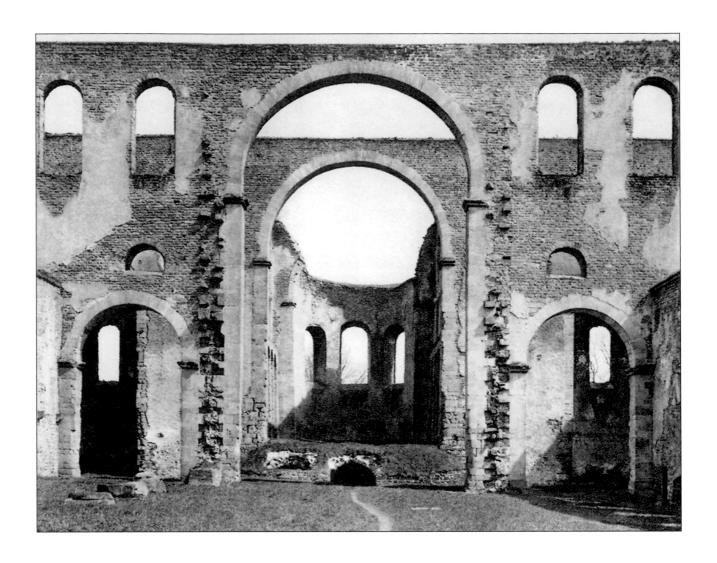

invention of the printing press. It was later continued during the Gothic period and used in richer forms of expression. Romanesque art, thus, had a definite didactic purpose.

The twin-choir churches, which have been used to describe the main elements of the Early Romanesque style, are really only characteristic of Saxony. In other German regions, churches show a simpler floor plan and usually only have one choir. This type of church is also often found in Saxony, but is so considerably different in detail that no uniform type with common characteristics can be established. There is no standard church that unifies all the characteristic peculiarities of the Romanesque style. All the churches of the Late Romanesque style have only the vaulted ceiling in common, which from the eleventh century replaced the flat wood-beam ceiling in Germany, and was formed into a generally observed system. Originally only used for narrow aisles, they also encompassed the wide central nave once the builders had learned to master the construction challenges. The heavy stone vault was immense in weight, which is why the walls had to be so massive in order to withstand the enormous pressure. For the same reason, there are few windows and doors in Romanesque buildings. The arched windows

Transept and apse, church ruins of Hersfeld Abbey, Bad Hersfeld (Germany), 1038- end of the 12th century (burned down in 1761).

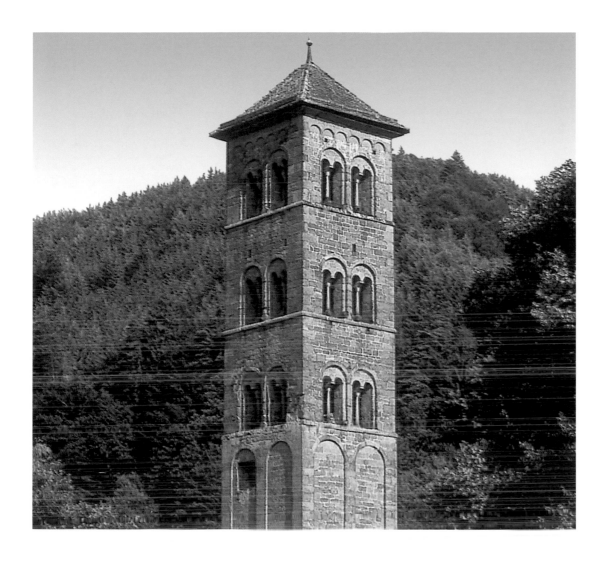

are explained by the necessity to spread the enormous pressure of the weight onto posts and columns, in order to ensure the building's stability.

Wherever Christianity spread, the monks were the first builders. It was only through years of experience that they learned how to master the building materials of their regions. Then, they became teachers to their lay brethren, from whom grew the bourgeois builders' guild. The building-savvy monks had already come to know the art of vaulting in the countries of Roman culture, to which they had come from the North. But only after intense practice were they able to also apply this knowledge to the new task of ecclesiastical architecture. They started by building vaults on smaller aisles, where they initially used the simplest form, the barrel vault, and only later the groin vault. In the wide central nave they had to make do with a wooden ceiling for a considerably longer period of time, until the master builders succeeded in constructing arches that could span such great distances. As indicated above, as the first vault forms existing in Roman buildings, the groin vault presumably resulted from the intersection of two barrel vaults. Thus, four dome caps were created, whose separating lines formed distinct "groins". Those caps, which held each other, needed only be supported on the four end points.

Owl Tower, Hirsau Abbey, Hirsau (Germany), 1080-1087.

The weight was so enormous that slender columns could not longer be used, but sturdy pillars had to be employed to support it. Every nave was covered with several of these vault bays based on a square floor plan, which were separated by wide transverse arches between the pillars. The central nave usually comprised three to six of these squares, the normally half-width aisles had double the number of squares, whose size, however, was only one quarter of a central nave square. Only when the builders mastered the art of spanning a groin vault over a rectangle could the bays in the aisles correspond in length to those of the central nave. Only thus did the floor plan of the Romanesque church achieve complete harmony. This varying division of the bays is illustrated by a comparison of the floor plan of the Cathedral of Speyer, which in its strict structure represents the so-called "unified Romanesque system", with that of the Abteikirche (abbey church) of Maria Laach. At the Cathedral of Speyer, the normally square bays of the central nave are also rectangular.

In both of the churches a vestibule known as "paradise" in the Middle Ages is preserved, which was supposedly used by penitents as a reminder of the atrium in a Christian basilica. This is most clearly illustrated by the church in Maria Laach, a twin-choir structure, to which the vestibule was only added at the beginning of the thirteenth century – this is how long the early Christian building customs remained alive. Even though the choir layout of these churches, which were finished at the same time around the turn of the twelfth century, is relatively simple, other churches of the same period display richly formed choirs. By leading the aisles around the choir an ambulatory was gained, usually half the height of the choir, which served to grant the streams of pilgrims access to the holy relics kept in the choir. It was later enlarged by the addition of small apses for the installation of secondary altars. Only the Gothic style brought this expansion of the choir to its conclusion by forming the apses into small chapels and eventually surrounding the choir with a ring of chapels. It was also the Gothic style which enabled the rood screen (in Latin, *lectorium*), a wooden or stone barrier, to achieve its artistic magnificence. It developed from the barriers (*cancelli*) which already separated the choir from the central nave in early Christian basilicas and was equipped with two or more passageways. In the centre, a chancel-like structure with a lectern, accessible by a set of stairs, rose and served for the reading of spiritual texts from the gospel.

The creation of individual forms and ornaments was as varied as the layout of the floor plans, where arches, pillars and columns in particular could be considered. It was already indicated that alongside the capital, whose Antique ornamentation had been imitated with more or less understanding, a separate Romanesque capital form developed in the form of the cushion-cap capital, whose smoothly carved, semi-circular surfaces where probably painted. Later, they were covered with relief ornamentation of foliage and twisted bands, which gradually obscured the square column top, rendering the original form underneath completely unrecognisable. Fable motifs, human and animal figures, demons and saints, in natural but also frequently fantastic forms were woven into the ornamentation.

Eastern apse with "Roman gallery", St Martin Cathedral (end of 10th, 17th-18th century) and St Stephan church (after 1011), Mainz (Germany).

Eastern view of nave, St Martin Cathedral (end of 10th, 17th-18th century) and St Stephan church (after 1011), Mainz (Germany).

Eastern nave view, Cathedral of St Mary and St Steven ("Imperial Cathedral of Speyer"), Speyer (Germany), 1030-1061.

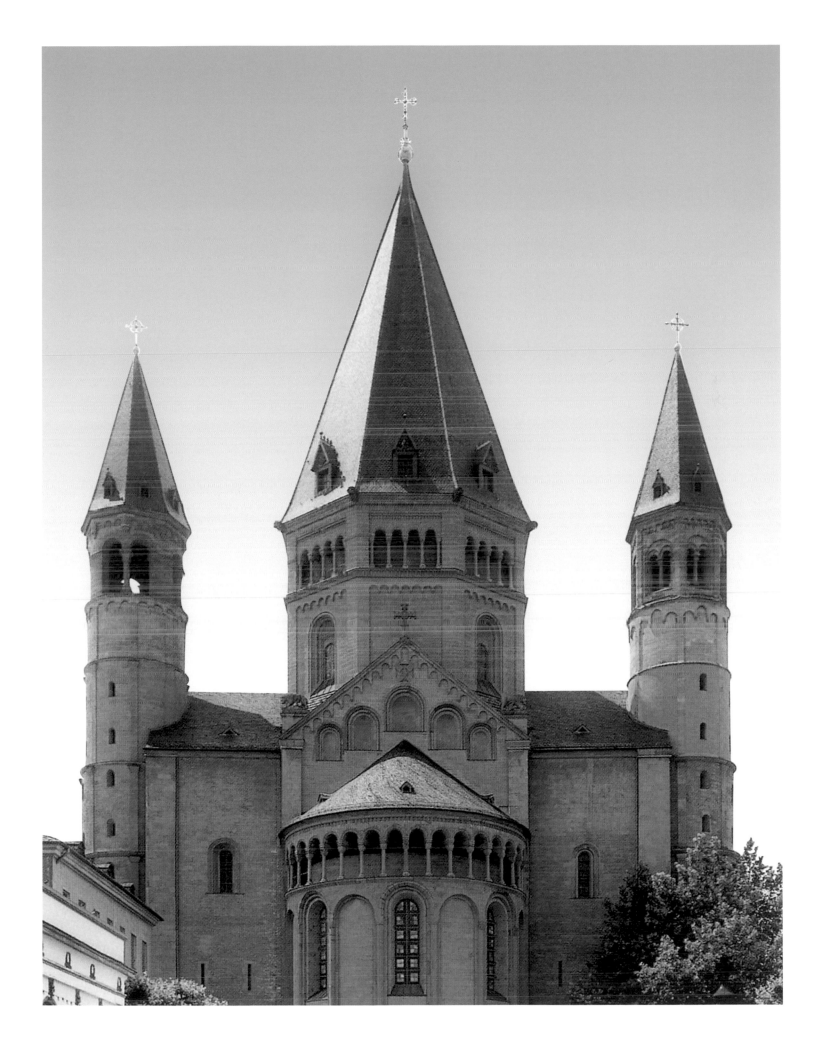

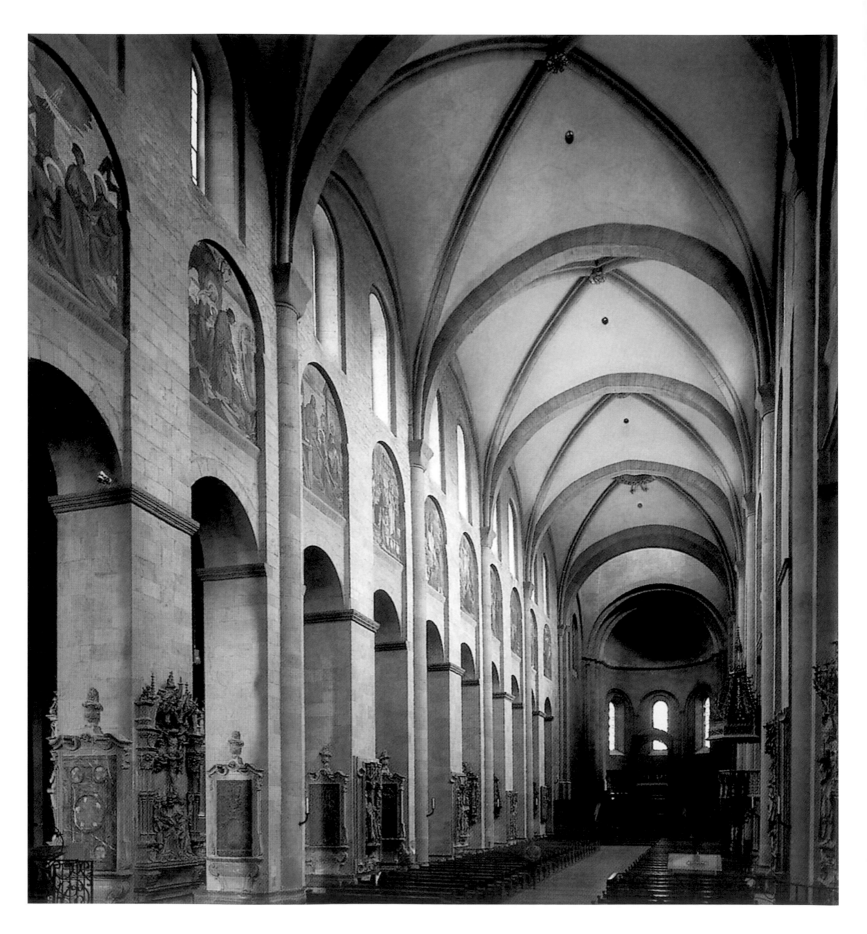

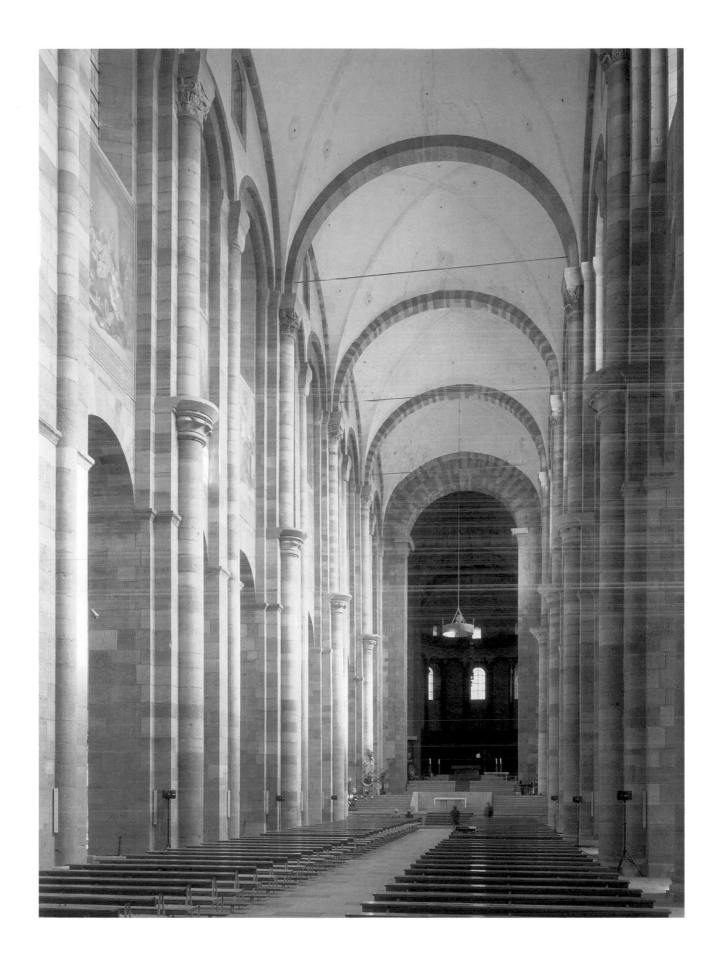

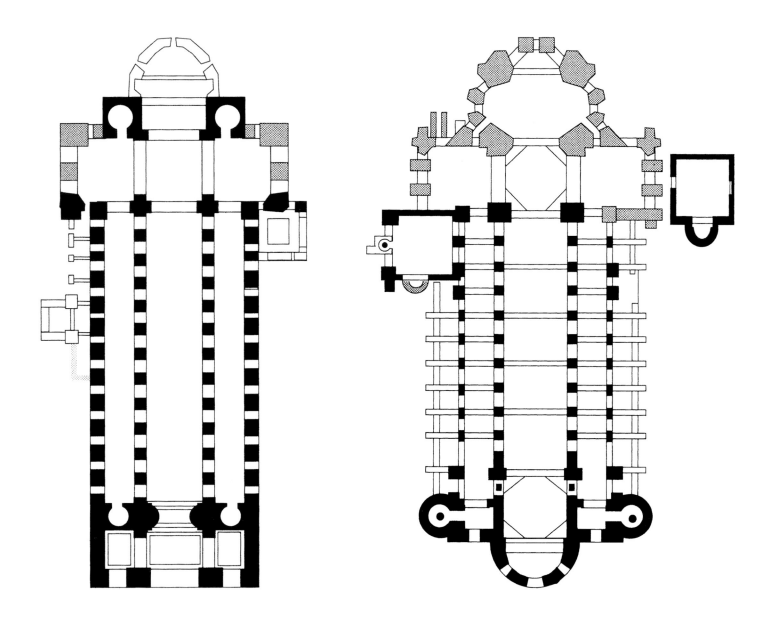

Horizontal plan, Cathedral of St Mary and St Steven ("Imperial Cathedral of Speyer"), Speyer (Germany), 1030-1061.

Horizontal plan, St Martin Cathedral (end of 10th, 17th-18th century) and St Stephan church (after 1011), Mainz (Germany).

The stonemasons, particularly of the later Romanesque period, sought to outdo each other by inventing ever more fantastic designs, in which the comical and terrible combined into a grotesque effect, particularly as the influences conveyed by the Crusades asserted themselves. The basic form of the cushion-cap capital can hardly be recognised in those figurative capitals. Echoes of basic Antique forms presumably still exist in the cup and bud shapes of the capital, but the ornamentation was new at the time, and its independence can again be found most clearly in the monuments in Germany.

The column base was usually shaped after the Attic example; a hollow moulding located on top of a rectangular plinth between two tori. The fact that the lower torus was resting directly on the plinth did not sit well with the artist builders for long. Initially, they trimmed the four corners with round blocks, later with tuber-shaped leaves, which only then brought about the actual transition between round and squared. The initially smooth column shafts

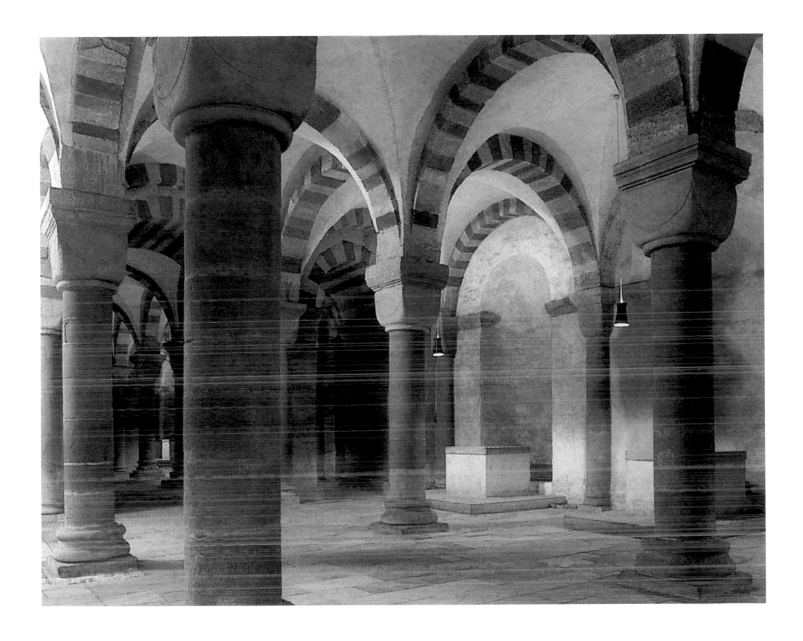

were later covered with sculpted ornamentation; interlacings reminiscent of twisted bands, zigzag patterns and more.

The original basic square pillars, which were only attached to a simple cover plate on the top and a wooden hollow moulding, soon took on richer forms. The edges were bevelled or moulded and the resulting corners were filled with small, slim columns, a technique that made the pillar appear more vivid and which could already be found in Muslim buildings such as those in Cairo. Later, the four pillar surfaces – or possibly only two of them – had engaged columns attached to them, mostly with their own capitals, which had their own function; they carried the vault's transverse arches. Finally, the pillar tops also received sculpted adornment corresponding to the richness of the rest of the ornamentation. Thus, the formation of the Romanesque style was in the process of a soaring development on both the construction and ornamentation sides, until it was gradually replaced by the use of form of the Gothic period.

Crypt-Hall, Cathedral of St Mary and St Steven ("Imperial Cathedral of Speyer", Speyer (Germany), 1030-1061.

Maria Laach Abbey, Maria Laach (Germany), 1093-12th century.

Western chevet view, Cathedral of St Peter ("Worms Cathedral"), Worms (Germany), 1110-13th century.

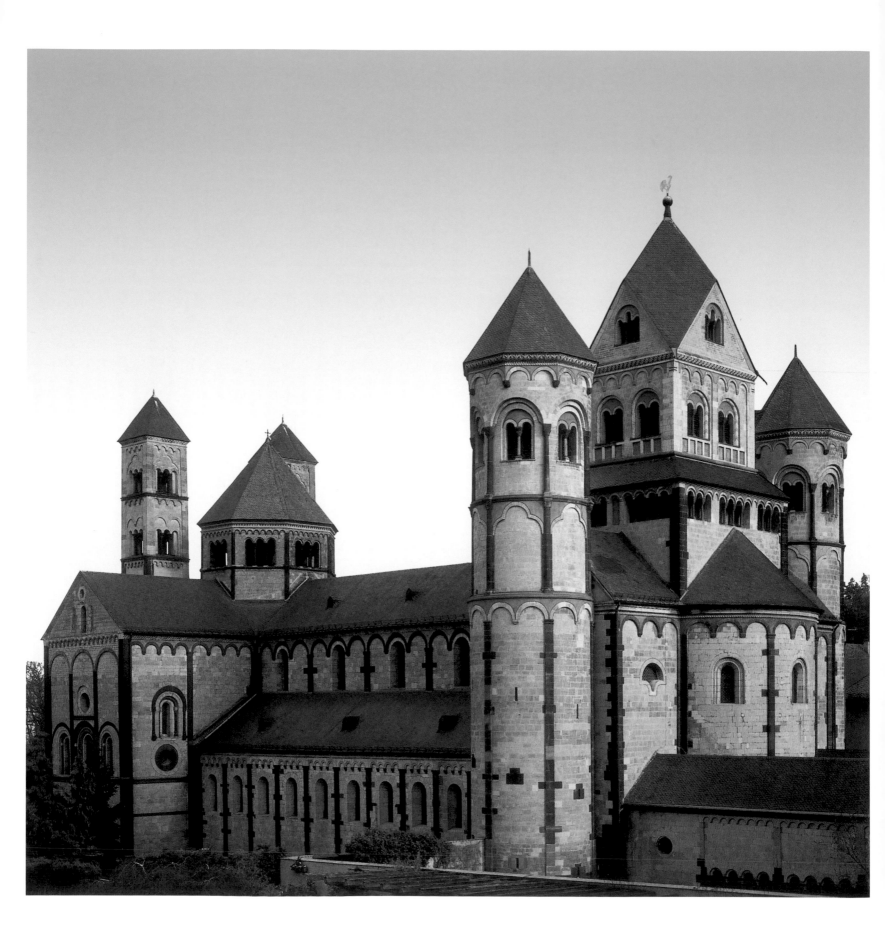

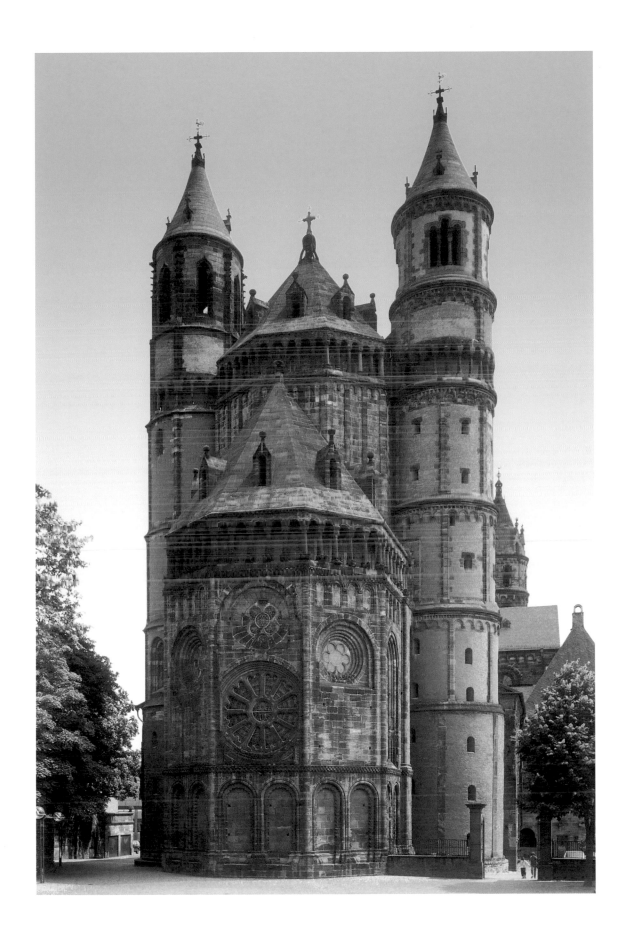

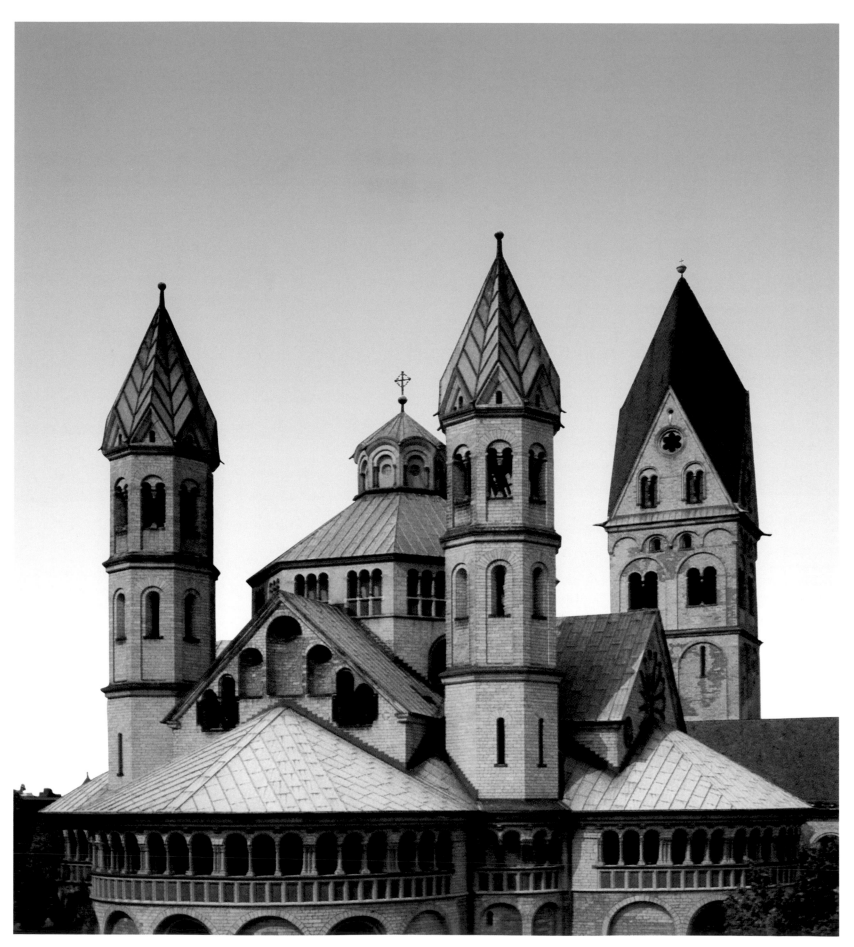

II. Romanesque Monuments in Central Europe

Germany

However many varied expressions the Romanesque style of architecture may have found on German soil, there are still three regions that stand out from the others with particularly distinct individual characteristics; Saxony, the Rhineland and Westphalia. These regions' buildings also most clearly reflect their inhabitants' tribal culture. For the Saxons, their dogged hold to the traditions of Carolingian times and their sense for strict regularity is typical, and finds a particular expression in the methodic alternation between the pillars and columns carrying the upper walls of the central naves. The buildings of the Rhineland reflect the light-hearted sense of beauty and love of grandeur of a carefree people. The defiant rise of the massive walls between the towers of the western façade in Westphalia corresponds to their taste for the simple and practical, which aimed only to fulfil a particular need without placing great emphasis on decorative forms, but ever more on the buildings' stability by means of effective construction.

Stiftskirche (collegiate church) St Cyriacus in Gernrode

The Gernrode Stiftskirche (p.9-10) in modern-day Saxony-Anhalt built from 959 A.D. is one of the many structures pre formed by the Carolingian monastic churches, which were built with two choirs and two transepts. It also retained its overall original character in all other parts, so that it can be gauged from this structure the extent to which Romanesque architecture had already blossomed in Germany in the tenth century, in both the spatial effects of the interior and the monumentality of the exterior appearance.

The church owes its name to St Cyriacus. Margrave Gero, founder of this church, had brought back a relic of the saint from his pilgrimage to Rome in 963 A.D., during which he also obtained a papal blessing for this building. One feature of the Stiftskirche is the reconstruction of the Holy Sepulchre dating from the eleventh century.

The addition of a second choir at the west end, which generally corresponded exactly to the eastern one, occured wherever two patron saints were honoured. The western choir is not always paired with a transept. In this Stiftskirche, it is demonstrated that the western basilica form is also the foundation of the new system, but in many ways expanded and enriched by new forms. The main old elements – choir, nave and transept – were retained. The choir, however, was gradually enlarged by the insertion of a rectangular space between it and the transept, whose size corresponds to that of the square resulting from the intersection of the

North-east view, Church of the Holy Apostles, Cologne (Germany), first third of the 11th century, oriental parts constructed after 1192.

View of the chevet, Church of St Maria in the Capitol, Cologne (Germany), 1049-1065.

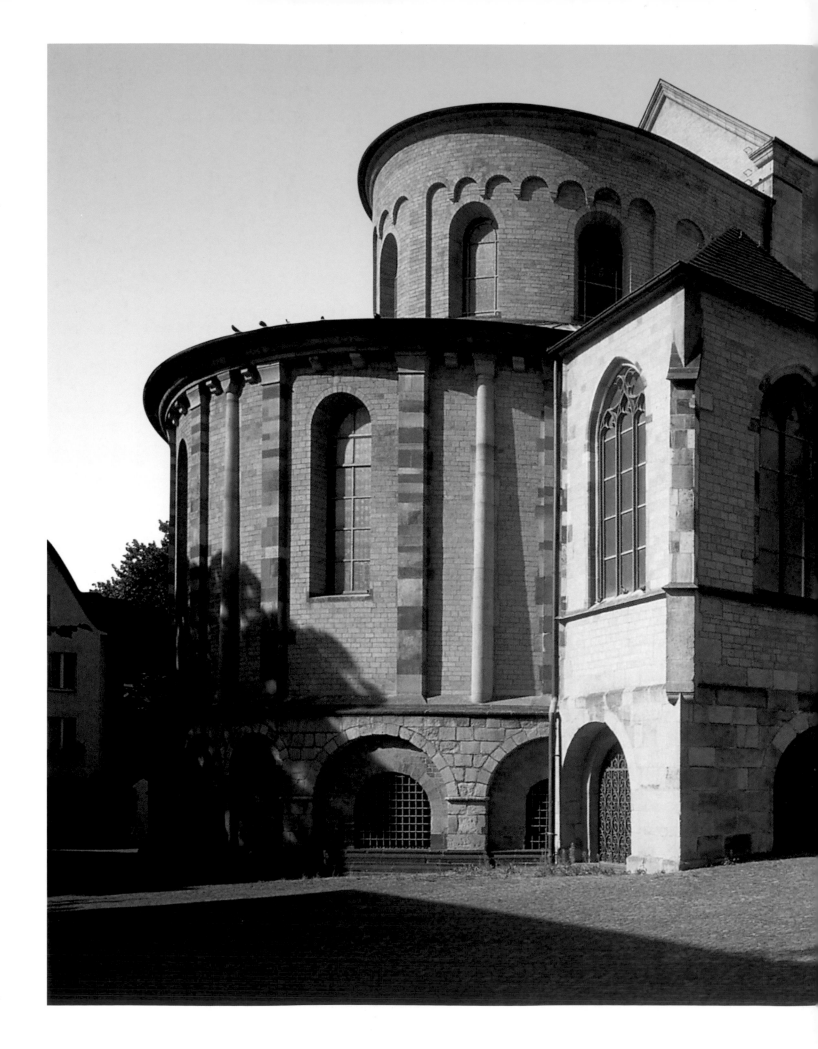

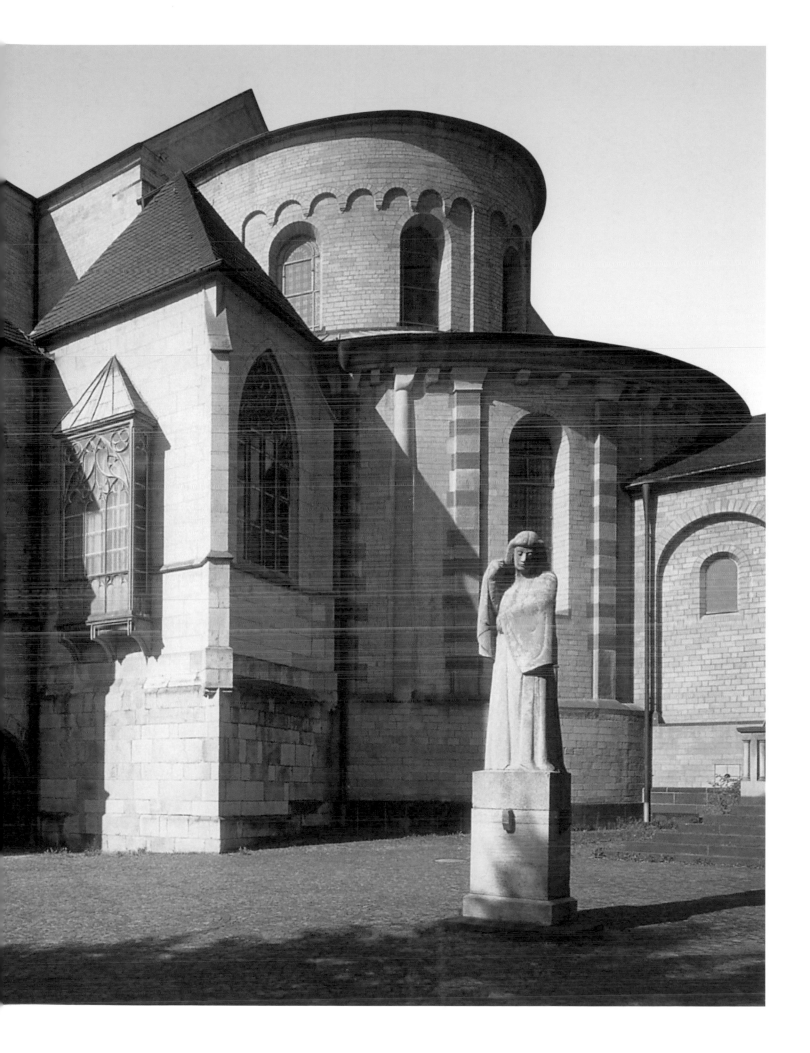

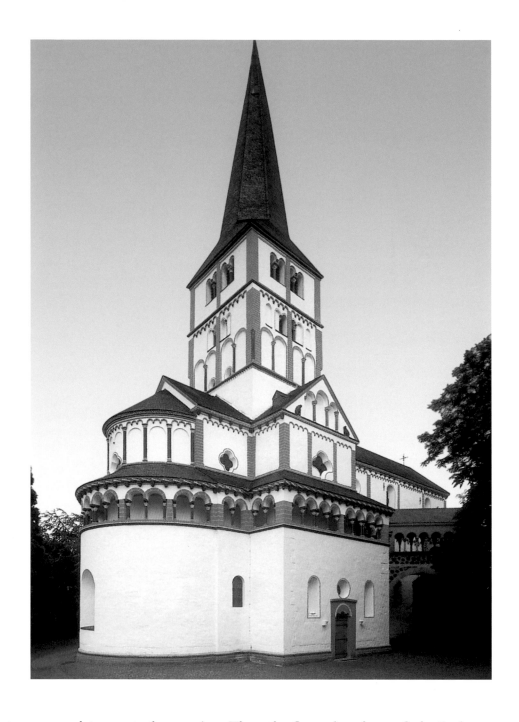

centre nave and transept; the crossing. Thus, the floor plan shape of the Latin cross was created already in the monastic plan of St Gall, which replaced the T-shaped floor plan and remained dominant throughout the Middle Ages. But after this type of twin-choir church had reached its climax in the twelfth, or possibly even the eleventh century, the two evenly developed cross-sections had a characteristic exterior appearance. In the most perfectly formed structure of this kind, the Michaeliskirche (St Michael's Church) in Hildesheim, it was even further accentuated by four towers attached to the gables of the transepts.

The central nave of the Stiftskirche rises to quite considerable height above the aisles, above which a triforium is installed, which was originally connected by a gallery on the

North-east exterior view, St Clemens Church, Büsum (Germany), 1434-1442.

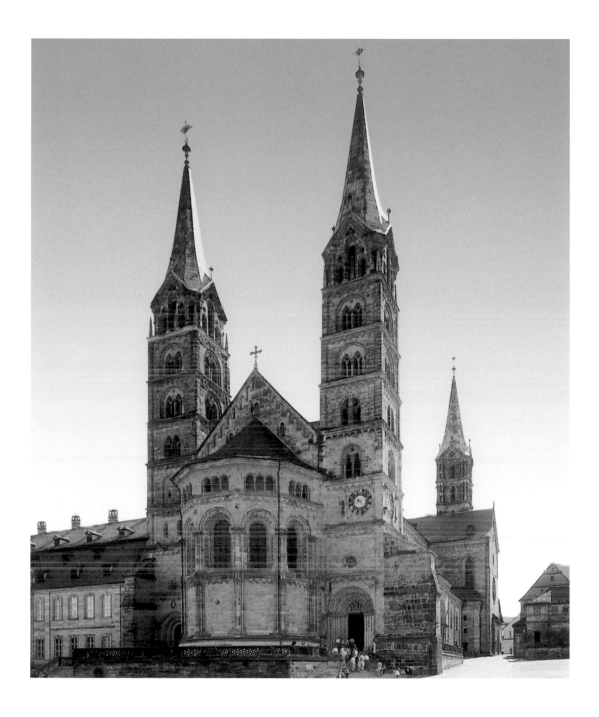

west side. They were probably used by nuns, who, separate from the lay world, were able to participate in the service in those rooms. The arcades of the central nave were alternately supported by pillars and columns, a form of construction that was presumably first implemented in the Wipertikirche's crypt.

Michaeliskirche (St Michael's Church) of Hildesheim

This alternation of supports was later developed into a true system. In the Michaeliskirche of Hildesheim (p.15–16–17), for example, as opposed to the churches where the central nave walls

Bamberg Cathedral, Bamberg (Germany), 1004-1012 (burned down in 1087), rebuilt from 1111 to the 13th century.

were supported by either columns or pillars, the alternation of supports had the aesthetic purpose of emphasising the meaningful structuring of the interior. The series of arches in the triforium, too, are separated in the centre by a pillar, whose position corresponds to that of the lower pillar. The capitals of the columns are still connected to Ancient traditions as they are reminiscent of the shape and foliage work of Corinthian capitals. Between the leaves appear heads and partial figures, which can probably be viewed as an invention of German artisans. They later developed into Romanesque figurative capitals in which medieval artists could exhibit the full richness of their ideas. Another form of the Romanesque capital is the simple shape of a pair of columns with cushion-top capitals at the entrance to Gernrode crypt. It is part of a later period of renewal and renovation in the church interior.

The nave and aisles are, as was customary in the Early Christian basilicas, roofed with flat wooden beam ceilings. The wood was covered with quite rich painting, which cleverly made use of the sectioned ceiling (p.12). The ceiling frescos of the Michaeliskirche have, however, almost all completely disappeared, with the exception of those in the nave. They were the favourite creations of Bishop Bernward, who had an appreciation for art and was himself an architect, goldsmith and bronze caster. Of his building only a few remnants remain, among which the columns with the cushion-top capitals (the columns on the far left and right) are markedly different from the richly formed shapes of the later period of renewal, after it had burned down almost completely following a lightning strike in 1034.

Yet the floor plan remained the same, and it can be seen from this that the builders of the eleventh century already designed their churches according to well-considered ratios, within which the secret of the extremely harmonious effect of these Romanesque basilicas can be found. In the Michaeliskirche, the nave is three times as long as it is wide. The three resulting squares are framed by rectangular pillars, between which two columns each are inserted. This is the culmination of the alternation of supports, which was only widespread in Saxony, parallel to the pillar basilica. The two aisles also harmonise with the nave's proportional size, since they comprise three squares, which are about the same size as those of the central nave. These relatively simple calculations were guarded as the builders' secrets at the time, which were passed on from generation to generation by word of mouth. These remained in force until far into the Gothic period, during which the secrecy of the church masonic guild of the great cathedrals and basilicas was even written into the rules.

The floor plan of the Michaeliskirche, which today is part of UNESCO's World Cultural Heritage, is a prime example of the culmination of twin-choir church layout in the eleventh century. Its interior, which was only finalised in 1186, is a characteristic example of the rich extravagance in visual and painting décor, which was customary in Saxony at the height of the Romanesque style, and at the same time also speaks of the artistic capabilities of the time. The sculptors and stonemasons who created this art in stone and stucco were not content simply with very rich ornamentation of column capitals with foliage and figurative images. The exteriors of the capital covers as well as the interior of the arches were covered with delicate ornaments. Above the arches runs a vine-

North-west view, St George's Cathedral, Limburg (Germany), 1200-1235.

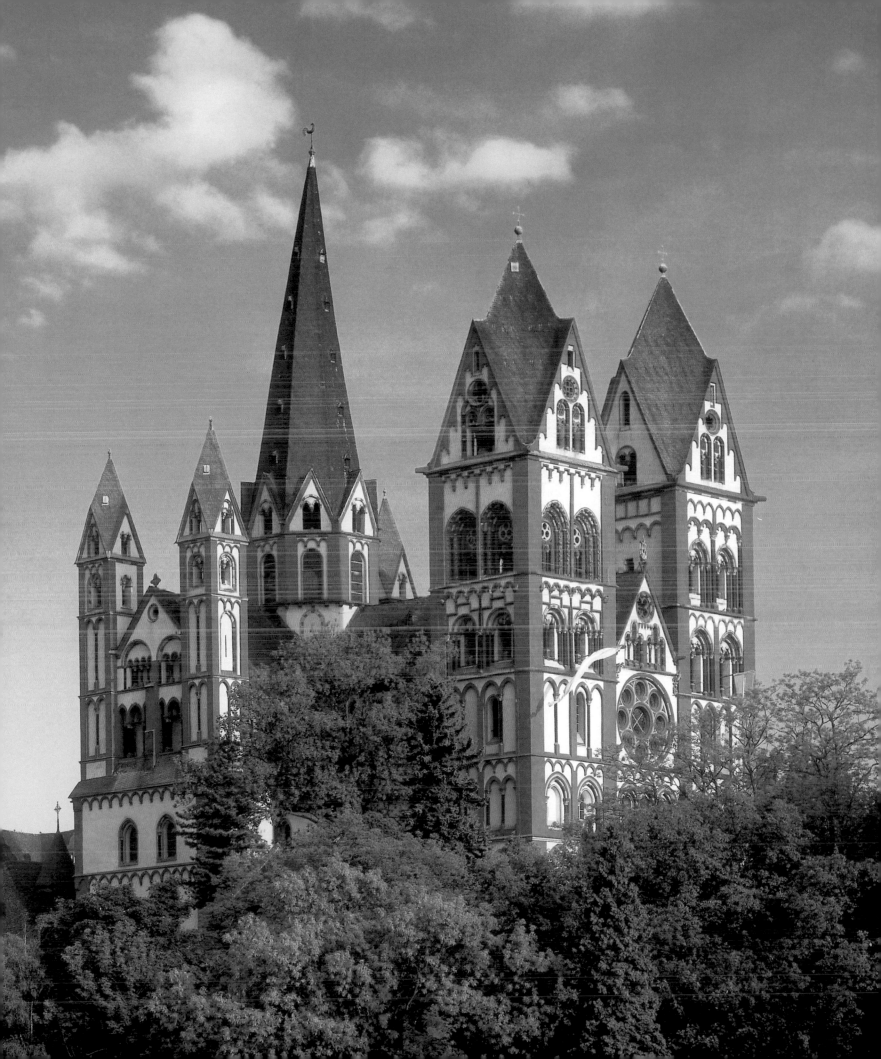

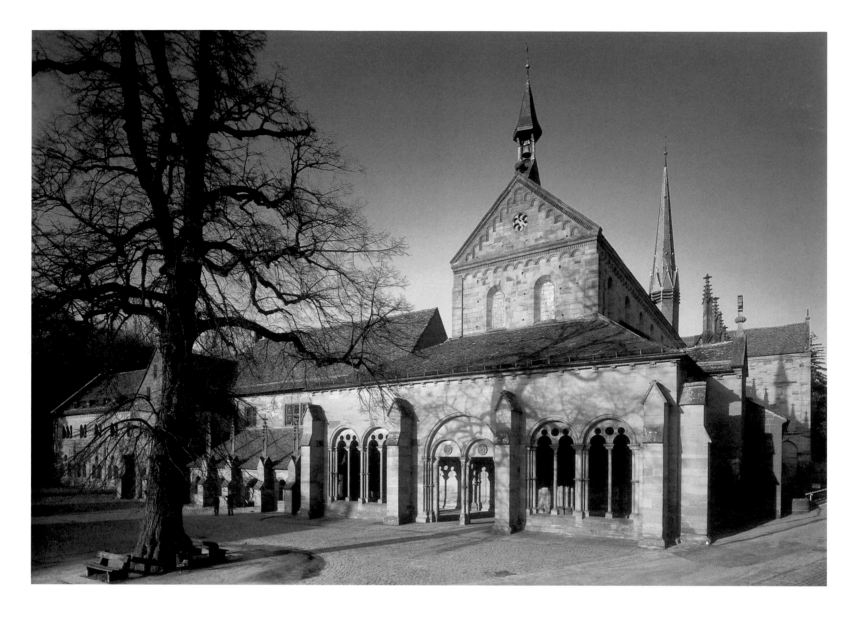

like frieze, which in the southern aisle depicts the heads of eight female figures standing on the cover plates, representing the Beatitudes.

This sculptural décor was complimented by a richly structured system of painting. It comprised, in a similar way to the polychrome buildings of Ancient Greece, the non-ornamented parts of the architecture as well as the sculptural décor. Thus the simple cushion-top capitals were painted with leaves, so that they were similar to the ancient calyx capitals. The smooth column shafts were either painted in one colour or marbled in varied colours or wrapped in colourful spiralling bands. In addition to this, there were figurative images on the ceilings and walls.

Cloistered buildings and square, Maulbronn Abbey, Maulbronn (Germany), 1147 (monastery) and 1178-13th century (church).

Other Ecclesiastical Buildings

Of the ecclesiastical buildings in Saxony, the following must be emphasised alongside the Stiftskirche in Gernrode and the Michaeliskirche of Hildesheim in Lower Saxony, through

which we demonstrated the main characteristics of the Romanesque style in its early and prime periods. They are the Schlosskirche (castle church) in Quedlinburg (Saxony-Anhalt) as well as the Godehardskirche (St Godehard's Church) in Hildesheim, the Stiftskirche (collegiate church) in Königslutter and, above all, the cathedral in Braunschweig (all three in Lower Saxony). Because this cathedral was the first to employ vault construction, it became an example for the entire region. Originally a double-aisle pillar basilica, it accumulated four side aisles in the fourteenth century when its aisles were doubled. The building's initial concept that strove for a serious, ceremonious effect was not impaired.

Wherever one finds a pure column basilica in Saxony, one can safely infer foreign sources. The church of the Paulinzella monastery in Thuringia (p.18-19), whose picturesque ruins still demonstrate today the artful structuring of the building, was built by monks from the Swabian Hirsau monastery. In the small town of Hirsau can be found a double-aisled building of about a hundred metres in length in the shape of a basilica, which was then the largest monastery with the largest Romanesque church building in Germany. At the end of the seventeenth century the church and a castle, which had been erected on the premises in the interim, were set on fire by French troops. Both magnificent buildings were destroyed by the flames. Only the cloister and one of the two original towers, the so-called Eulenturm (Owls' Tower) (p.21), survive today. The column basilica was the most common type of church in Swabia. Its most shining representatives are the cathedrals in Constance and Schaffenhausen, whereby the Constance cathedral was almost completely remodelled in the late Gothic period, particularly its exterior façade.

In the Rhineland, pillar basilicas are prevalent. This can probably be attributed to a quite common building material, the porous tuff stone, which could not be worked on in large pieces. Column basilicas are rare, particularly those with flat roofs, and the actual Rhineland building style of the Romanesque period achieved its highest development in the pillar basilica. The main representatives are the three central Rhineland Imperial Cathedrals in Mainz, Worms and Speyer. They are at the same time the most comprehensive and artistically perfected creations of Romanesque architecture in Germany. Thus, it is particularly mournful that they lost much of their original appearance due to fires, destruction in the many wars until the end of the eighteenth century, and the renovations of the recent past.

Stiftskirche in Bad Hersfeld

The modern-day ruin of the collegiate church (p.20) is the result of arson by French troops in 1761, who had stockpiled materials inside the collegiate church, which they did not want to leave to the enemy after their defeat in the Seven Years' War and the consequent withdrawal. The original monastic church was erected as a Carolingian *hallenkirche* (hall basilica) circa 830 A.D. and 850 A.D. After it burned down in 1038, a new Romanesque structure approximately 100 metres in length was built, with two bell towers, of which only one remains, on the west side. The structure is marked by its single Katharinenturm (St Catherine's Tower), which houses the oldest functioning bell in Germany dating from 1038. Due to its age, however,

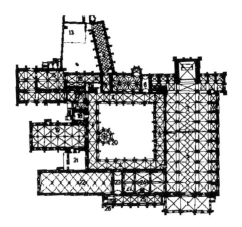

Horizontal plan, Maulbronn Abbey, Maulbronn (Germany), 1147 (monastery) and 1178-13th century (church).

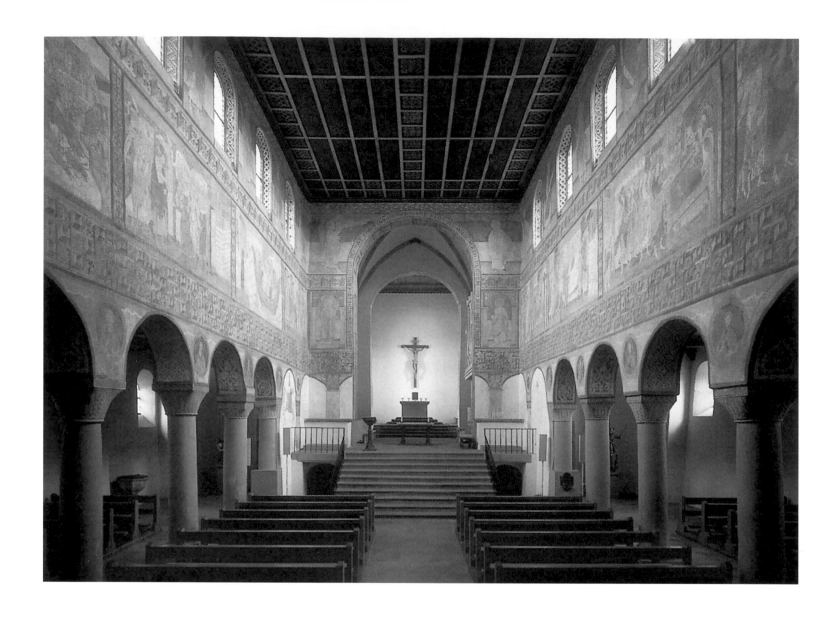

it only rings once a year to mark a festive occasion and to commemorate the monastery's first abbot, Lullus, the Archbishop of Mainz, who died in Hersfeld in 786 A.D. The collegiate church's ruin is considered the largest Romanesque church ruin in the world.

Mainz Cathedral

The oldest of the three listed Rhineland cathedrals is Mainz Cathedral (p.23-24-26), whose foundation by Bishop Willigis dates back to the end of the tenth century. The oldest remaining parts, the round side towers on the east side, which stem from the first third of the eleventh century, were so badly destroyed during a first fire on the day of consecration in 1009 and by another fire in 1137 that the cathedral had to be re-roofed. Based on newly expanded technical knowledge, the original flat wooden roofs were replaced with stone vaults. These, however, only remained until 1159, when intense fighting broke out between the archbishop and the citizens, whereby the latter stormed the cathedral and turned it into a fortress. After the cathedral had remained without a

Eastern view with Ottonian frescos, Church of St George, Oberzell (Germany), 896-beginning of the 11th century.

Nave, Jerichow Abbey, Jerichow (Germany), 1149-1172.

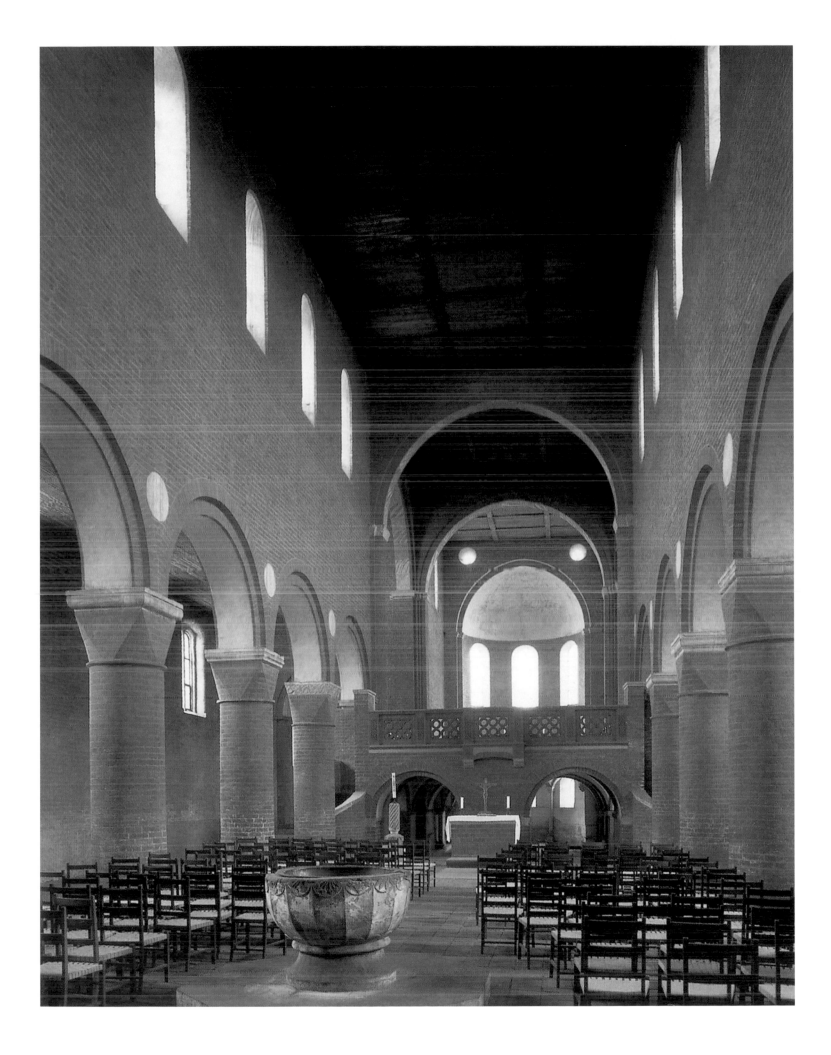

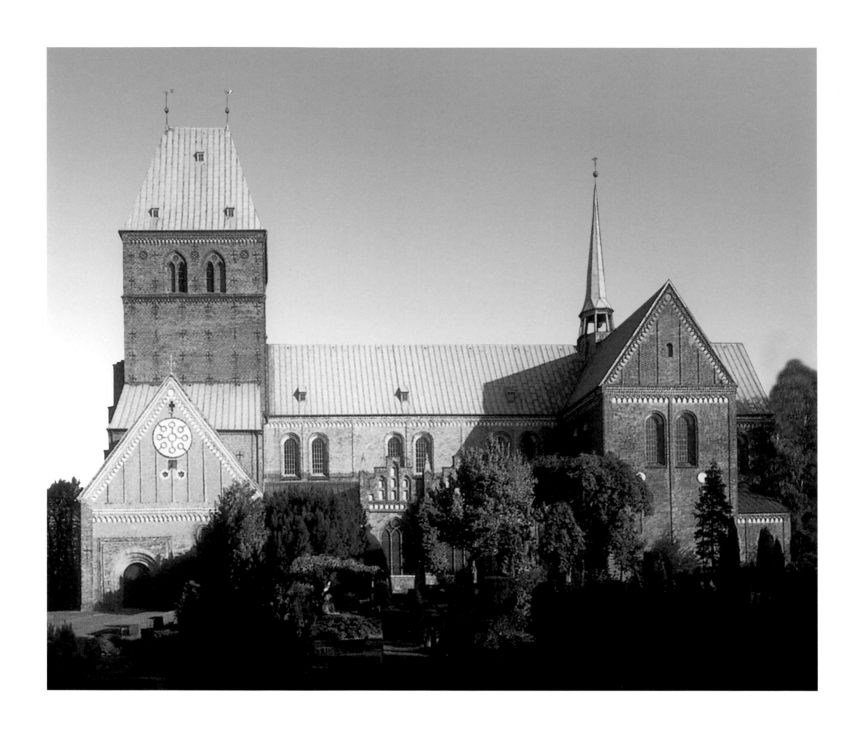

South view, Ratzeburg Cathedral,
Ratzeburg (Germany), 1160-1220.

roof for over twenty years, its reconstruction was started, but carried out so slowly that it was only finally concluded in 1239.

Due to this extended construction period, Mainz Cathedral does not present a uniform image of Romanesque style. Additions during the Gothic period interfere with the uniformity of the overall exterior and interior appearance. Careful reconstruction attempted to replace whatever was destroyed by shooting or bombardment during various wars. The cathedral succeeded in maintaining an appearance, at least, of its great age. Surrounded by rows of houses, Mainz Cathedral does not convey a monumental impression when viewed

up close. This, however, was probably not the creators' intent, since the building customs of medieval towns did not grant them great freedom. Where there were no fortifications to protect the citizens' residences, the main church took their place, with houses arranged in tight circles around it, trusting in the protective power of the house of the Lord. During wartime, they often proved their worth as safe places of refuge, particularly after the invention of long-distance fire weapons had become a great danger for towns under siege.

Only in the course of the nineteenth century did the structure of medieval towns, which was based on defense purposes, see a drastic change. Due to the disproportionately large growth in population, the traffic conditions changed at the expense of the old, romantic townscape. Thus church builders would calculate their designs based on the most impressive long-distance effect, if they wanted to set off their creations against the confinement of the towns. For the town residents themselves, the sculptural décor on the portals was sufficient. On the outside, however, the magnificent effect could only be achieved by size and the extent and variety of the ornamentation of the tower buildings. The effectiveness of the old masters' calculations with regard to long-distance can be seen most clearly in Mainz Cathedral. Seen from up close, it almost disappears in the surrounding mass of houses despite its huge proportions, while viewed from the other side of the Rhine, it majestically dominates the entire fluvial landscape.

Speyer Cathedral

Speyer Cathedral suffered an even worse fate than Mainz Cathedral. It surpassed the latter in the splendour of the original architectural conception and in the introduction of the large vault after its reconstruction in 1100 and the uniformity of its execution. It is considered the climax of the Early Romanesque period. It consisted of a nave vault, the oldest basilica covered completely with a groin vault, and the crypt, Europe's largest Romanesque column hall. As opposed to Mainz Cathedral, the monument of central ecclesiastical power in Germany, Speyer Cathedral (p.25-26-27) was to bear witness to the glory of the German Emperor. It was the intention of its founder, Conrad II, for the cathedral to serve as crypt for him and his successors. When he died nine years after the laying of the foundation stone, the tall, three-part crypt, which was supported by a forest of columns and extended beneath the upper church's choir and transept, had been completed and was ready to receive the sarcophagus. The church's founder was thus able to make it his final resting place. The proud structure was, however, only fully completed under his grandson, Henry IV, who had to undertake his famous pilgrimage to Canossa in the Italian province of Emilia-Romagna in January 1077 in order to settle his dispute with Pope Gregory and avert permanent excommunication. With the cathedral's completion, Henry IV erected the most splendid home and place of worship on German soil for the very same church that excommunicated and persecuted him with bitter hatred even after his death. The place, however, was never blessed. Three times it was destroyed by fire (the worst of which was in 1159, but then again in 1289 and 1540), yet always reconstructed.

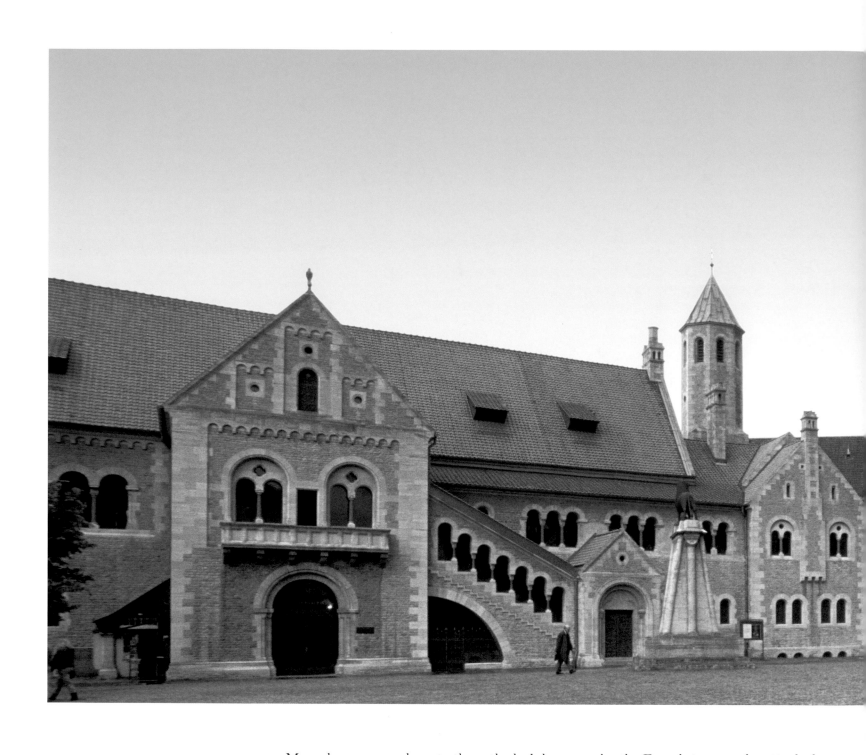

Fortified Castle of Brunswick
(Burg Dankwarderode), Brunswick
(Germany), after 1173.

More damage was done to the cathedral, however, by the French troops who attacked the Palatinate in 1689 and burned the cathedral down to its encirclement walls, having robbed the imperial burial sites. The cathedral's reconstruction was only begun in 1772. Barely was it completed, however, than it was ravaged again by the French and used as a storeroom for their horses' hay. The cathedral remained in this state of complete abandonment until 1814, when the Palatine was still part of Bavaria. King Maximilian I had this venerable monument of German imperial glory restored and dedicated for worship in 1822. It was treated with even greater care by his successor, King Ludwig I

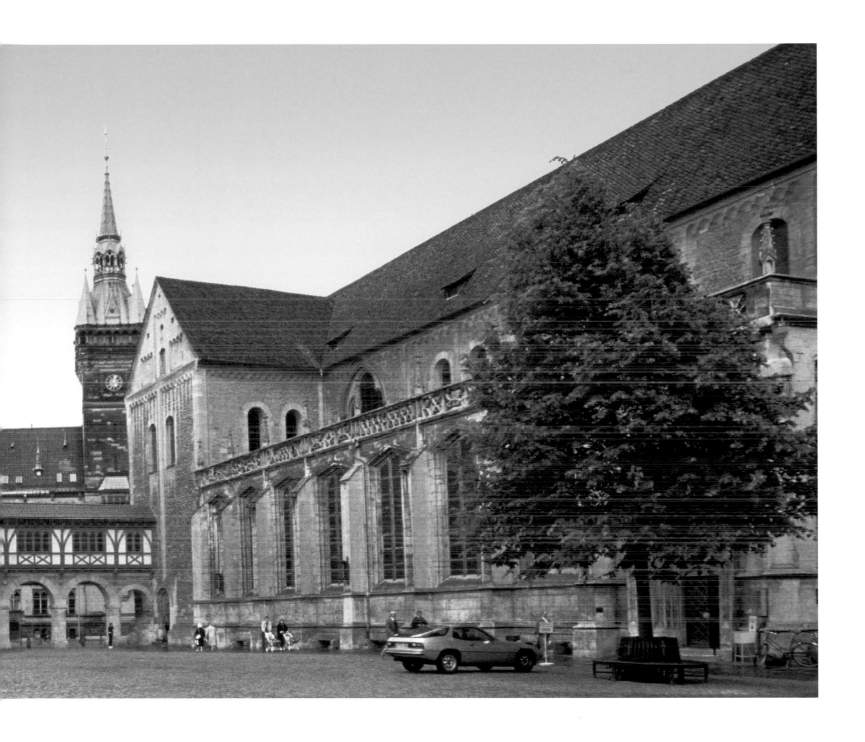

of Bavaria. He not only funded his expensive mistress, the dancer Lola Montez, but also had the west end towers and the vestibule with its domed tower reconstructed. He commissioned the etcher and historical painter Johann von Schraudolph to decorate the interior with a comprehensive series of frescos. Since Heinrich Hübsch, the architect entrusted with the reconstruction of the destroyed parts and the restoration of the entire building, stayed close to the old remnants, the cathedral's exterior in its current form also gives the impression of a harmonious, complete composition. The only old part apart from the crypt and the naves' encircling walls, however, is the upper structure at

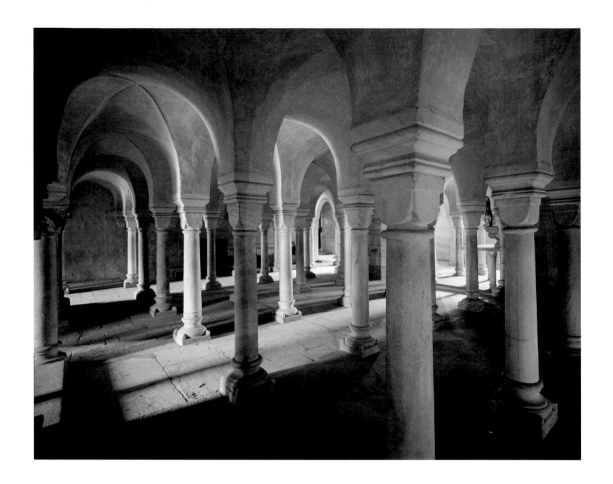

the east end. The picturesque overall effect of its external appearance is still augmented by a narrow gallery, called the dwarf gallery, unique to the Rhineland churches. A dwarf gallery is an open colonnade which in view of the scarcity of exterior ornamentation in Rhineland architecture did certainly not only have a decorative, but primarily a constructive function. This great cathedral became part of UNESCO's World Cultural Heritage in 1981.

Worms Cathedral

The exterior of Worms Cathedral, however, remained almost completely unharmed (p.29). While it was founded at the end of the tenth century, its modern form dates back to the eleventh and twelfth centuries. In the fourteenth century, the late period of Gothic style, it underwent renovations, which were mainly limited to the reconstruction of the north tower at the west end and the addition of a rich portal on the south side. Dependent on the Mainz and Speyer Cathedrals in its overall structure as well as in its details, it has no less grandeur of effect or picturesque attraction, even though it is the smallest of the three cathedrals. It has the same double choir set-up as Mainz Cathedral. It shares certain peculiarities in the construction of the nave with Speyer Cathedral, and in

Gurk Cathedral, Gurk (Austria),
12th century.

View of the south wall of the Imperial Palace of Gelnhausen (Germany), second half of the 12th century.

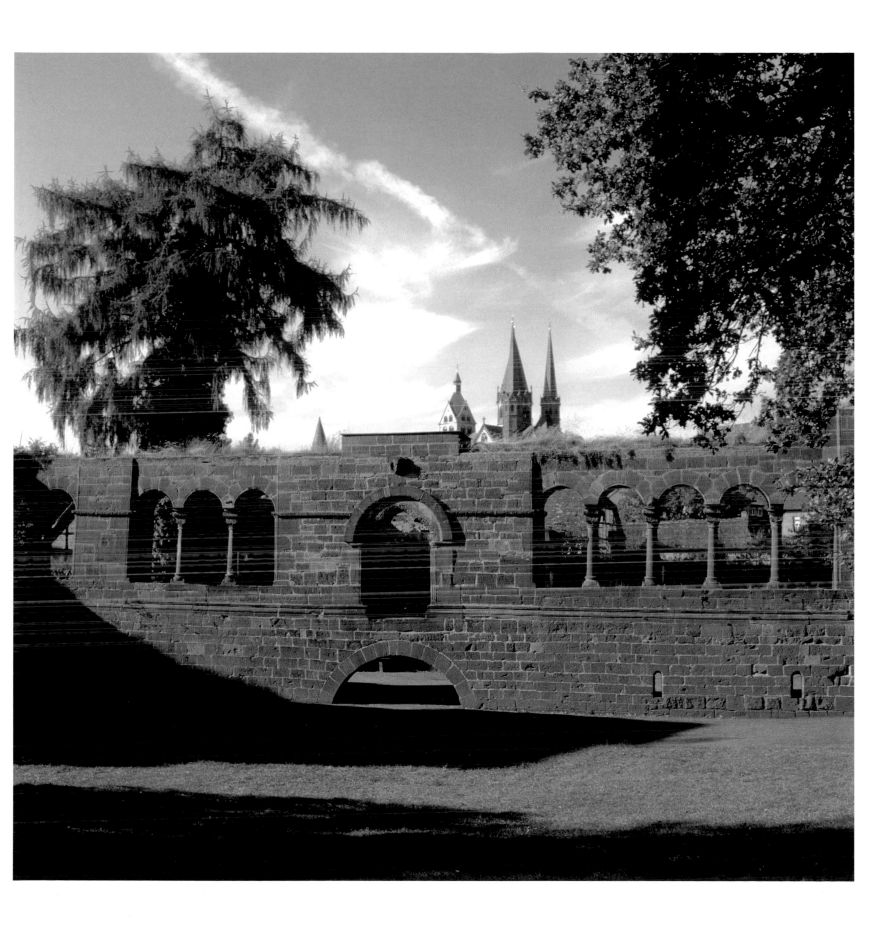

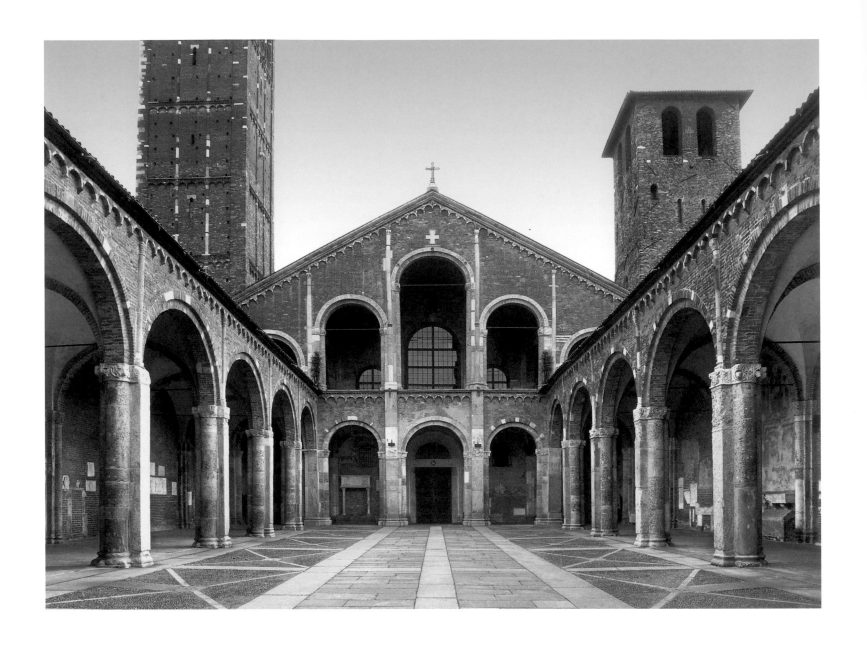

both the number and arrangement of the towers and dome, whose rich ornamentation, however, surpasses that of its two models.

Abteikirche (Monastic church) Maria Laach
Completely spared by any war or fire is the former Abteikirche (monastic church) of Maria Laach Monastery (p.28) located on Laacher See in Eifel province off the great military roads. It was erected from 1103 until the end of the twelfth century by the monks of the Benedictine order and bears the honorary title of Basilica minor bestowed by Pope Pius XI in 1926. It is also fitted with six domes and towers, though on a considerably smaller scale, and can certainly compete with the three great central Rhineland cathedrals.

Portico of the atrium and façade, Basilica of Sant'Ambrogio, Milan (Italy), 379-386 (continual restorations until 1099).

The church is a veritable tourist magnet, and the nearby crater lake attracted visitors until recently with water sport activities, which are now forbidden, since the lake potentially still harbours a World War II aeroplane wreck armed with bombs.

Churches in Cologne

A separate group of Rhineland churches is formed by the church buildings in Cologne, which are dominated by a characteristic floor plan. The earliest example is the Church of St Marien im Kapitol (St Mary's of the Capitol) (p.32-33) of 1049. In addition to the choir, the transept arms also end in semi-circular apses covered with half domes. This gave the eastern part of the church a clover shape. In the course of the eleventh and twelfth centuries, these choirs were so richly developed that they became more dominant than the nave.

Church architecture in Cologne reached its climax in the second half of the twelfth century with the completion of the buildings of Groß St Martin (Great St Martin) and Apostelkirche (Apostles Church) (p.30). In the Apostelkirche, the exterior walls of all three choirs are evenly structured by means of blind arcades on top of pilasters for the first floor, on top of columns on the second floor and by a panel frieze around the towers, which are round on the bottom and octagonal on top, as well as a dwarf gallery. They are thus pulled together with the three choirs to a unified structure of great elegance.

In isolated parts of these two churches, the pointed arch characteristic of the Gothic style can be seen, which is why one is inclined to count it among of the buildings of the so-called transition style. But the pointed arch has a purely decorative purpose here. In northeast France, however, where the architecture later named "Gothic" by Giorgio Vasari first emerged and was put into a certain system, it was considered a constructive element of basic importance from the start. French stonemasons probably brought the new construction forms to Germany. They were, however, only used decoratively here, since Romanesque architecture, which was still on the rise, was so sure of its own constructive power that it did not need external help. Despite the Gothic elements, the churches remained Romanesque in their essence, and Romanesque architecture only disappeared in Germany when the Gothic style was so completely developed that its constructive advantages were generally accepted.

Thus there is no reason to hold on to the concept of a separate "transition style" of architecture, which in any case would only be documented in Germany. The Romanesque style only integrated richer decorative and sometimes also more advantageous constructive elements of foreign origin where it was able to display its love of splendour due to favourable political or economic conditions, without ever changing its essential features. In other regions of Germany, which were not as accessible for the influence from northern France as the Rhine area, it is even probable that certain forms such as the pointed or cusped arch, which later became indicative of Gothic architecture, were brought back to Germany from Syria and Palestine. This is true also for Sicily, which was dominated by the Normans, with returning crusaders with an interest in the arts.

The Double Church of Schwarzrheindorf

Alone amongst the Rhineland's ecclesiastical buildings is the double church of Schwarzrheindorf in Bonn-Villich, on the right bank of the Rhine. It was originally built as the burial church of Arnold von Wied, later Archbishop of Cologne, and laid out in two levels above a floor plan in the shape of a Greek cross. Consecrated in 1151, it was soon extended by lengthening the nave and lost some of its character. It is not only remarkable because of its basic form reminiscent of the buildings of Carolingian times, but also because of its ceiling frescos. For the first time, the open arcade gallery appears here, running along underneath the roof, and its constructive purpose becomes very clear; it is meant to lighten the load of the upper wall onto the lower one as well as the foundation.

Ecclesiastical Architecture in Westphalia

The utility principle, which put emphasis on the constructive elements over the ornamental, appears most clearly in Westphalia's ecclesiastical architecture. Here, they dispensed with the richness of architectural ornamentation customary in the Rhineland, with the picturesque grouping of the building elements and the rich towers. They made do with a massive tower, usually attached to the western façade. As early as in the eleventh century, the advantages of vault construction became known. The locals' practical sense probably resulted in the characteristic Westphalia form of the *hallenkirche* (hall church), which was widespread in other regions of Germany during the Gothic period. The naves and aisles were of the same or almost the same height, and later also executed in the same width, so that the interior of the church resembled a hall separated by two rows of pillars. This brought about the advantage of being able to cover the nave and both aisles with the same roof. In the gradual development of the *hallenkirche*, the upper walls in the aisles were eliminated, so that the windows in the aisles provided sufficient lighting for the entire room. The cathedrals in Herford and Paderborn in North Rhine-Westphalia are the most beautiful Westphalian hallenkirchen, while the cathedrals in Soest and Muenster as well as in Osnabrueck in Lower Saxony represent the older building type with the nave being taller than the aisles.

Southern Germany

The Romanesque churches in southern Germany are of lesser artistic importance compared to those in the Rhineland and northern Germany. Only a few churches in Swabia can be considered, where, as mentioned earlier, the column basilica was customary. Alongside Constance Cathedral, the three churches on the island of Reichenau, in particular the Georgskirche (St George's Church) in Oberzell, a building dating from the tenth and eleventh centuries, must be mentioned.

Western façade, Modena Cathedral, Modena (Italy), 12th century.

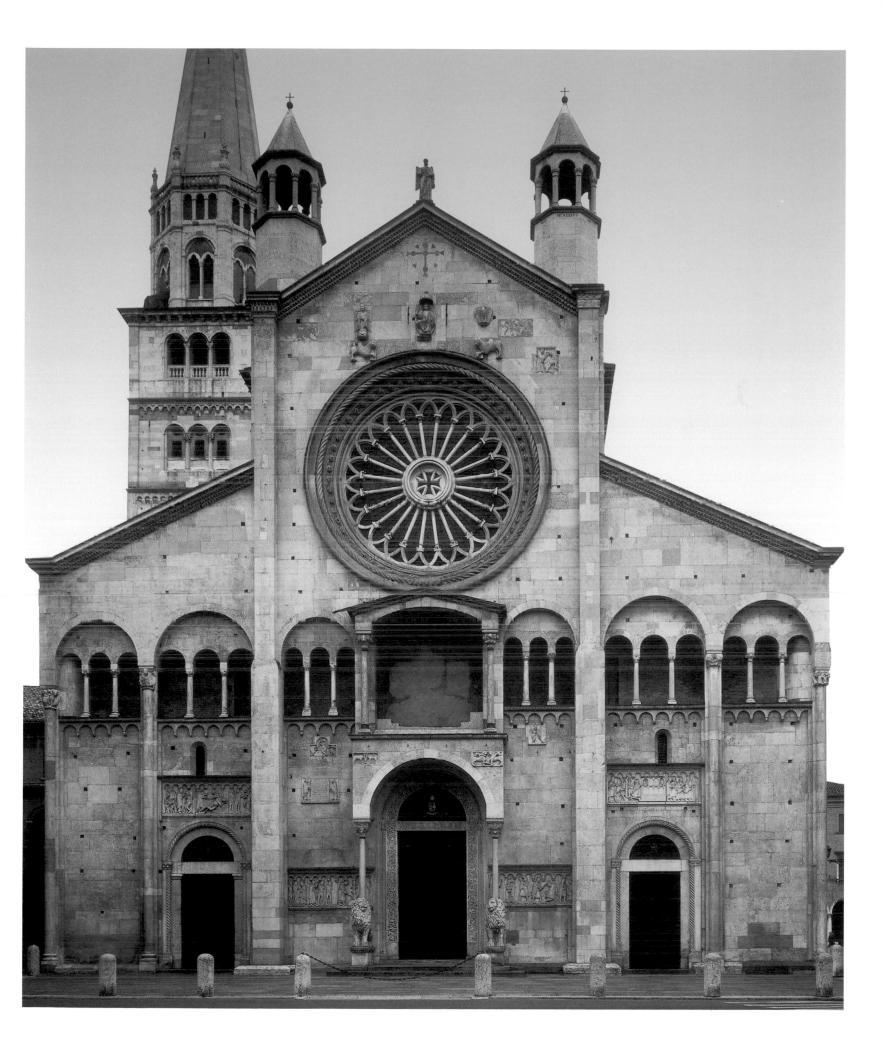

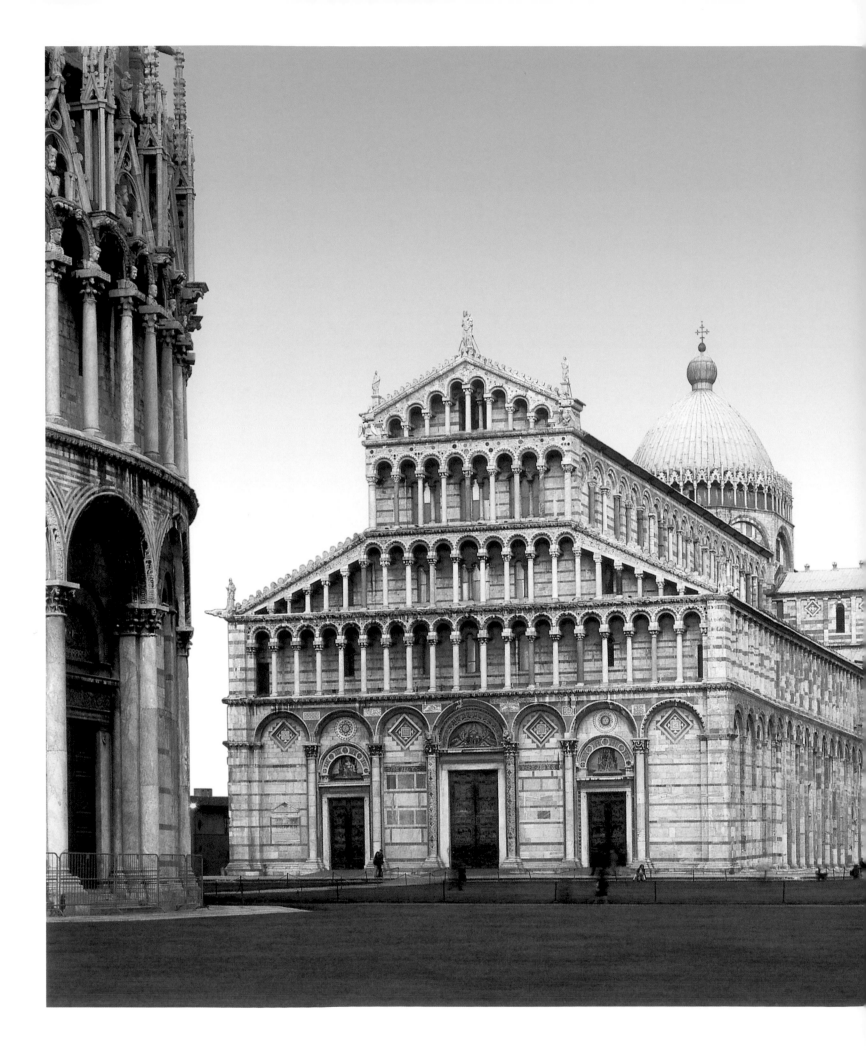

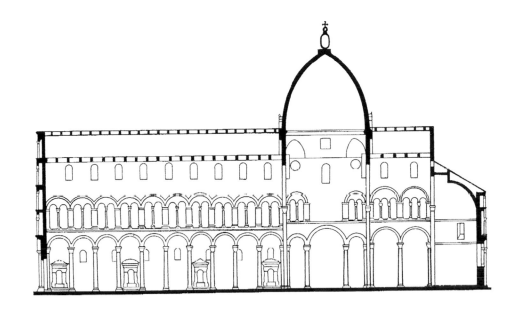

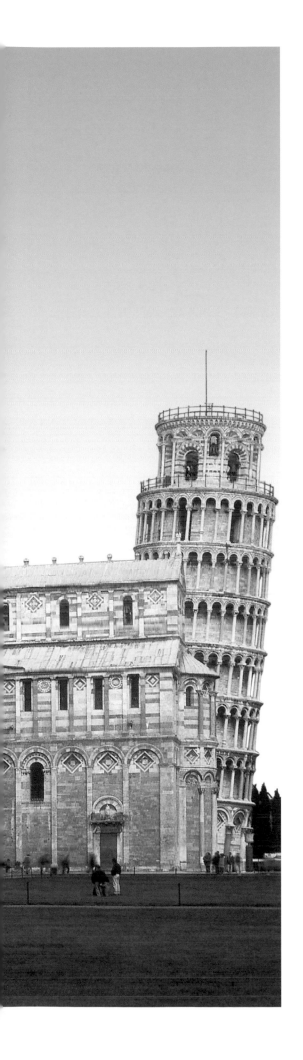

Cathedral, baptistery and campanile, Piazza dei Miracoli ("Square of Miracles"), Pisa (Italy), 1064-1350.

Elevation of the principal nave, vertical plan, Cathedral of Piazza dei Miracoli ("Square of Miracles"), Pisa (Italy), 1064-1350.

Western façade, Cathedral of the Santa Maria Assunta, Spoleto (Italy), c. 1063-1380.

Mosaics (1140-1170) of the dome and apse, Palatine Chapel, Palermo (Italy), 1080.

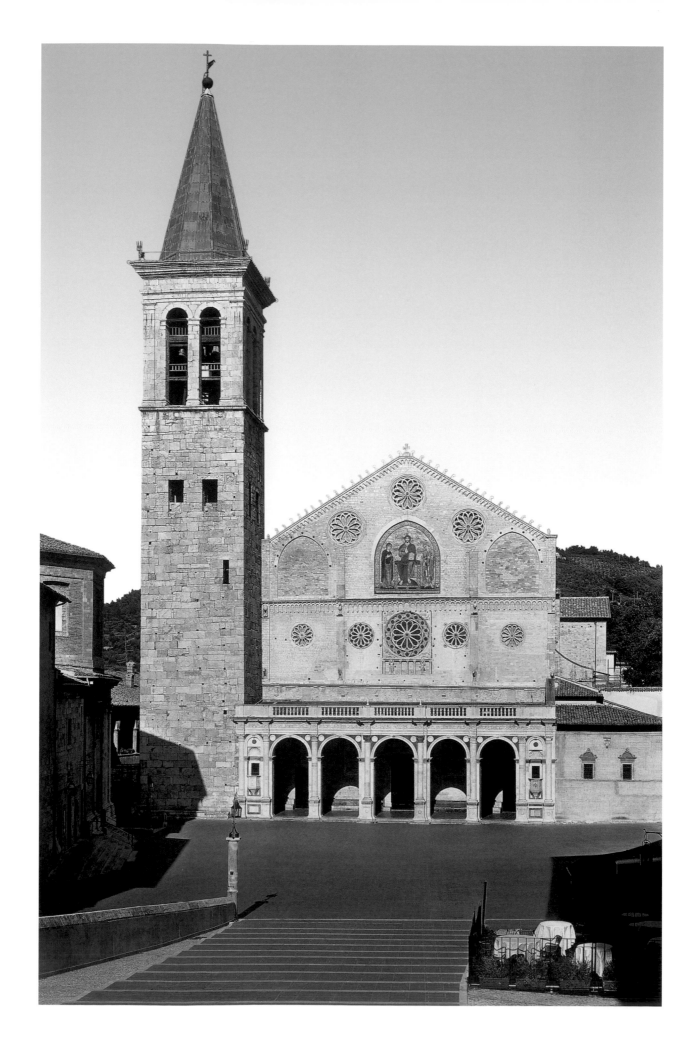

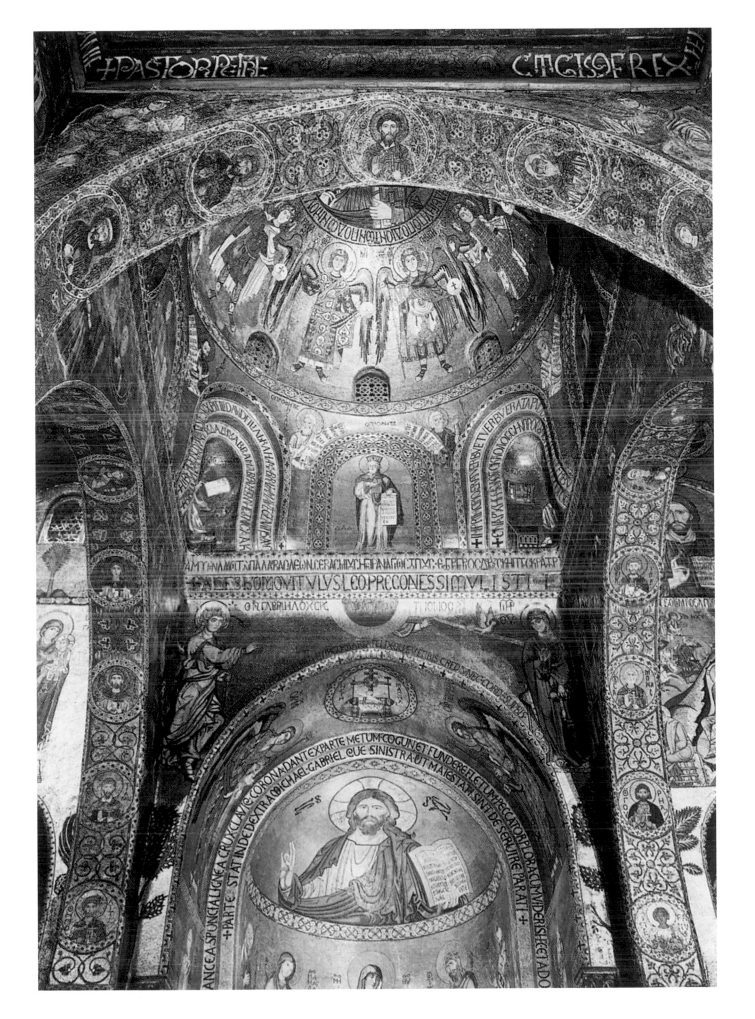

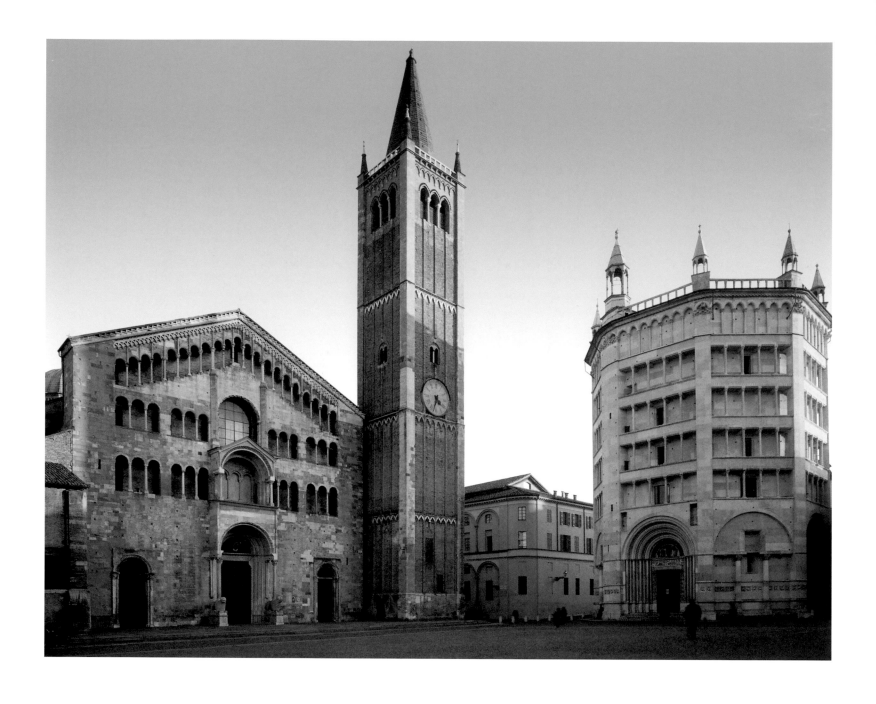

Western façade, Parma Cathedral and campanile (after 1106), the Baptistery of Parma (on the right) (1196-1260), Parma (Italy).

Bavaria - Bamberg Cathedral

In Bavaria, Romanesque architecture can be found in its simplest form for the longest period of time, up to the point that Bamberg Cathedral (p.35), one of the most splendid and at the same time artistically valuable monuments of Romanesque architecture in Germany, was created at the end of the period. It was long considered one of the buildings of the transition period, since the arcades and groin vaults of the nave show pointed arches and Gothic elements appear also on the façade, in particular in the window framings of pointed arches on the west side. In its overall character, however, Bamberg Cathedral is definitely a

Romanesque edifice. The western towers, which were built during the final years of this period, are completely Romanesque in form. Thus, at a time when the Gothic style was already widespread in Germany, there was still enough understanding of the unified organism of a work of art that one stuck with unwavering tenacity to a meaningful plan and implemented it in the spirit of its creator in opposition to prevailing fashion trends. It appears as though the basic elements of the Rhineland and Saxon schools were fused in the implementation. This combination of the two most peculiar directions of Romanesque architecture in Germany made Bamberg Cathedral the climax in the last phase of the Romanesque style on German soil. This is not only based on its architectural make-up, which combines the merits of grand appearance with a perfect correspondence of ratios, but also on the rich sculptural decoration of its portals and, among others, the famous *Bamberg Horseman* (around 1230-1240).

Hesse – Limburg Cathedral

The constructive forms of the Gothic style are much more clearly apparent in the cathedral of Limburg an der Lahn (twelfth or thirteenth century), whose architecture was not only influenced by the initially prevailing Rhineland but also by northern French models. In its structure, the cathedral shows definite Romanesque traits (p.37). The original Romanesque arrangement and formation of the towers – there are seven – found its most splendid development in this cathedral, despite its modest dimensions.

Thuringia – Naumburg Cathedral

The late Romanesque-Gothic cathedral of St Peter and St Paul with its famous Patron statues by the "Naumburg Master", whose dates of birth and death are unknown, on the west choir (around 1250), is also among the most important and famous examples of ecclesiastical architecture of the time. The Patron statues depict the twelve patrons (founders), who are also representative of all donators and sponsors of the cathedral, on the western choir. In place of their burial sites in the cathedral, which were acquired by donation, but later removed, commemorative tombstones were integrated into the vault structure, and displayed almost four metres above the ambulatory. Each of the sculptures has its own baldachin. Among the most important patrons, and thus located in the centre of the group, are the last owners of the former Naumburg Castle, Margrave Herman with his wife Reglindis, and Eckard with his famous wife Ute. All the figures are dressed in thirteenth-century fashion. The stained-glass windows in the cathedral's west choir also deserve special mention. The depicted figures of holy men and women are a continuation of the Patron statues, and are also portrayed in the fashion of the time.

View of the choir, Basilica di San Miniato al Monte ("Basilica of St Minias on the Mountain"), Florence (Italy), 1013-15th century.

Archways and cloister, Basilica of St Paul Outside the Walls (or St Paul without-the-Walls), Rome (Italy), 13th century.

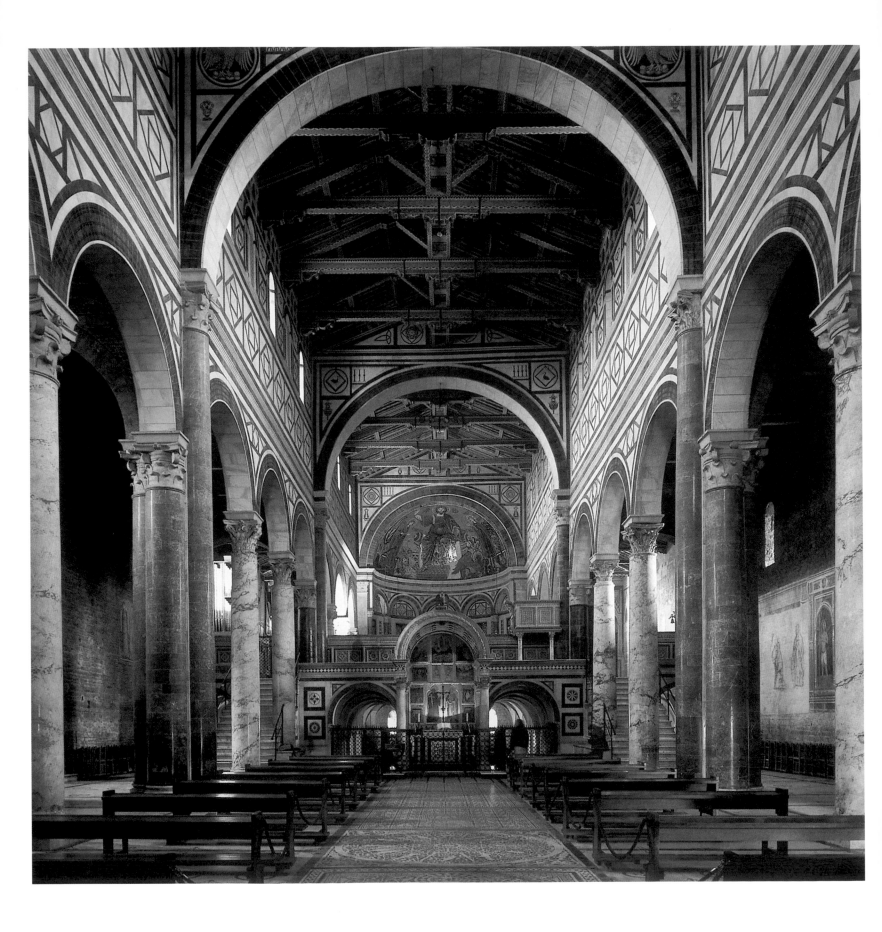

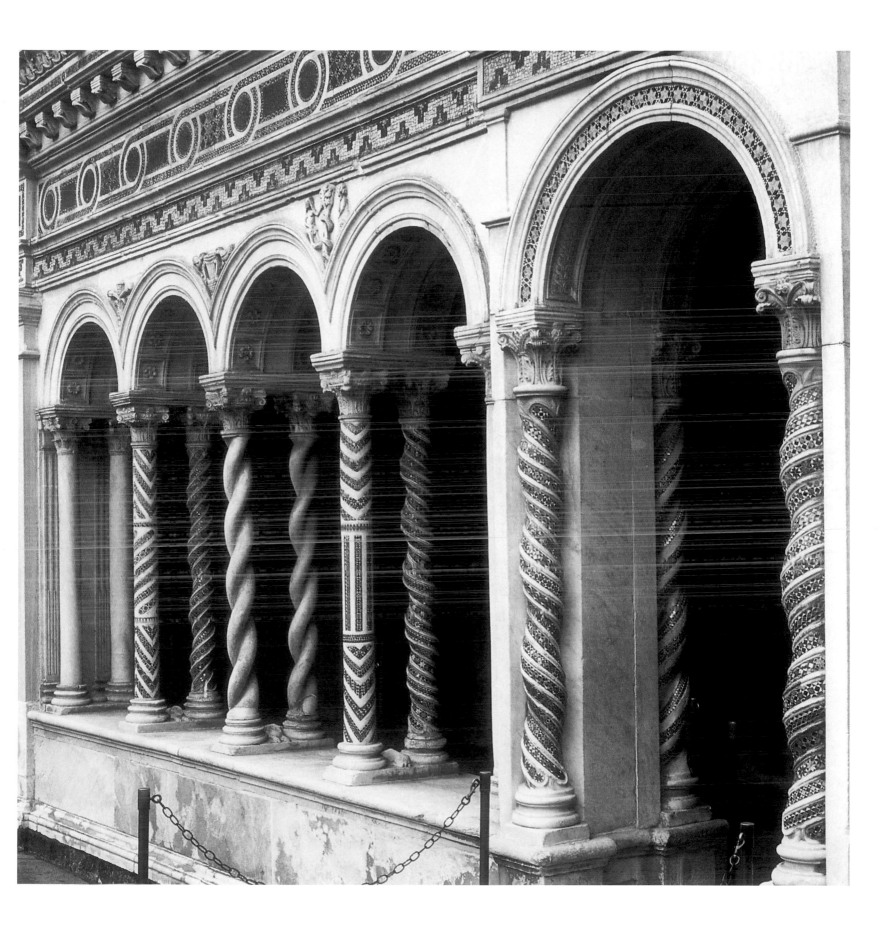

Baptistery, St John Lateran, Rome (Italy),
4th century.

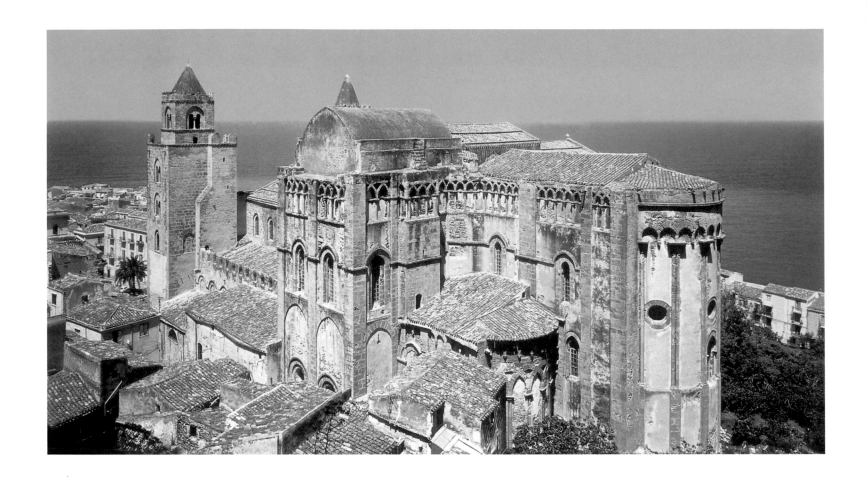

Liebfrauenkirche (Church of Our Lady) in Arnstadt

The construction time for the double-aisled basilica, the Liebfrauenkirche (Church of Our Lady) extends over almost a century, having begun in 1220 and been completed in 1300. At the beginning of the nineteenth century, it was turned into a storeroom, as were some other churches. On this church structure, which was at the time reconstructed by Hubert Stier, only the lower level and the façade of the twin tower are Romanesque. The remainder dates from the Gothic period. The building, in particular the eastern choir, had become so run-down by the end of the twentieth century that a restoration was urgently needed. Thus the choir, roof truss, roof and system of lightning rods was repaired, as well as a range of other work carried out, from the reinforcement of the buttresses and bell tower to electrical installations.

For this church, too, as for the church in Bonn, the original Romanesque character was changed so little that one cannot speak of a new style – the transition style.

The Cistercian order, which had emigrated from France, gained a foothold in Germany during the second half of the twelfth century and did not only settle in southern and central Germany, but also in the then relatively inhospitable north, in particular in Brandenburg. They founded numerous churches and monasteries, where the newly created buildings were

South-East view, Cefalu Cathedral, Sicily (Italy), started in 1131.

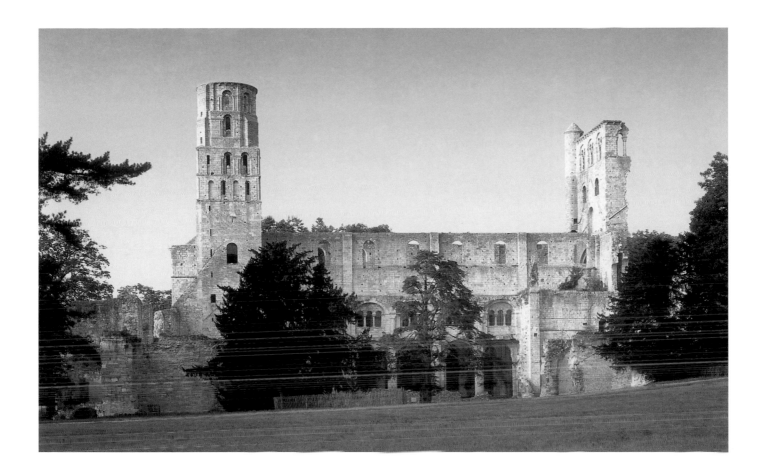

architecturally adjusted to the order's ascetic ideals. The Cistercian order, which had developed from the Benedictine order, argued particularly against towers, since bells were forbidden according to their rules. They contented themselves with simple roof turrets. Neither did they like the round choir forms, which they replaced with rectangular ones. In general, they banned all sculptural decorations and paintings from their churches, including the stained-glass windows and chandeliers, and placed an even larger emphasis on purposeful construction. That is why they turned to Gothic architecture early on, which they had come to know and love in their homeland. Most Cistercian churches and monasteries, despite basic Romanesque forms, thus contain Gothic elements, which grew more and more predominant in the course of the thirteenth century.

Abteikirche (Abbey Church) of Heisterbach

Located in the Rhineland region of the Siebengebirge mountains, the surviving choir of Heisterbach abbey church, which was built between 1202 and 1233 and largely destroyed in 1810, clearly shows that a sort of buttress system was used to better stabilise the vault. In the following years, this became particularly characteristic of the Gothic style. The Cistercians, in fact, did not always observe their own architectural rules to the strictest degree.

Exterior view, Abbey Church of Notre-Dame ("Jumièges Abbey"), Jumièges (France), c. 654.

While their structures were still in harsh contrast to the magnificent exterior presentation of the churches, they abstained from the preached simplicity in the monastery and church of Maulbronn (p.38-39) in Swabia, their most brilliant creation on German soil. Some churches and monasteries in Austria, too, such as in Heiligenkreuz and Lilienfeld, are proof that the Cistercian order did not lack an appreciation for art. They were, when local custom demanded it, not as ascetic, and open to a greater display of splendour.

Northern Germany – Cathedrals and Churches

The local building customs in the lowland plains of northern Germany corresponded most to those of the Cistercians. Due to the lack of natural rock, they had resorted to brick building, which required a great simplicity in the treatment of forms as well as in ornamentation. The financial difficulties faced by the population were also a driving factor. In particular the German settlers in the lands east of the River Elbe had to first make the ground farmable and defend themselves against the Slavic population. Thus, in those regions of Germany, ecclesiastical buildings of artistic importance were only created from the middle of the twelfth century. Most of them are even from the period where vaults were already formed with pointed arches, and thus have to be considered part of the transitional style.

The new use of form is a particularly striking feature of these buildings, and was developed with great logical consistency from the nature of the building material and where certain decorative forms indicate that at least the ornamentation was also influenced by foreign lands. It is likely that brick makers and foremen came from northern Italy and introduced brick building, which had long been customary there, into northern Germany. The population's serious character quickly gained the upper hand over the building and decoration forms, which, imported from a sunnier country, radiated charm and cheerfulness, and thus a decisive influence. The only form that prevailed was the round arch frieze, which was indicative of Italian roots and was formed of intersecting arches. This made up the only decoration of the high-rising walls along with diamond friezes, series of stones placed at right angles to each other and patterns made by coloured glazed bricks. Otherwise, their monotonous red was only interrupted by the white mortar joints. On the inside too the bricks mostly remained free of plasterwork, and even where the curvature was decorated with paintings, the whitewash was left in its original colour, since the contrast between red and white was very decorative.

It was also due to the character of brick building that the cubed form of the cushion-top capitals of Romanesque style were replaced by a trapezoid form, which was better suited for the rectangular shaped bricks. The pillar basilica is the main type of these northern German brick churches, with only few exceptions. The Klosterkirche (monastic church) of Jerichow (p.41) in Brandenburg, founded in 1149 but only completed during the thirteenth century, is a column basilica with a flat roof. All other buildings of similar artistic and monumental importance, however, are pillar basilicas.

Nave, Benedictine Abbey of St Etienne, Caen (France), 1066.

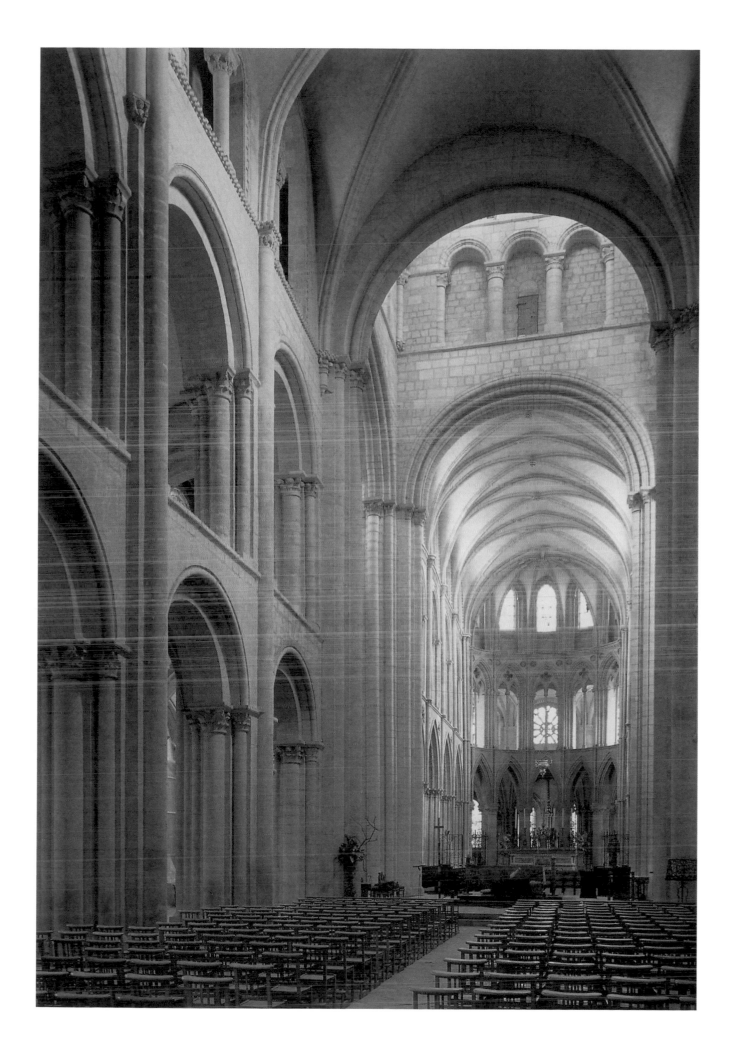

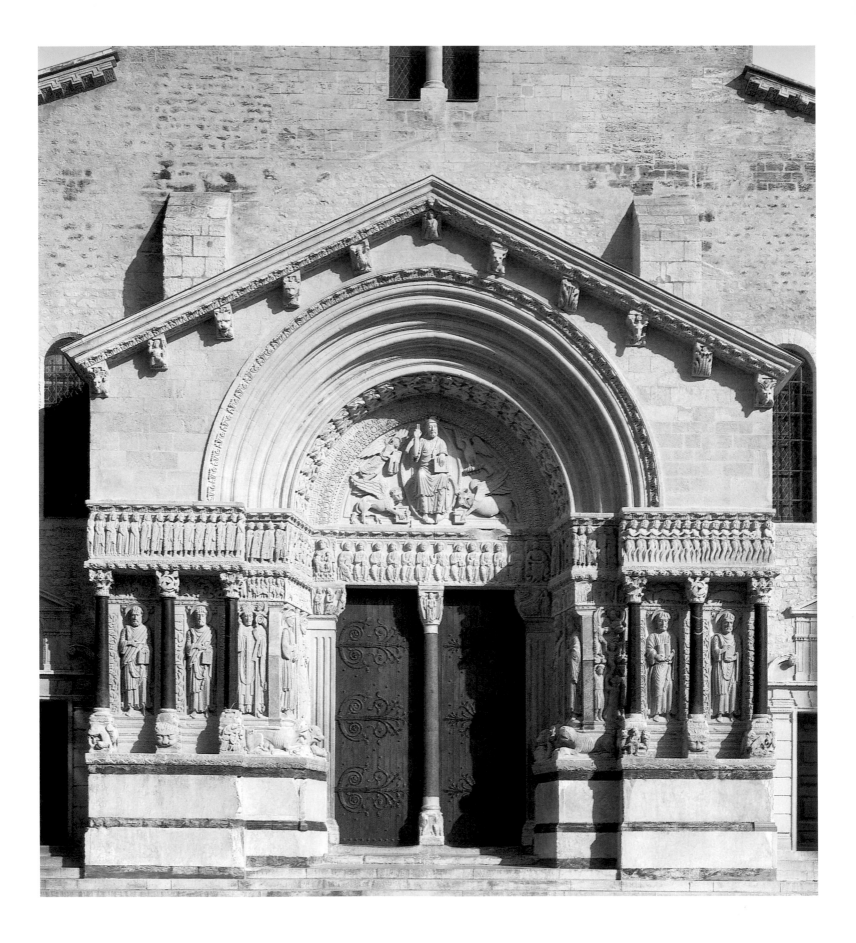

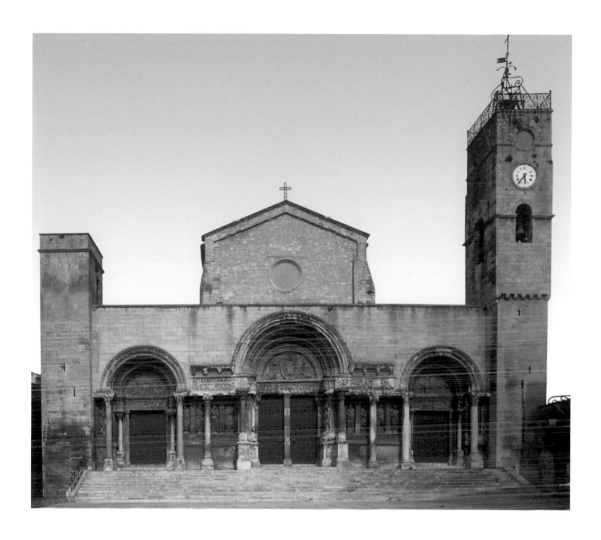

Lübeck and Ratzeburg Cathedrals

The cathedrals of Lübeck and Ratzeburg are the most prominent monuments of brick building in northern Germany during this transition period. The formerly rich Hanseatic town's population cultivated its love of splendour and added a portal, vaulted with a pointed arch, though Romanesque in all other details. This was executed in sandstone with columns of polished basalt, on the north side of the otherwise very simple Lübeck cathedral.

In the cathedral of Ratzeburg, which was completed at the beginning of the thirteenth century, the individual Gothic elements are more pronounced, particularly the nave's pointed arch vaults and the tower windows. But the massive, squat overall appearance still shows definite features of Romanesque architecture.

In contrast to this, the Cistercian churches in Chlorin and Lehnin in Brandenburg are of such predominantly Gothic character that they must be considered heralds of Gothic architecture.

Portal of the façade, Cathedral of
Saint-Trophime, Arles (France),
12th century.

Façade, Abbey Church of Saint-Gilles-
du-Gard, Saint-Gilles-du-Gard (France),
founded at the end of the 11th century
and at the beginning of the 12th century.

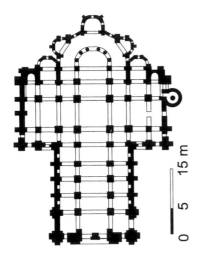

Horizontal plan, Abbey Church of
Sainte-Foy, Conques-en-Rouergue
(France), 11th-12th century.

Northern view, Abbey Church of
Sainte-Foy, Conques-en-Rouergue
(France), 11th-12th century.

Wall of the nave, Abbey Church of
Sainte-Foy, Conques-en-Rouergue
(France), 11th-12th century.

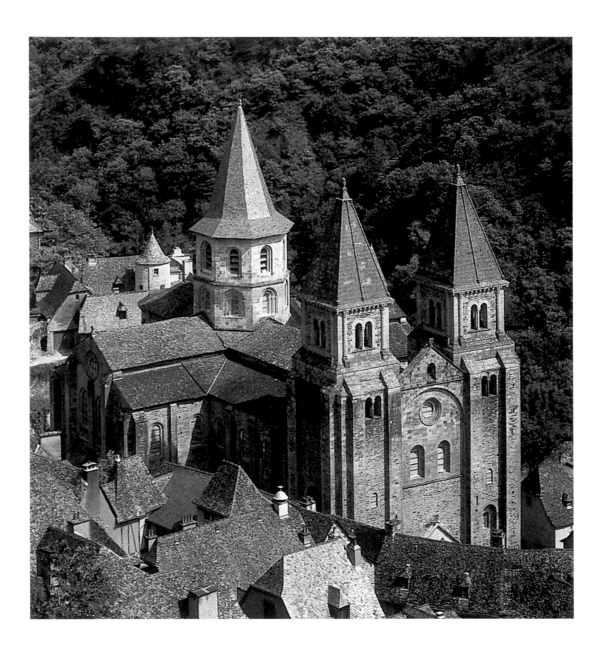

Loccum Monastery

Loccum Monastery, built in the later Romanesque style and located not far from Steinhuder Meer (Steinhude Sea, which does not have a lot in common with an actual ocean, but is only a small inland lake), has been inviting reflection and contemplation since 1163. Construction of the monastic church of St Mary and St George was begun in about 1240. Even though there are no monks nowadays, the premises, which include a preachers' seminary for the education of pastors, are still run by an abbot and convent. In the monastery's immediate vicinity and, since the monastery was not secularised, belonging to it, is a remarkable landscape of lakes and forests, which reminds us of the original cultivation by the monks.

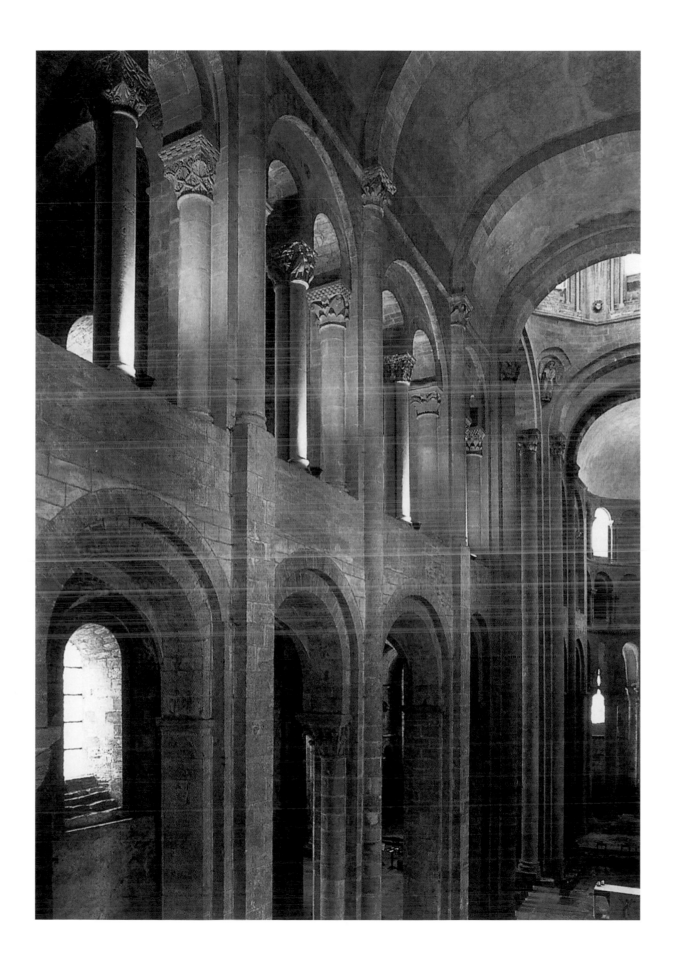

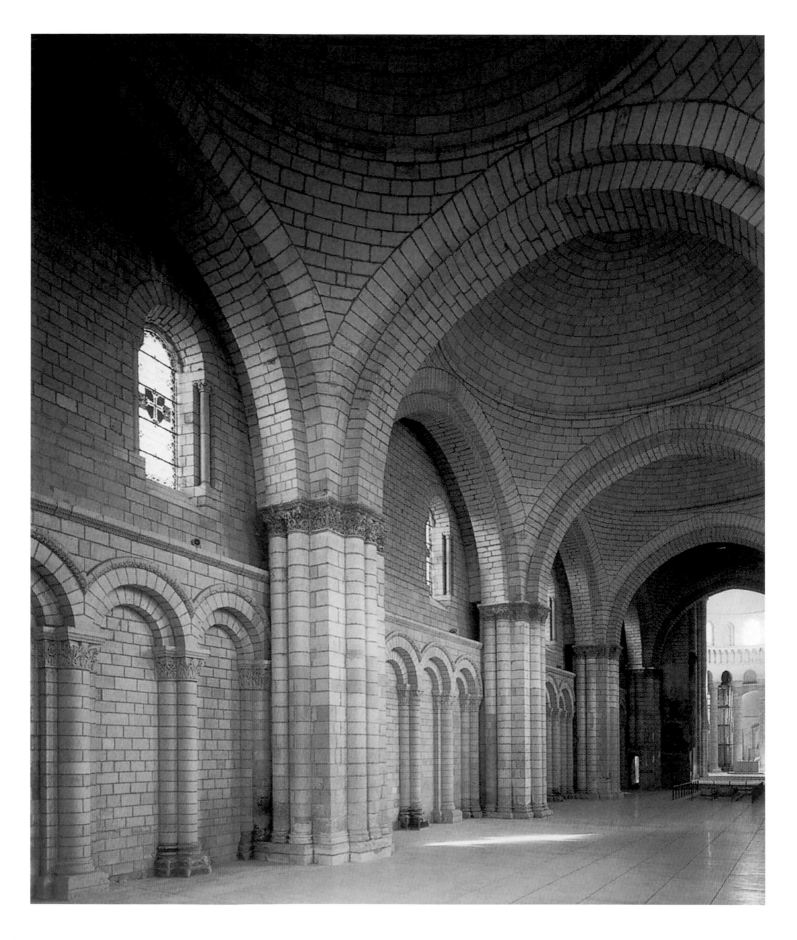

Secular Buildings

Only a few of the castles, palaces, and stately homes of the Romanesque period, and many of those only in scarce remains, escaped renovation, destruction, abandonment or the restoration frenzy of the later centuries. At least three of the most prominent royal houses of the eleventh and twelfth centuries were resurrected from the rubble to renewed glory by sensible reconstruction. Residences in Cluny in Burgundy, in Cologne and the Dreikönigshaus (Magi House) in Trier bear witness to the power of secular Romanesque art.

Wartburg Castle

The largest among these castles is the Wartburg, founded in 1067 in Eisenach, in Thuringia. It is located on a rock plateau at an altitude of 410 metres and was gradually enlarged to its current size in the course of the twelfth and thirteenth centuries. At the beginning of the thirteenth century Elizabeth of Hungary, who was canonised by Pope Gregory IX in 1235, lived there, and from 1521 to 1522 the monk Martin Luther lived there, under the alias of Squire Jörg, and began his translation of the New Testament. The main part of the castle is the three-storey palace, the actual residence of the Thuringian landgraves, with a large ballroom on the top floor. The Wartburg became part of UNESCO's World Heritage in 1999.

The Castles and Palaces in Goslar and Braunschweig

A ballroom like the one at Wartburg Castle had to be present in every imperial palace and great mansion. It usually encompassed the entire top floor, as in the only remaining imperial palace in Goslar, which Emperor Henry III built between 1040 and 1050. After the palace had been renovated during the twelfth and thirteenth centuries, a fire broke out soon after the second renovation, in which the wing with the imperial living quarters was destroyed. Today, only the two-storey ballroom structure remains, whose upper level opens into seven massive, three-part round arch windows. In addition, the two-storey imperial chapel survived, cross-shaped on the bottom and octagonal on the top, in which the heart of Henry III lays buried underneath a slab of stone. It is connected to the ballroom structure by an intermediary building. After Goslar had fallen to the Prussian state together with the kingdom of Hanover, the regeneration of the building was begun. This was completed with the reconstruction of the grand staircase, which originally led from the ground floor to the empty square in front of the palace.

Dankwarderode Castle in Brunswick (p.44–45), which was erected between 1150 and 1175 and was the seat of Henry the Lion, was also completely reconstructed. Such small parts remained of it, however, that a complete reconstruction had to be undertaken. The last restoration was completed in 1995 and shows the castle in its full splendour.

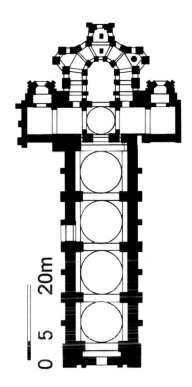

Domed nave, Abbey Church of Fontevraud, Fontevraud-l'Abbaye (France), founded in 1101.

Horizontal plan, Abbey Church of Fontevraud, Fontevraud-l'Abbaye (France), founded in 1101.

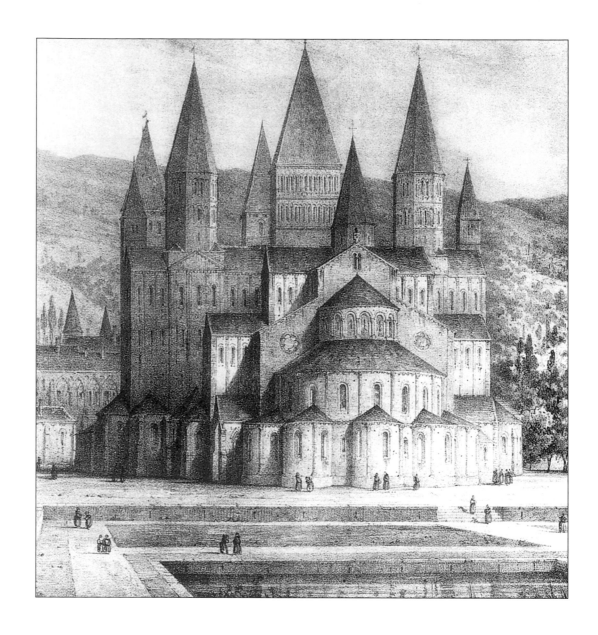

These and other castles and palaces were, however, surpassed by far in artistic presentation by the residences erected in various parts of his empire by Emperor Frederick I, known as Barbarossa on account of his red beard. Most of the palatine residences – such as Kaiserswerth in the Rhineland, Trifels in Rhineland-Palatine and Wimpfen am Berg in Baden-Württemberg, Hagenau in the French province of Alsace, or Eger in the Czech Republic – however, disappeared completely or almost completely. One can only try to imagine their former splendour from old descriptions and images.

The Imperial Residence of Gelnhausen

The enormous size of these imperial residences can be seen from the remains of the one in Gelnhausen (p.47) (located near Frankfurt am Main and currently the geographic centre of

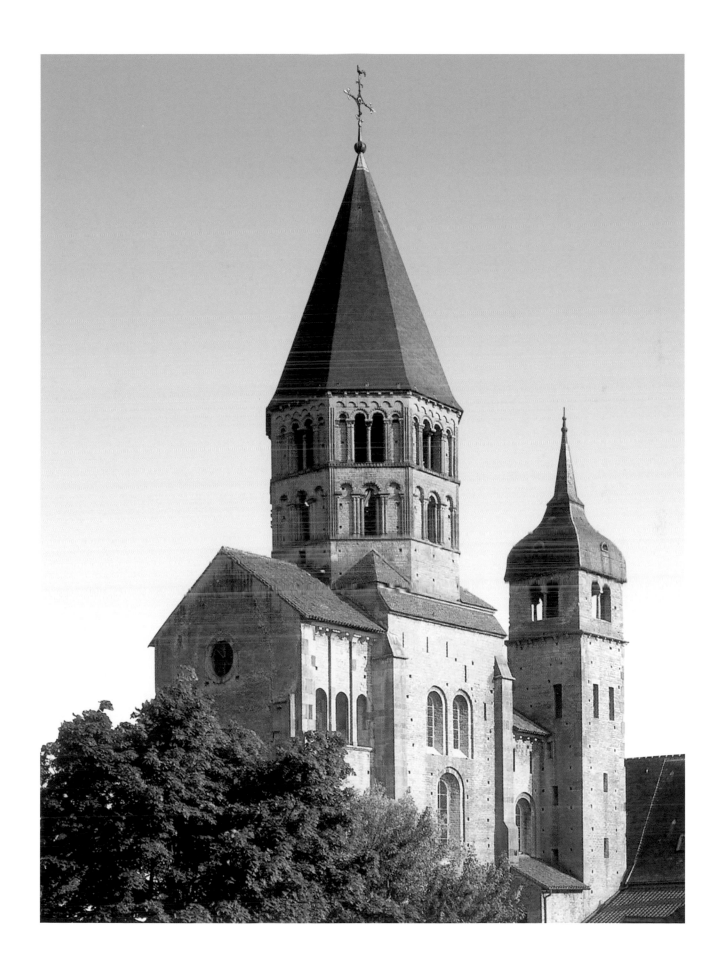

the European Union), which was completed in about 1170 and today is located in the centre of the city. Today there remains the gateway with its double entrance, a portion of the encircling walls of the chapel above and the lowest main floor of the adjoining residence, which contained the ballroom. The lowest floor is simple and unadorned, as in the imperial residence in Goslar. The ballroom floor, to which a double staircase used to lead, is accessible through a richly decorated portal vaulted with a cusped arch. It is structured with open rows of arcades, borne by coupled columns. It can be seen from the well-preserved sculptured decoration of the column capitals, ledges and the portal's arch what extraordinary artistic powers were at the Emperor's command. His taste had been refined by his many trips to Italy and his love of splendour had also been increased by the many buildings he saw there, though his financial capabilities could not quite meet his love of grandeur.

The then unusual shape of the cusped arch as well as certain details of the ornamentation are indicative of Oriental influences, from where the crusaders had brought back new artistic ideas to Germany. In Gelnhausen there is another Romanesque building, in which the imperial residence's main motifs are repeated, though in simpler form. Judging from its imposing exterior it probably did not serve as a private residence, and can probably be considered the oldest preserved German city hall, and thus the oldest work of bourgeois architecture in Germany.

Austria

In Austria, the Early Romanesque period began approximately during the eleventh century, after the end of the Hungarian invasions. A century later, the High Romanesque period began, followed by the Late Romanesque period. Both Lower and Upper Austria were influenced by the Cistercian style and the rest of the country was under the influence of the Hirsau reformation, which was originated by Wilhelm von Hirsau, a highly educated abbot and monastic reformer. He not only dedicated himself to monastic reform, but also to music and astronomy, and wrote scholarly papers. Most of the Romanesque monastic churches in Austria almost completely lost their Romanesque roots because of later renovations. The oldest Romanesque crypt is located in Göss, the most beautiful one in Gurk Cathedral.

Gurk Cathedral

The Mariendom (St Mary's Cathedral) of Gurk (p.46) in the Austrian province of Carinthia is considered one of the most important buildings of the Austrian and European Romanesque period. Erected in High Romanesque style between 1140 and 1200, it remains largely in its original form today. The long basilica's western façade has two towers, a crypt with one hundred columns and three apses. The bishop's chapel in the western gallery houses paintings in the zigzag style and the rest of the cathedral is home to other important paintings of the Late Romanesque period. It also contains the tomb of St Hemma, the cathedral's founder.

Plan of the Monastery, Abbey Church of Saint-Pierre-et-Saint-Paul, Cluny (France), 909/910-1130.

A. Church
B. Chapel of the Virgin
C. Hospital
D. Refectory
E. Kitchen
F. Monumental portal
G, H, I. Inn and stables
K. Noviciate
L. Chapel of the cemetery
M. Annex of the dormitory
N. Abbey chapel
1. Ancient church
1a. Ancient narthex
2. Chapter house
3. Parlor
4. Friars rooms
5. Dormitory (first floor)
6. Latrines
8. Warming room
11. Covered fountain
12. Friars' kitchen
13. Lays' kitchen
14. Store
15. Chaplaincy
19. Cemetery
32. Bakery
36. Inn for female guests
41. Cowsheds and Lays' houses
42. Latrines

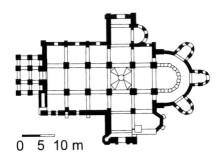

0 5 10 m

St Paul in the Lavant Valley

One of Austria's largest church castles is the collegiate church of St Paul in the Lavant Valley, which developed from a large fortified castle. In the monastery's centre, there is a Romanesque collegiate church with notable reliefs and frescos. Construction was commenced during the second half of the eleventh century, and completed during the first half of the twelfth century. When the Turks marched on Vienna, they attempted to storm the walls surrounding the monastery, but failed miserably and withdrew discouraged.

The Town Parish Church in Friesach

Silver pfennigs were minted in Friesach in the Middle Ages. The town's resultant prosperity may have contributed to the fact that many medieval buildings can still be found there today. Among them are two Romanesque buildings, the double-aisled Stadtpfarrkirche (Town Parish Church), a basilica, and the Peterskirche (St Peter's Church), which resembles the Grabeskirche (Church of the Holy Sepulchre) in Quedlinburg, which were both erected between the eleventh and thirteenth centuries.

Italy

Romanesque architecture in Italy is even more colourful and varied than that of Germany. In the different regions of Italy, a variety of different Romanesque styles can be found. What remained from Ancient times was integrated with foreign elements since the early Middle Ages. Their influence increased over the course of time, until the never quite severed connection with ancient Roman art was re-established everywhere around the turn of the fifteenth century and created at least an artistic unity for all of Italy. The country's geographic location made it easy for foreign artistic ideas to enter the country during the war-ridden Middle Ages. The Italians' receptivity became greater as their lives with and among the foreigners who had come to Italy either as peaceful merchants or as conquerors became richer and more pleasant. Even the roughest among them, the Lombards, who emigrated from the North across the Alps in around 560 A.D. and ruled all of northern Italy for 200 years, brought a new culture with them. It fused with the local culture but gave it some characteristic traits, which are especially evident in the buildings erected under Lombard rule.

The Lombards' edifices, which were probably erected jointly by local and immigrant builders, were also changed so heavily during the Middle Ages that the true character of Lombard art is hard to determine. It is mainly credited with the introduction of the cross-shaped floor plan for ecclesiastical architecture and the vaulting of the nave. The descendants of the Ancient Romans, however, did not have to learn the art of vaulting from these immigrants. What was new to the Lombards was thus more in the field of ornamentation, where large wall spaces were covered with decorative architectural friezes. This contrasted with Ancient ornamentation and gave the

Horizontal plan, Basilica of the Sacred Heart, ancient portal of Notre-Dame, Paray-le-Monial (France), end of the 11th century (narthex), 1090-1190 (church).

North-east view, Basilica of the Sacred Heart, ancient portal of Notre-Dame, Paray-le-Monial (France), end of the 11th century (narthex), 1090-1190 (church).

Nave, Basilica of the Sacred Heart, ancient portal of Notre-Dame, Paray-le-Monial (France), end of 11th century (narthex), 1090-1190 (church).

Nave, Abbey of Fontenay, Marmagne (France), founded in 1118.

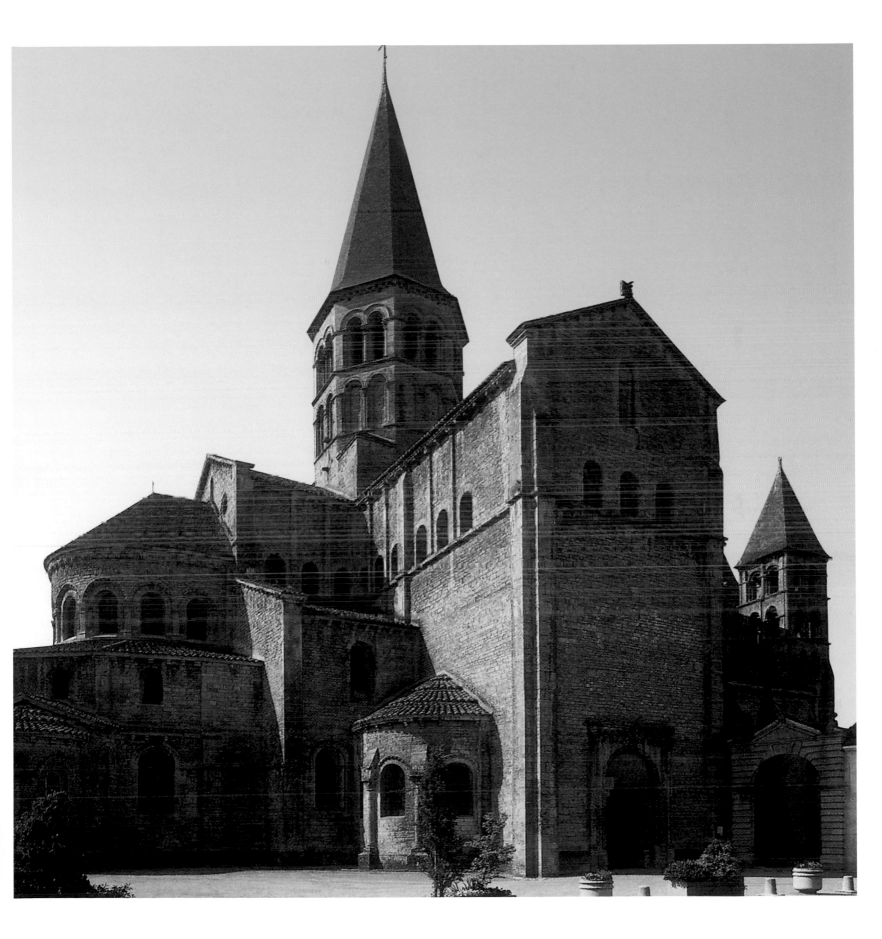

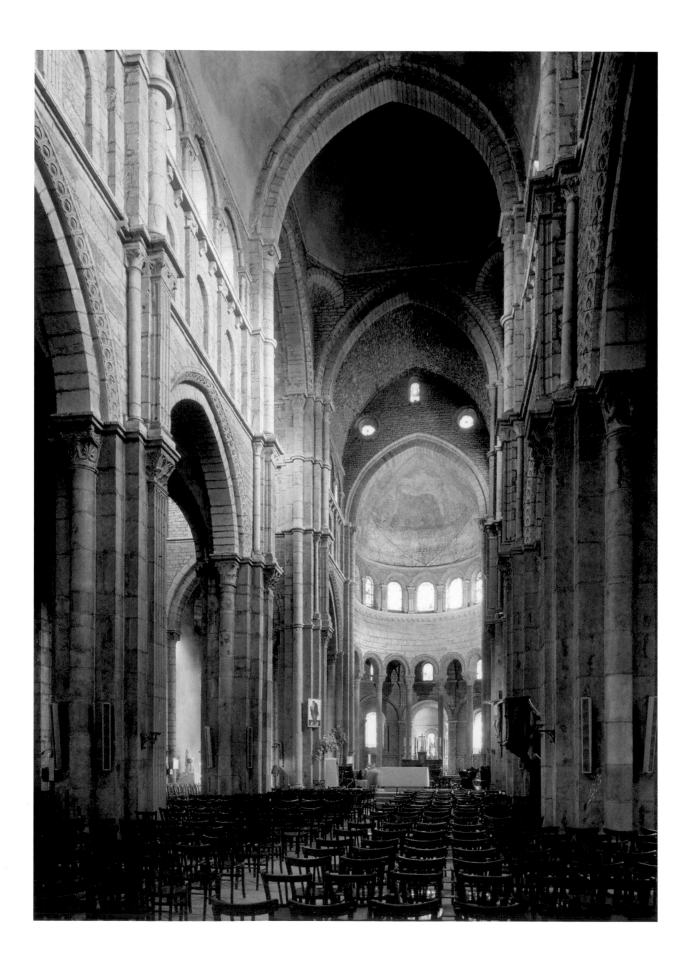

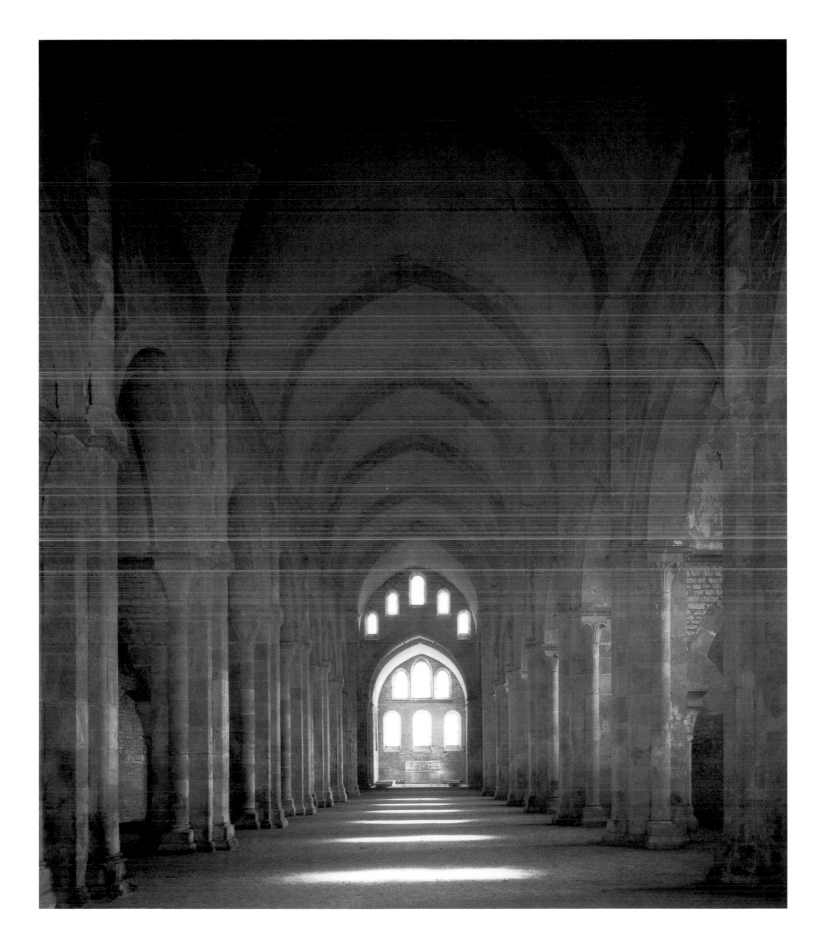

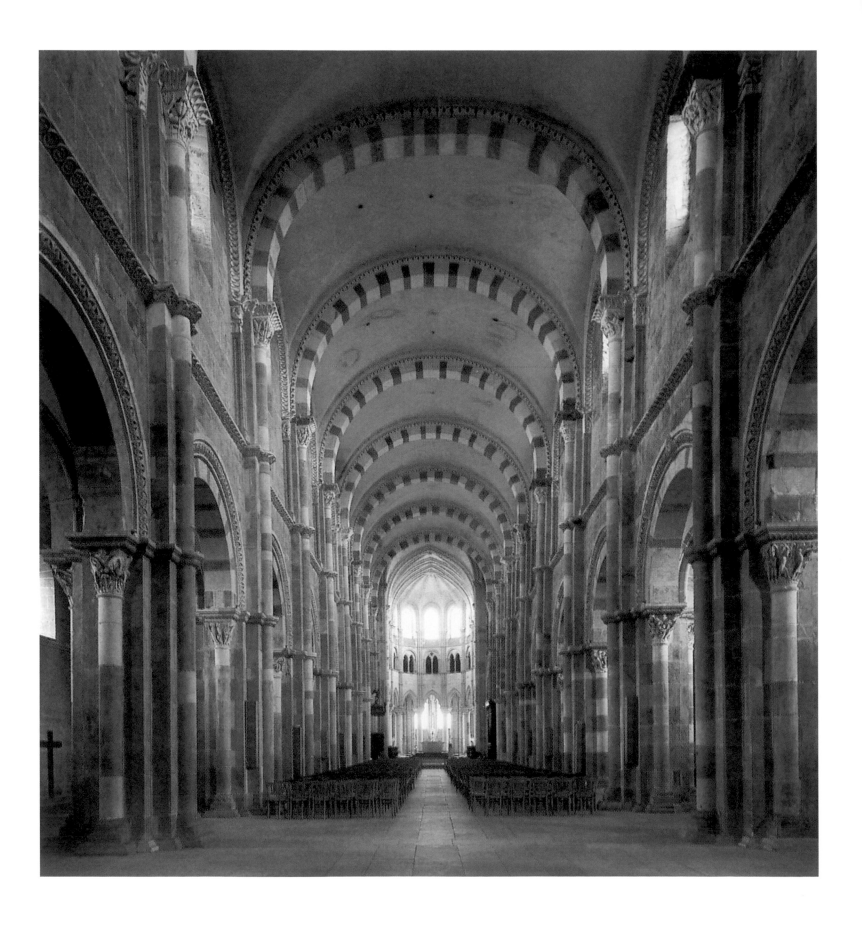

new buildings a foreign look. The façades were adorned with galleries, arcades and other round arch decorations. An excellent example of this is the Leaning Tower of Pisa.

Mosaics, which were adopted from Byzantine art, can often be found as wall decorations. This type of art had reached Italy and Central Europe from the Middle East on the heavily travelled merchant routes along the well-maintained Roman roads, as well as through the Crusades. Many other cultural assets also came from Byzantium, the heir to the Roman Empire, in this manner.

Among the most important buildings is the basilica Sant'Ambrogio in Milan (p.48), which, erected towards the end of the fourth century, had become a model for ecclesiastical architecture, with its magnificent golden altar (p.167). During a reconstruction period in Romanesque style in around 1128, ribbed vaults and a dwarf gallery were built for the first time. Other important incidents of Romanesque architecture of the twelfth century in northern Italy are the churches of San Michele in Pavia and the cathedrals and baptisteries of Parma, Cremona, Piacenza and Modena.

In southern Italy, the architecture of the twelfth century was strongly influenced by Byzantine, Arabic and Norman elements, which can easily be seen in the generous use of mosaics and "braided" pointed arches. The style typical of the region was known as "Siculo-Norman". The most beautiful examples of this style are the cathedrals of Cefalù and Monreale, as well as the Capella Palatina in Palermo (p.55).

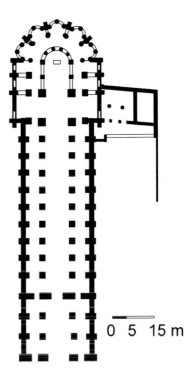

The Cathedrals of Monza, Brescia and Cividale

Of the many Romanesque buildings, the most noteworthy are the cathedral of Monza, in which the crown of Theodelinda, Queen of Lombards, is housed among other art treasures, and the monastic complex Santa Giulia in Brescia with its fragments of ninth-century frescos. Cividale, located in the northeastern Italian province of Friuli, bears further witness to Early Romanesque Lombard art in Italy. Inside the local fourteenth-century cathedral is the Museo Cristiano, in which the Lombard throne as well as the Callixtus baptismal font are located.

Pisa Cathedral

Construction on Pisa Cathedral with the adjacent baptistery and the famous Leaning Tower (p.52-53) was also commenced during the Romanesque period. Despite the long construction time of over 200 years, a coherent image was created by the use of the same material, Carrara marble, and the uniform façade design. The cathedral became a model for later buildings and was considered Christendom's most monumental edifice for centuries. Buscheto di Giovanni Guidice, an architect about whom hardly any information is available, started the construction of the Santa Maria Assunta cathedral (p.54) on the alluvial land outside the old city walls in 1063. The cathedral's cross-shaped floor plan was still unknown in Italy at the time. Above the four-aisled basilica's crossing with the double-aisled transept, an oval dome rises above an octagonal foundation. Lupo di Gante and Puccio di Gadduccio added a dome in Gothic style in 1380.

Nave view towards the east, Basilica of Sainte Marie Madeleine, Vézelay (France), 878-1120/1150, 1190 (chancel and transept).

Horizontal plan, Basilica of Sainte-Marie-Madeleine, Vézelay (France), 878-1120/1150, 1190 (chancel and transept).

Principal portal, Basilica of Sainte-Marie-Madeleine, Vézelay (France), 878-1120/1150, 1190 (chancel and transept).

Gislebertus, Portal from the façade of Saint-Lazare Cathedral, Autun (France), started in 1120.

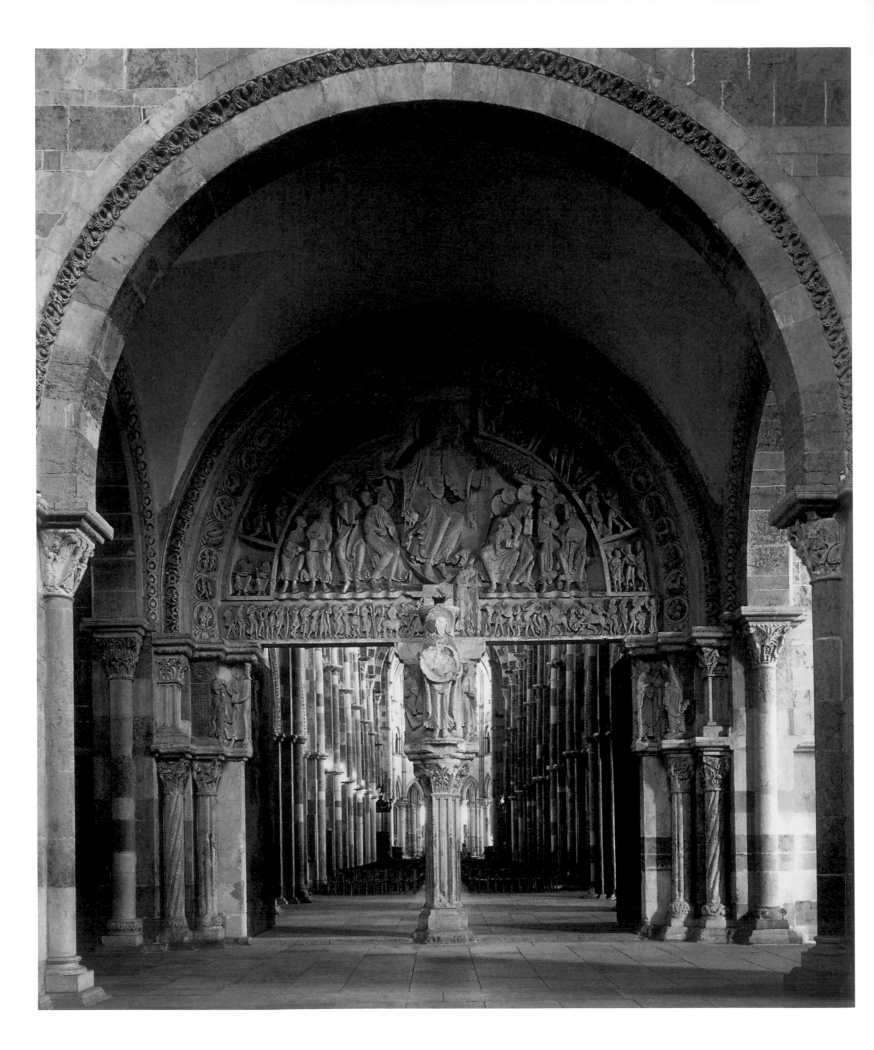

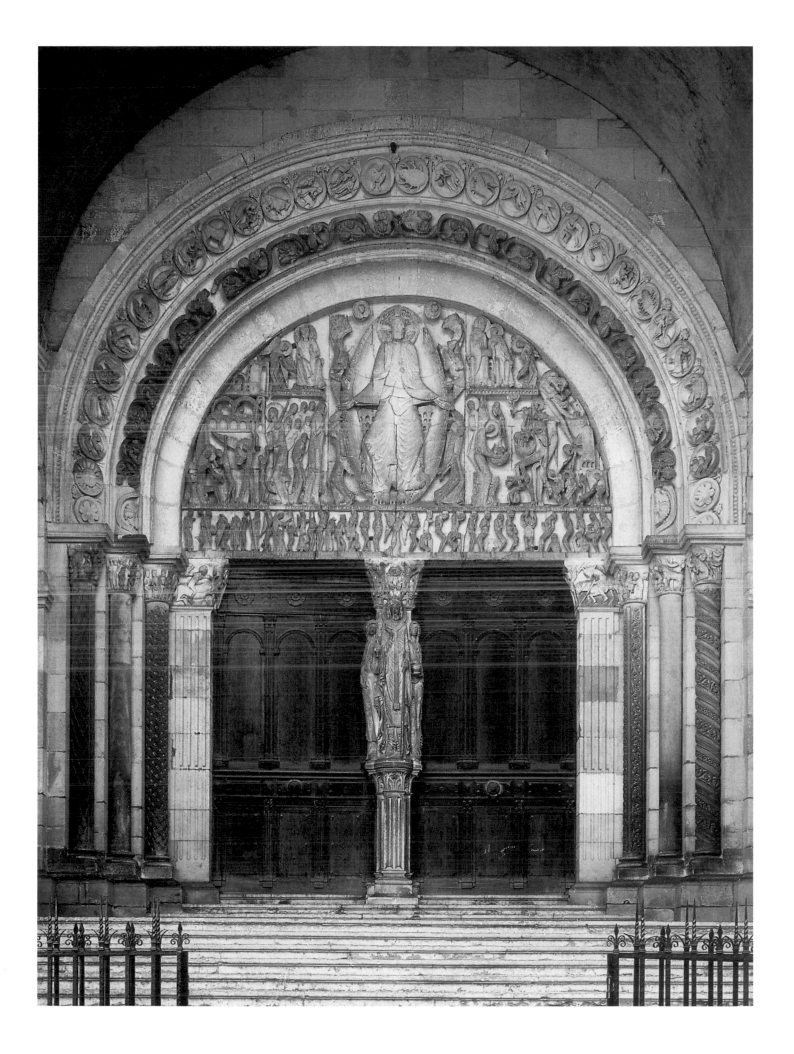

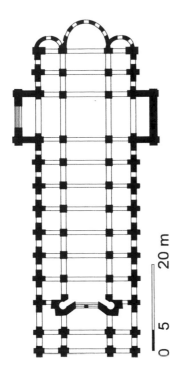

The cathedral's façade was created by Rainaldo at the end of the twelfth century, and his commemorative writing can still be seen above the central gate. On the ground floor with its three gates, four loggias with 52 columns rise above seven blind arcades and offer a view of the colourful marble wall behind. Andrea Pisano's statue *Madonna with Child* is located on the gable of the 35.4 metre wide and 34.1 metre tall façade. The mosaic of *Christ in Glory* completed by Cimabue (Cenni di Pepo) in 1302 in the apse is a first artistic high point. A further climax is the richly decorated chancel, also created by Pisano. It was created between 1302 and 1311 and is considered the most perfect of all comparable chancels. The eight columns represent Christ and the Archangels Michael, Ecclesia and Hercules. The central column symbolises the three Christian virtues; Faith, Love and Hope. The columns bear the round chancel font, which symbolises the New Testament; the reliefs depict scenes from the Bible. The cathedral became an example of Pisan Romanesque style throughout Tuscany.

The Cathedrals in Parma, Modena and Ferrara

Parma Cathedral (p.56), which was begun during the eleventh century, and completed and consecrated in 1106, possesses a series of particularly beautiful stone reliefs and frescos. The ensemble on the Piazza Duomo also includes the baptistery – the baptismal church – built between 1196 and 1307. The crypt houses the particularly beautiful tomb of Bishop Bernard of Parma, about whom we have little information.

A number of further Romanesque ecclesiastical structures are located in Modena and the surrounding province. This includes above all Modena Cathedral (p.51), for which construction was started at the end of the eleventh century, and which was included in UNESCO's list of World Cultural Heritage sites together with the Torre Civica and the Piazza Grande in 1997.

Ferrara Cathedral was commenced in 1132, completion and consecration date back to 1177. The particularly beautiful floor of white and coloured marble was added about fifty years later. The cathedral, with its striking number of sculptures and figurative portrayals, is one of Italy's most beautiful Romanesque cathedrals.

The Cosmati

The limited artistic activity in medieval Rome really only had a decorative purpose, since the desolate "Capital of the World", which had been wrecked by frequent civil wars and the princes' despotic rule, was lacking enterprise spirit. Artistic creations were almost exclusively limited to small decorative work inside the churches; chancels and altars, choir screens, portals, vestibules, tabernacles and so on. This work was still closely linked to Antiquity. With their decorations in colourful marble mosaics, in the design of which the Cosmati artistic dynasty achieved particularly great mastery, they were still able create something special.

Horizontal plan, Saint-Lazare Cathedral, Autun (France), started in 1120.

North wall of the central nave, Saint-Lazare Cathedral, Autun (France), started in 1120.

Nave and collaterals at two levels, Church of Saint-Hilaire-le-Grand, Poitiers (France), 11th century.

Nave, Abbey of Saint-Savin-sur-Gartempe, Saint-Savin-sur-Gartempe (France), 1040-1090.

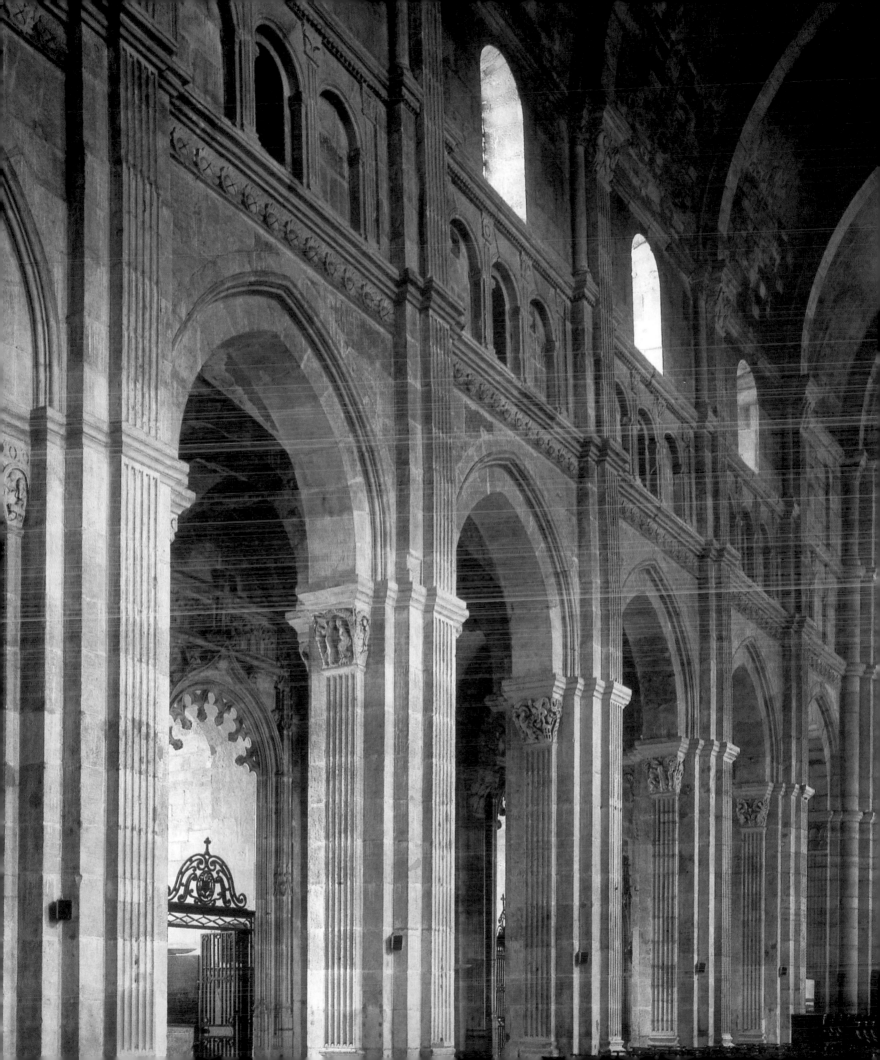

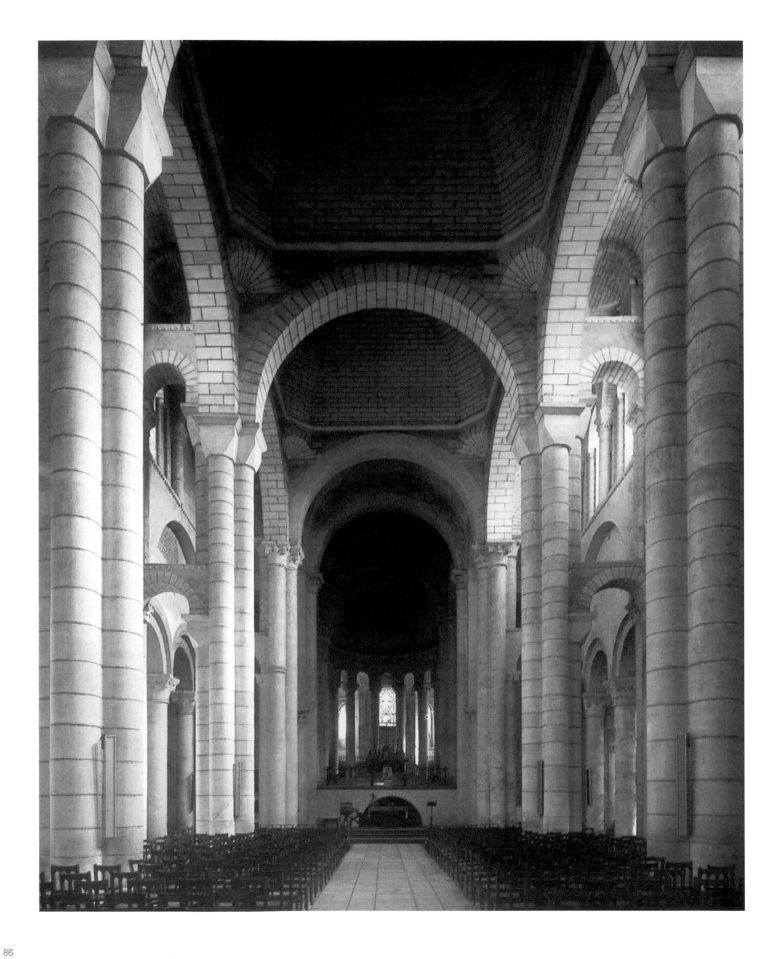

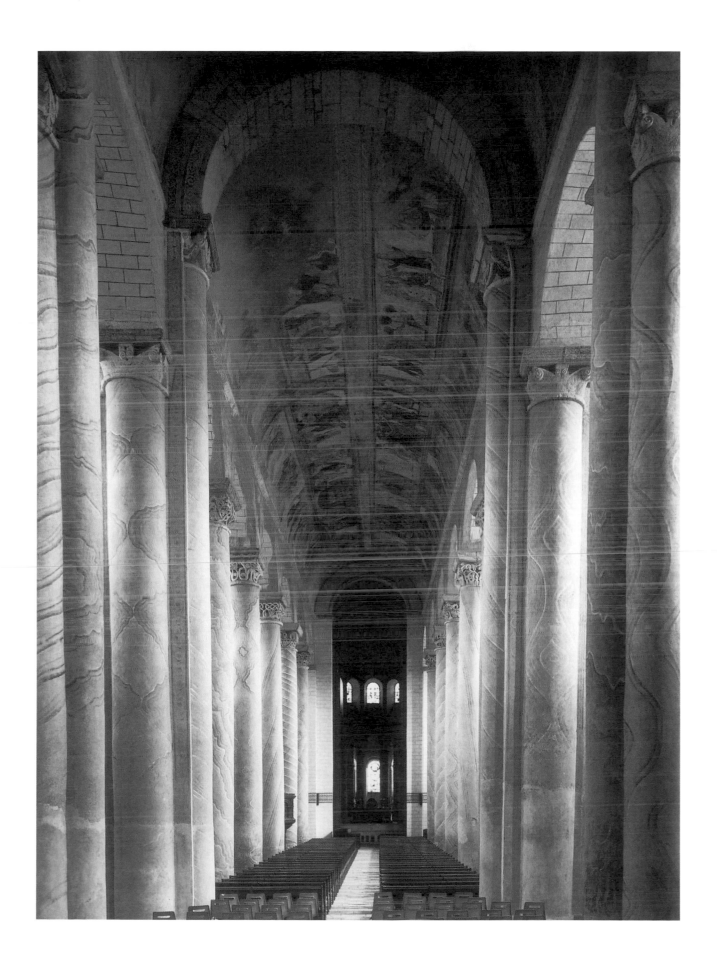

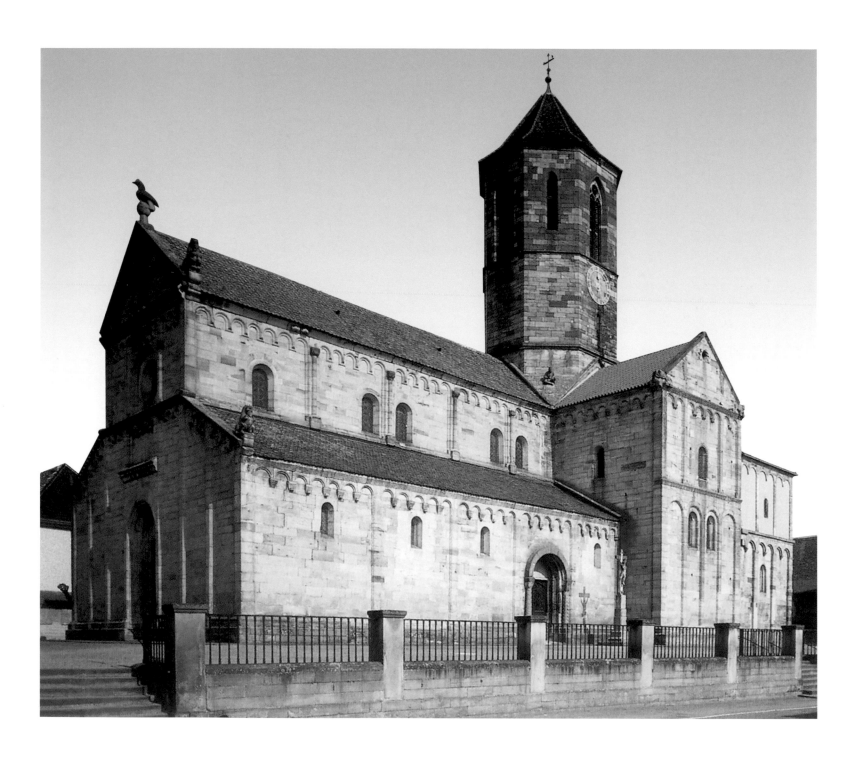

The Cosmati derived their name from the family's patriarch. His name, however, was not only passed on to family members, but also to outsiders who were skilled in the same kind of art. In the end, Cosmati art included some of the larger buildings, monastic courtyards and cloisters. The most famous are those of St John Lateran (San Giovanni di Laterino) and St Paul Outside the Walls (San Paolo fuera le Mura) (p.59), because they show an integration of fantastic art with opulent nature. The Basilica of St John Lateran is a four-aisled basilica from the fourth century. The monumental façade, in particular, dates from that time. The monastery's cloister is considered one of the most beautiful in Rome and was erected between 1215 and 1232. The approximately 36.6 metre long arcades were filled with richly ornamented, partially turned columns. They demonstrate Cosmati ornamentation in its purest form. The initially round but today octagonal Lateran baptistery is probably the oldest in Christendom, and is considered a model for all baptisteries (p.60-61). It was built in around 315 A.D. under Emperor Constantine. Remnants of ancient mosaics, a bronze door and the ancient columns of Egyptian porphyry were able to withstand time.

The artists' inventive genius in forming the capitals and the strangely braided and twisted columns seems inexhaustible; one pair hardly resembles another. But only the material's splendour and the rich vegetation of the ornamental courtyards, which the corridors surround, are unique to Italy. A similar richness of invention can also be found in German cloisters, for example in Magdeburg Cathedral, whose southern wing with its long row of twin columns was created several decades before the Roman cloisters described above. Whether these fantastic shapes may have been imported from the Orient can hardly be determined given the constant turnover of lower priesthood and monastic builders, which was part of the fundamental beliefs of Roman hierarchy

France

In France, too, Romanesque buildings appeared in a great variety of forms, which partly reflected the character of the population in the different landscapes, and was partly also rooted in local tradition. The most important examples of Romanesque architecture can be found in Burgundy, where the type of the barrel-vaulted basilica originated, as well as in Auvergne, Languedoc, Normandy and Aquitaine. This architecture is marked by a great spectrum of vault shapes, and Lombard vaulting techniques were adapted there. The local architects, however, also developed their own vaulting style, in which thrust is diverted into flying buttresses. In southern France, echoes of Ancient architecture were more frequently revived, and their noble simplicity was somewhat enlarged by southern French fantasy. Thus it was here that the pointed Moorish arch, which was probably imported from Sicily, was first introduced, and the church façades were richly decorated.

South-west view, Church of Saint-Pierre-et-Paul, Rosheim (France), 12th century (church), 14th century (tower).

Overall view, Saint-Nectaire Church, Notre-Dame-du-Mont-Cornadore (France), 12th century.

View of the chevet, Saint-Austremoine Abbey, Issoire (France), 937-mid-12th century.

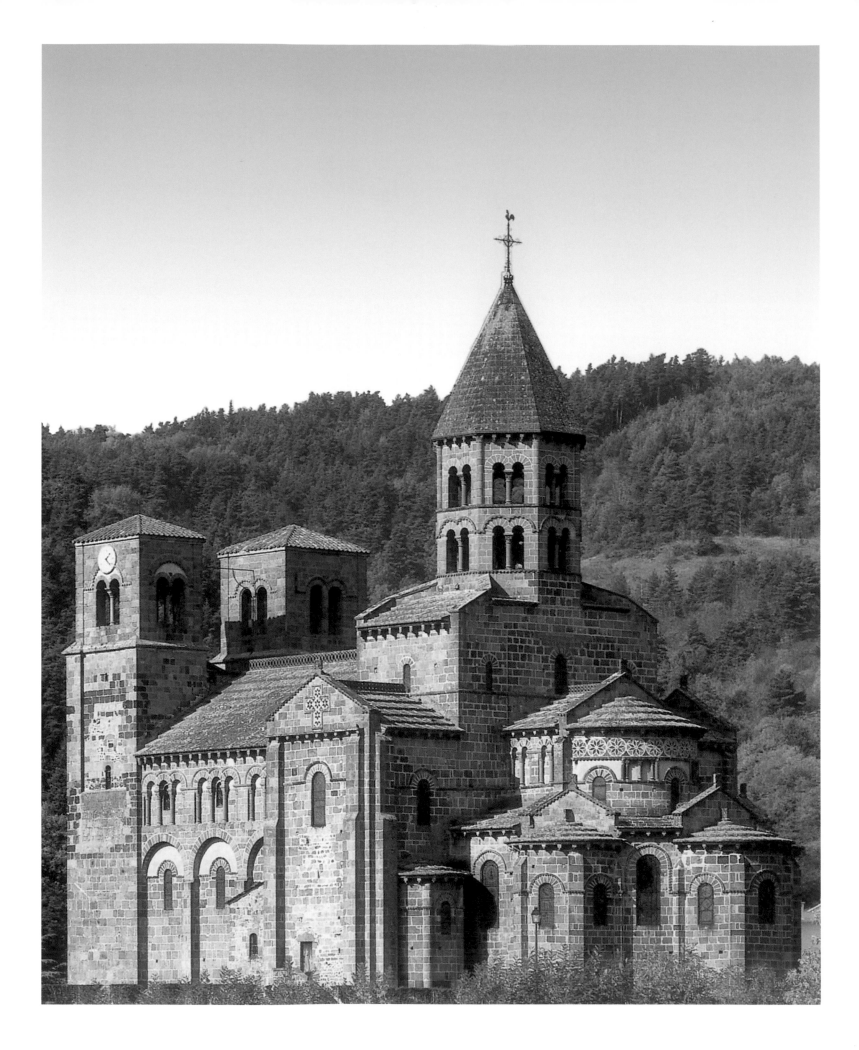

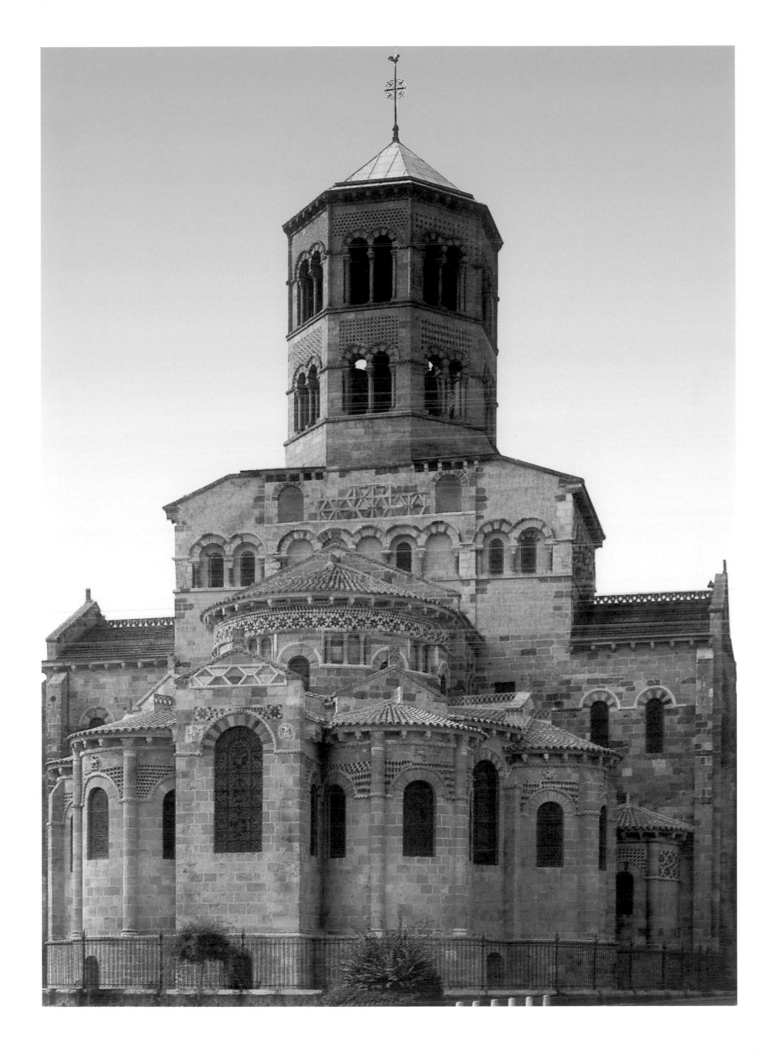

Northern France

In northern France only the Normans, as the Vikings were called there, had their own architecture. Norman churches are relatively close in appearance to the German Romanesque type, with their layout of two towers at the west end and a massive tower above the crossing. However, the ornamentation is different, since it is limited to strict geometric elements, such as diamond, checkerboard and zigzag patterns without figurative or vegetation elements. There is something dry and strict about this ornamentation, which matches the rough and belligerent spirit of the conquering people.

The same character is shared by Norman castles, which were built in the form of three- or multilevel, usually rectangular towers, mainly intent on protection and defense, in which festive and residential rooms were located on top of each other. The castles in Loches and Beaugeny on the Loire river are still well-preserved monuments of this type of castle. The main church in Normandy, Sainte-Trinité in Caen, which was made of the local light sandstone, and the nearby monastery of Saint-Etienne (p.65), in which the Norman style finds its most perfect expression, were founded in 1066 by William the Conqueror. They are considered perfect examples of Romanesque architecture in Normandy.

Notre-Dame Cathedral and the Bayeux Tapestry

Notre-Dame Cathedral in Bayeux, a magnificent example of Romanesque architecture, was destroyed by fire for the first time in 1105, and again after its reconstruction in 1160. The second renovation was then carried out in the Gothic style. The Hundred Years' War forced a halt in the building's progress and what had been built so far was turned into a fortress. Afterwards the cathedral went through a period of continuous change, and it was close to demolition when cracks were discovered in its columns in the nineteenth century. The destruction of the building was heavily advocated by builder Viollet-le-Duc. Eventually, however, the foundation was reinforced so that the most endangered crossing tower could be saved and completed in the Gothic style.

The Bayeux Tapestry (p.188), embroidery on canvas dating, as many state, from the eleventh century, and probably the world's most famous tapestry, was to decorate the Romanesque cathedral. The tapestry was, despite all legends, not made by William the Conqueror's wife, since it is first mentioned during the last quarter of the fifteenth century. The seventy metre long and forty-five centimetre wide canvas was commissioned by Bishop Eudes de Conteville, the brother of William I. It is remarkable that the motif is not of religious nature; instead, it reports in considerable detail the Norman Duke William's 1066 invasion of England.

The Bayeux Tapestry must, however, be regarded as an exception in Romanesque Europe, since the majority of the most beautiful textile art of the period is of Arabic or Byzantine origin.

Western view of the narthex, Fleury Abbey, Saint-Benoît-sur-Loire (France), founded in 640.

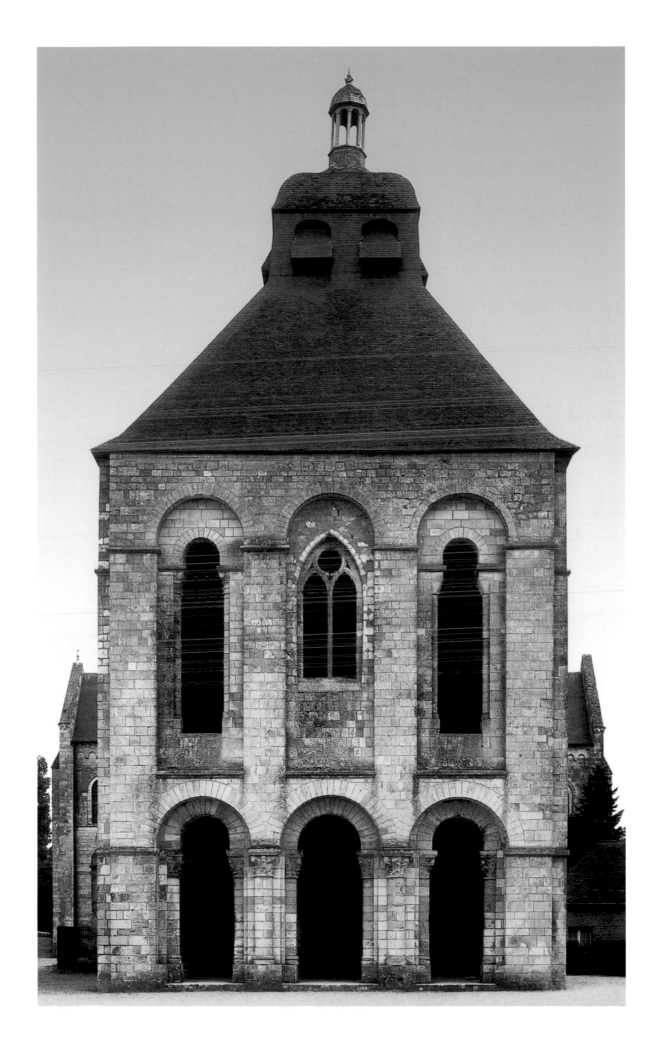

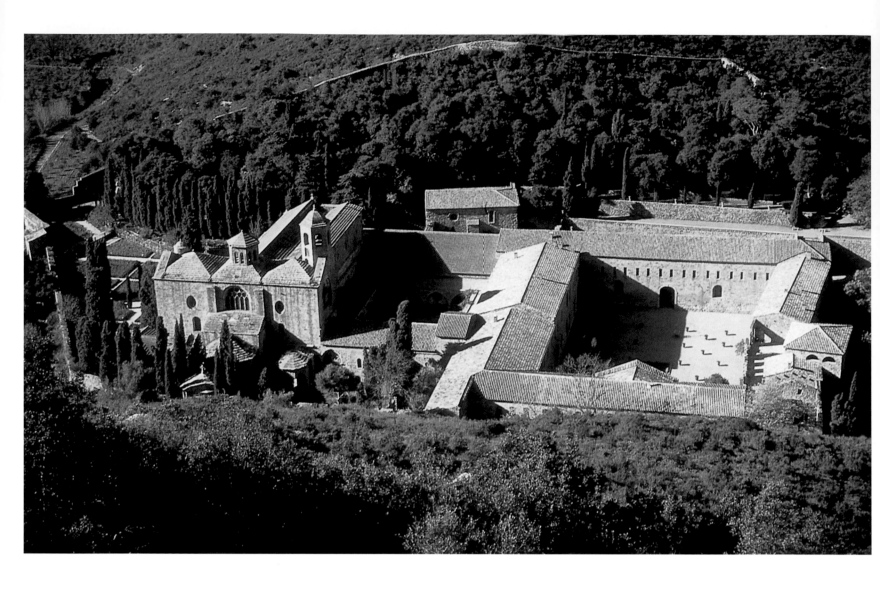

Royaumont Abbey

In the Ile-de-France Département, the abbey of Royaumont, founded in 1228 by Louis IX, or St Louis, is a further example of the Cistercians' strict Romanesque art. Its imposing size at the time indicates a royal designation, and the isolated location within a circle of ponds and waters illustrates the Cistercian order's strict principles. The abbey soon became a leading religious centre in the region, which was famous for the monks' illumination, and was sought after and admired for the occupants' knowledge of medicine and healing. The abbey consisted of a basilica, a monastery with dormitory, refectory and chapter house, the abbot's palace, working quarters and the monastic gardens. Only the cloister, sacristy and refectory remain, however. The façade has seven round arch windows, three on top and four on the bottom – numbers full of meaning in the Christian tradition. The number "three" is a prime number and symbolises the Divine Trinity; the Father, the Son and the Holy Spirit. "Three" also stands for the Spiritual, the All-Encompassing, for Holiness and Perfection. In terms of medieval symbolism, a secular city was often marked by four arcades; the Heavenly Jerusalem, however, always by three.

General view, Abbey of Fontfroide, Narbonne (France), started in 1093.

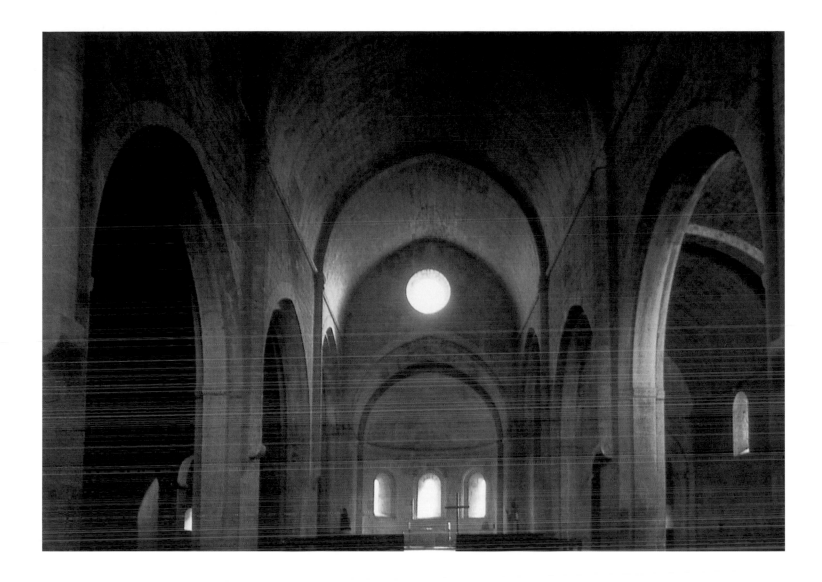

Eastern France: Alsace

Some Alsatian churches demonstrate a relatively large variety of styles of architecture, probably due to foreign influences. This includes, for example, the church in Mauresmünster and the towerless church of Saint-Pierre-et-Saint-Paul in Rosheim (p.88), which is reminiscent of Italian examples. The church of St Fides in Schlettstadt, which dates from the beginning of the thirteenth century, has more in common with Central Rhineland examples, in particular Speyer Cathedral. Even though they are three completely different types, they prove that Romanesque architecture strived for the greatest diversity in its appearance even in the last steps of its development.

Western France

Poitou

The church of Saint-Pierre is visible from afar, as it was for pilgrims when it was built

Eastern nave view, Abbey of Thoronet, Le Thoronet (France), 1160-1190.

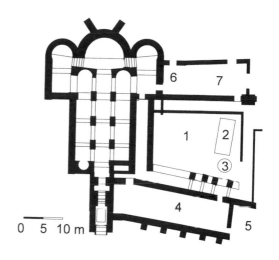

View of the apse, nave, and western
tower, Gellone Abbey, Saint-Guilhem-
le-Désert (France), founded in 804.

Horizontal plan, Gellone Abbey,
Saint-Guilhem-le-Désert (France),
founded in 804.

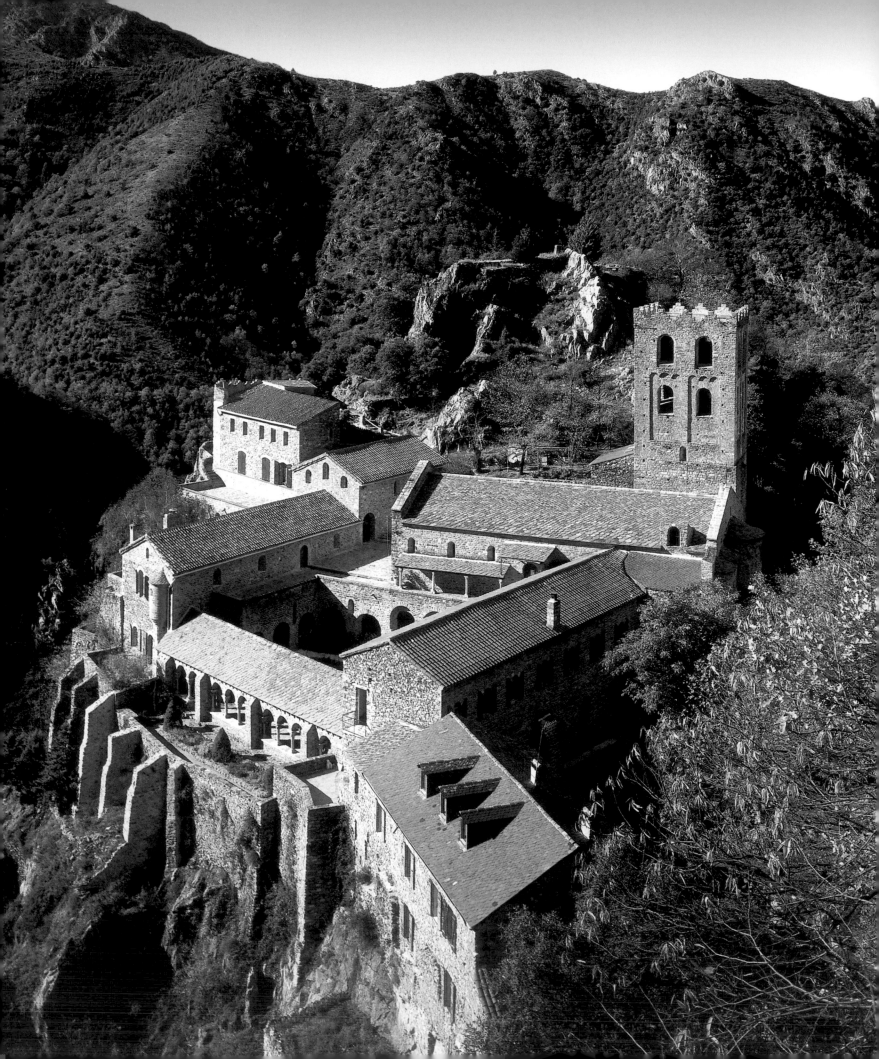

between 1120 and 1170 on a remote plain. Although it is one of the masterpieces of Poitevin and French Romanesque, it is relatively unknown.

The façade is divided into two storeys; the western façade possesses the typical three-portal zone on the ground level. The sculpted decorations, which adorn the windows and portal in several rows, are also typical. The four archivolts of the main portal are richly decorated and tell the story of the Prudent and the Foolish Virgins, with a half-figure of Christ dividing the Prudent from the Foolish. They symbolise the then very popular theme of opposition between Good and Evil. The right tympanum also contains a figure of Jesus surrounded by the Apostles Peter and Paul. The church was built with a protruding choir top and two lateral apses, but without an ambulatory.

The church's artistic highlight is the southern portal with its marvellous decoration comprising over 150 figures. But the church's sculpted decoration also contains secular themes, which stem from Poitou's legends and fairy tales. Thus, one can admire the Fairy Melusine, mythical creatures, half-man, half-beast, demons, monsters and double-headed birds amongst others. The church's capitals are also richly and creatively decorated. The most famous and popular are those showing devils pulling with all four hands on a mask's beard, and those decorated with mythical animals.

Notre-Dame-la-Grande church in Poitiers

The most unique monument of southern French art, the characterful Romanesque church of Notre-Dame-la-Grande in Poitiers (Poitou-Charente) (p.86), distinctly differs both architecturally and in its decorative details from German and Italian churches of the same age. It is considered architecturally particularly important, and is one of the most beautiful Romanesque buildings in western France. The richly formed western façade reflects the entire repertoire of Romanesque art; the church was recognised as a collegiate church in 1090.

Southern France

Such a large number of ancient monuments were preserved in southern France that they exerted a considerable influence on Romanesque architecture there.

Aveyron

A milestone of the southern French Romanesque style, the monastic church of Sainte-Foy (p.68-69), is located on a remote mountain slope in Conques. It owes its name to a young martyr by the name of Fides, (Foy – Faith), who is venerated here. Begun in around 1041 and completed only at the beginning of the twelfth century, the monastic church is in both the Early and High Romanesque styles. The Benedictine monastery possesses one of the

Saint-Martin-du-Canigou Abbey, Canigou (France), 1009-12th century.

oldest and largest barrel vaults of the Romanesque period. The five-fold "relayed" choir with its ring of chapels is a pre-configuration of the later ring of chapels.

The abbey church's highlight is the large tympanum in the entrance portal, which can be dated to before 1130. The leitmotif here, too, is the Last Judgement, which is illustrated in sculpture with more than 117 figures of reddish and yellow sandstone. Christ, in the aureole, sits enthroned in the centre and divides the world into Good (on the left) and Evil (on the right) with his outstretched arm. The Seven Deadly Sins and the Virtues are represented here in sculpture form and used pedagogically. It can be assumed that the figures were also painted. This theme was defining for the culture of Romanesque Europe.

The church's nave is extraordinarily steep and tall with a height of 22 metres and a length of 56 metres. It is a remarkable architectural achievement of its time. The structure at Conques was, as was so often the case with pilgrimage churches, laid out as a gallery basilica. The galleries are open towards the nave, with a double opening each. They were mainly intended to support the nave's vault, but also served as a sleeping area for pilgrims.

The church, however, did not hold up to the destructions of time and the French Revolution. The basilica was to be demolished in 1840, and it is only thanks to Prosper Mérimée, the famous poet, that this highlight of the Romanesque period was saved from destruction and restored.

Gellone Abbey
Saint-Guilhem-le-Désert, near the Pont du Diable – the oldest Romanesque bridge in France (1030) – is a picturesque village situated at the foot of Gellone (p.96-97), nestling between two mountain ranges. The closed Romanesque monastery, an admirable example of the artistic style born in the Languedoc, lasted throughout the Middle Ages, and was an important stage of the southern part of the route to Santiago de Compostela. Gellone Abbey of Saint-Guilhelm-le-Désert was founded in 804 by William (Guilhem) of Orange, the grandson of Charles Martel. It took its name from the relic of the Holy Cross given to St Guilhem by the Emperor Charlemagne on his entrance into Holy Orders. Today, parts of the cloisters can be found in the Cloisters museum in New York.

The churches of Saint-Gilles-du-Gard and Saint-Trophime d'Arles
Among most important and mature Romanesque buildings is the church of Saint-Gilles-du-Gard dating from the twelfth century. Saint-Gilles-du-Gard (p.67), together with Saint-Trophime d'Arles (p.66), possesses one of the most important Romanesque portals in Provence. The three-portal construction is – like that of Saint-Trophime – inspired by the numerous ancient triumphal arches of Provence, and it is located at the front of the church building. Here, too, free columns are placed in front of the wall, between which fourteen statues of angels and apostles are found in the box alcoves. The execution of the fall of their garment folds, however, indicates that various artists worked on the statues, and that they

Façade, Basilica Saint-Sernin, Toulouse (France), 1077-1119.

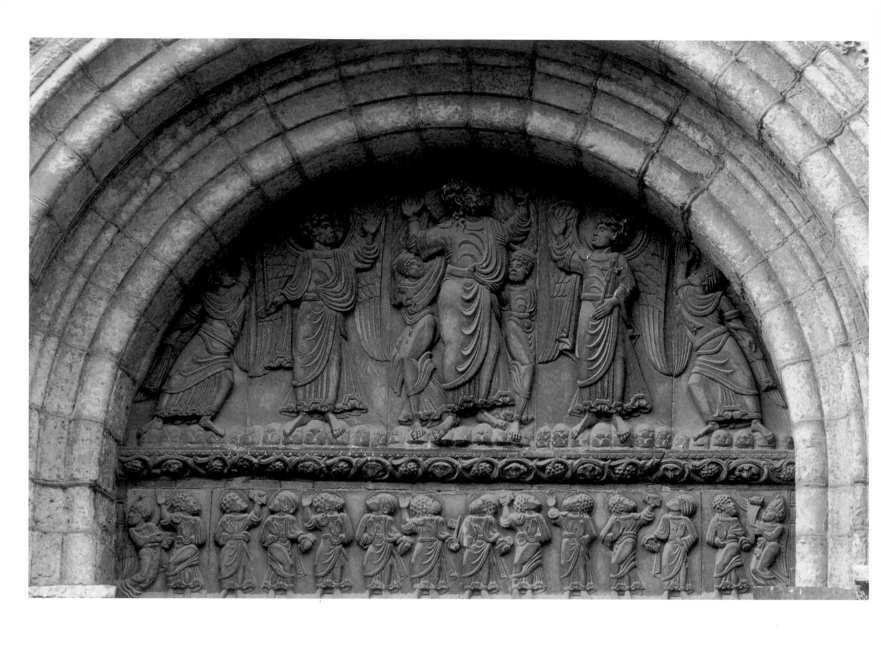

had already distanced themselves from the Romanesque style. The central portal's tympanum shows the *Majestas Domini*, which was renovated during the seventeenth century, surrounded by the rudimentarily preserved symbolic figures of the Evangelists. In the interior of the left-hand portal's arch, the Adoration of the Magi is depicted, in the right-hand one is a heavily destroyed image of the Crucifixion.

On the left lintel there is a depiction of the entrance into Jerusalem, on the central one a scene showing the Last Supper, and on the right Christ's burial. On the same level, further reliefs are located between the portals, so that a frieze according to Ancient models emerged, depicting the life of Christ. Even though the individual scenes are only partially preserved, it can still be seen what is generally true for the art of sculpture in medieval Provence. It is marked by a great joy of narration, which finds a detailed expression in the events of the Passion. Human behaviour is characterised in a particularly clear, vivid, and realistic manner.

Tympanum of the Miégeville door,
Basilica Saint-Sernin, Toulouse (France),
1077-1119.

Central France

Fontevraud Abbey

Europe's largest and most extraordinary monastery is Fontevraud Abbey (p.70-71) near Saumur in Anjou (modern-day Maine-et-Loire), founded in 1101 by the hermit and preacher Robert d'Arbrissel. Its construction, however, was supposedly only begun during the first quarter of the eleventh century. Initially set up as a women's convent, it later became a mixed monastery and consisted of two separate communities, one for nuns, the other for monks. Later, it was extended to make four monasteries, of which Le Grand Moutier was designated for the nuns who dedicated their lives to prayer, and Saint-Benoit as a hospital. The second monastery, La Madeleine, was built for lay sisters, who dedicated their lives to the abbey. In the third building, Saint-Lazare, the nuns nursed lepers, and the fourth, Saint-Jean-de-l'Habit, was the monks' and priests' residence.

The monastery was greatly supported by the Counts of Anjou, who had chosen it as their royal burial site. The nave, erected between 1200 and 1256, houses the tombs of Henry II of England, Eleanor of Aquitaine, Richard I Lionheart, John Lackland and his wife Isabella of Angoulême. These tombs are some of the earliest of their kind, in which the deceased are portrayed lying on a majestic bed on a stone sarcophagus, colourfully painted and royally crowned. Renowned for her legendary education and culture, Eleanor of Aquitaine is shown reading a book (p.149).

The abbey church of Fontevraud consists of a Romanesque choir built by Pope Callixtus II, a nave erected between 1125 and 1160, and a transept with crossing tower, as well as a western façade with two smaller towers. The abbey's Romanesque stonemasonry was restored with great skill, and replaced by new objects in the Romanesque style. Under Emperor Napoleon and up until 1963 the monastery was used as a prison. Four domes, which cannot hide their Byzantine origins, crown the undivided hall of the nave, which until then had usually been erected as a basilica with two side-aisles. Every pilaster in the nave is reinforced with two engaged columns as supports. The capitals, on the other hand, have both their thematic as well as stylistic origins in the art of southwestern France.

The relatively well-preserved Romanesque stone kitchen is remarkable and shows the talent of its builders. The building is an octagon, and even the vault is octagonal. The entire construction, which is based on complex numerological symbolism, is extraordinary. The building's stone roof with its pinecones can be traced back to the Angevin Romanesque style.

Saint-Benoît-sur-Loire

The beautiful Benedictine abbey of Saint-Benoît-sur-Loire (p.93), located in the town of the same name in Loiret, also deserves mention. The relics of St Benedict of Nursia, the founder

of the Benedictine order, who lived as a hermit for some years, are kept here. Thus, the abbey was a place of pilgrimage for those who revered the saint for many centuries.

Cluny Abbey

Founded in 910 A.D. by Count William III of Aquitaine, known as Towhead, as the then largest place of worship in the Christendom, Cluny Abbey (p.72-73-74) became one of the most influential and largest religious centres of the Middle Ages. For over two centuries it ruled more than 1,000 monasteries and more than 20,000 monks. The abbey church, a vaulted basilica with four side-aisles, had two transepts and a choir with ambulatory and a ring of chapels. The vaulting of the nave at Cluny took place at the same time as that of Speyer Cathedral in Germany. On the one hand, the abbey has a classic early medieval monastic foundation, on the other hand, the foundation documents contain something completely new for the time. This was a dual release, which removed the monastery from the realm of the bishop as well as that of the secular prince, and placed it directly under papal control. Due to these privileges and free abbot elections, Cluny became the starting point for a series of monastic reforms, known as Cluniac Reforms after the abbey.

The use of massive pillars and walls as supports, which had to bear the heavy stone vaults, led to a blueprint in which the entire construction consisted of several small, connected elements, the so-called bays. These bays are groin-vaulted rooms that rise above a rectangular or square floor plan.

The abbey was dissolved in 1790, one year after the French Revolution, destroyed, and sold off stone by stone. Today, only a portion of one of the two transepts remains.

Paray-le-Monial

The town of Paray-le-Monial, situated in Burgundy, was established in 973 around a priory that from 999 was under the authority of Cluny Abbey, which was at that time the largest sacred Christian construction. As sober on the inside as on the exterior, the Abbey-Church (p.76-77-78) was built in the purest Cluniac style. Restored to its original form in 1875, the church is now a three-storey basilica with a simple transept of 40.5 metres and a single nave. Besides the 63.5-metre nave there are two west portals and a great lantern tower at the crossing of the transept, which reaches fifty-six metres in height. The choir comprises an ambulatory and chapels radiating outwards. The building was first named Notre-Dame, then the Basilica of the Sacré-Coeur after the church became the second French place of pilgrimage during the second half of the seventeenth century. This was due to the appearance of Christ before Marguerite-Marie Alacoque. The church's decoration is surprisingly sober, and there is an almost total lack of ornamental sculptures. It also has no sculpted tympanum and the pillars are devoid of decoration, with the exception of a few

Overall view of the cloister and detail of two capitals, Saint-Pierre Abbey, Moissac (France), founded during the 7th century.

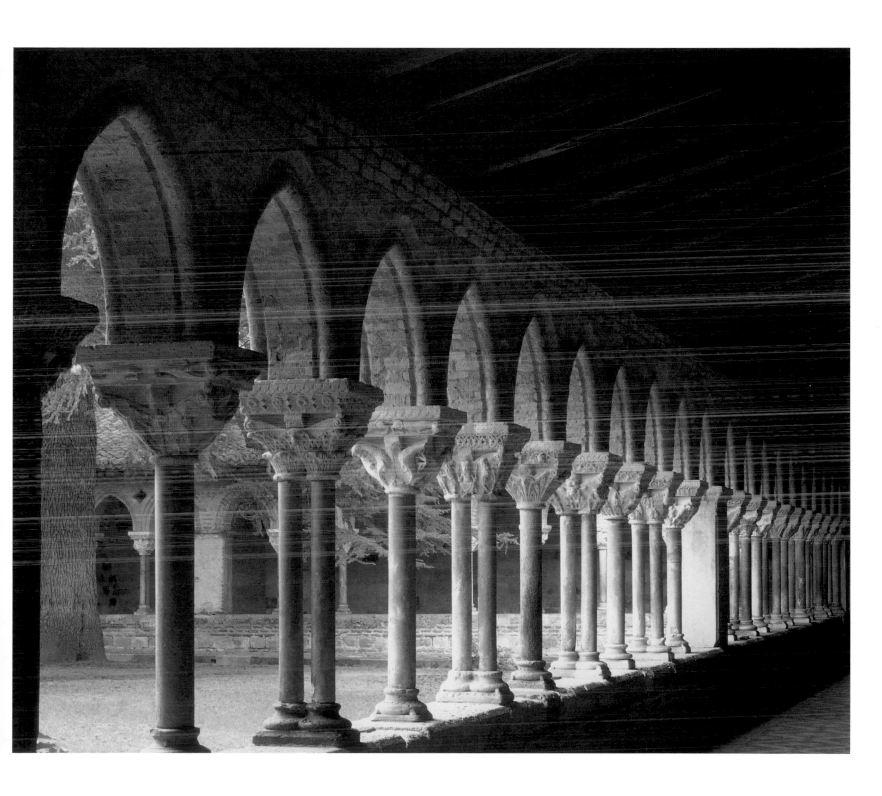

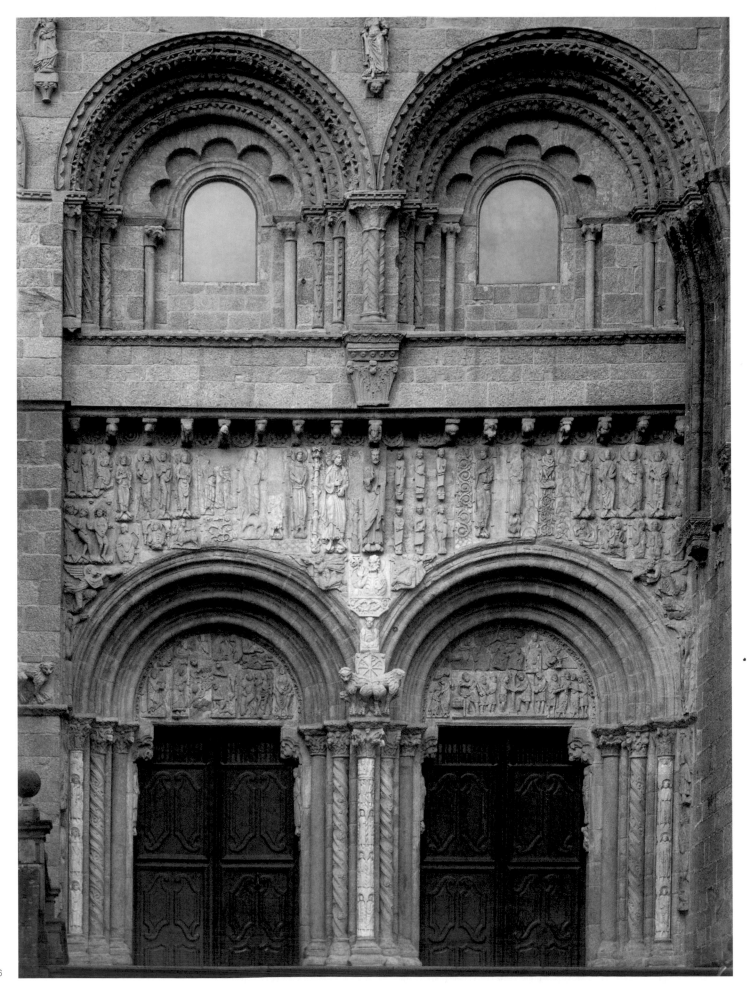

scenic representations. The few windows of varying colours and dimensions allow only a dim light to filter into the building. The church is considered one of the most beautiful examples of Romanesque Cluniac architecture in France.

Basilica Sainte-Marie-Madeleine, Vézelay

The Basilica of Sainte-Marie-Madeleine in Vézelay (p.80-81-82), a famous place of pilgrimage, is a medieval pearl, which was erected in 878 (then rebuilt in 1120 on the location of the predecessive Carolingian building). It is one of the most beautiful edifices from the Romanesque period in Burgundy. Its spacious design and the unique lighting made the basilica world-renowned. It is one of the stations on the pilgrimage to Santiago de Compostela in Spain, because according to legend it houses the tomb of St Mary Magdalene. The basilica's columns are topped by the famous ninety-nine story-telling capitals. The tympanum above the two-winged entrance portal as well as the interior of the arch inside the vestibule is remarkable, too.

Fontenay Abbey

St Bernard of Clairvaux founded the abbey of Fontenay (p.79), which is still intact today, with its simple, clear, strict façade based on the order's ideals. This magnificent example of Romanesque Cistercian art is located in a remote area, approximately thirty-seven miles from Dijon, Burgundy's capital. The abbey consists of a church with marvellous groin vaults, a monastery and the gardens. The rules of the Cistercian order did not permit towers, only bells and roof turrets; ornamentation, figurative capital decoration, or sculpted portals were inadmissible. Colourful window glass was forbidden. The style of the Cistercian monks was radically different from the rest of Romanesque architecture in this respect, in particular from Cluny. Thus they became the precursors of the ascetic version of the Gothic style.

The church building is 66 metres long and 16.75 metres tall. There are no pews and the floor is made of tamped down clay. The abbey was preserved in the manner in which it was conceived in the twelfth century. Its nave, up to the choir, is roofed over with a Burgundian pointed barrel on massive transverse arches. Lighting is provided through the side-aisles and the dense window clusters on the entrance wall, the choir walls and at the end of the transept. The interior decoration is strict and simple too, and the walls consist either of bare stone, or are plastered with the joints painted white. White was the only colour permitted, like the Cistercians' clothing. The almost ascetic building forms of the Cistercians were held in high esteem and soon spread all over Europe. The basilica with its two side-aisles houses the thirteenth century larger-than-life stone statue of the Madonna of Fontenay, and the tomb plates of Burgundian nobility. The dormitory, where the monks slept on bags of straw, was 55.75 metres long and located above the

Door of the Platerías, Cathedral of Santiago de Compostela, Santiago de Compostela (Spain), 1075-1128.

chapter house, whose columns are already indicative of Gothic style. The cloister with its capitals is of particular beauty.

Cathedral of Saint-Lazare in Autun

A further highlight of Burgundy Romanesque is the Cathedral of Saint-Lazare (p.84–85) in Autun with its richly decorated façades and two side-aisles, completed in 1178. The church used to be isolated in the open country and could be seen – especially by pilgrims – from afar. Today, it is on the highest point of the upper town. Even though it is relatively unknown, it is one of the single most important buildings of the French Romanesque.

The west portal (p.83) is of particular artistic value, with its arch interior depicting the Last Judgement by the master of Burgundy Gislebertus, created between 1130 and 1135. The leitmotif for the portal's design is the juxtaposition of Good and Evil. The southern portal shows more than 150 figures and is the richest in the entire region. The master also directed the work on the cathedral. The powerful monastery in Cluny served as the example for the nave, though the cathedral lost its Romanesque exterior when restored by Eugène Viollet-le-Duc. Only the church's interior, including the three-fold wall structure adopted from Cluny, the arcades with pointed arches between the cross-shaped arcade, the groined vault of the side-aisles, and the nave's vault with its pointed barrel are entirely Romanesque.

Pontigny

The Cistercian abbey church founded in 1114 is located in the magical landscape of Burgundy, not far from Auxerre. At 108 metres in length and 25 metres in width, it is certainly the largest preserved Cistercian abbey church. A total of forty-three daughter monasteries depended on Pontigny, among them Saint-Sulpice and Quincy. Based on the Cistercians' puritan way of life, the churches are painted completely white on the inside, like the monks' clothing. Apart from a wooden choir screen and the choir stalls, the interior bears hardly any decoration. Due to its buttresses, which did not yet exist in the Romanesque period, the choir is at least partially Gothic.

The two-level wall elevation is also very simple, as was almost everything built by the Cistercians. To support the nave there are, typical in Cistercian design, no pillars, simply rectangular attachments with engaged columns. The nave has a ribbed vault, while the side-aisles feature groin vaults. The church's quiet simplicity instils a reverent mood in the faithful.

Horizontal plan, Cathedral of Santiago de Compostela, Santiago de Compostela (Spain), 1075-1128.

Nave view across the transept, Cathedral of Santiago de Compostela, Santiago de Compostela (Spain), 1075-1128.

The Church of Saint-Andoche in Saulieu

Named after the martyr Andochius, the church of Saint-Andoche houses the saint's relics. The church, located in Saulieu in Burgundy, was rebuilt according to Romanesque principles

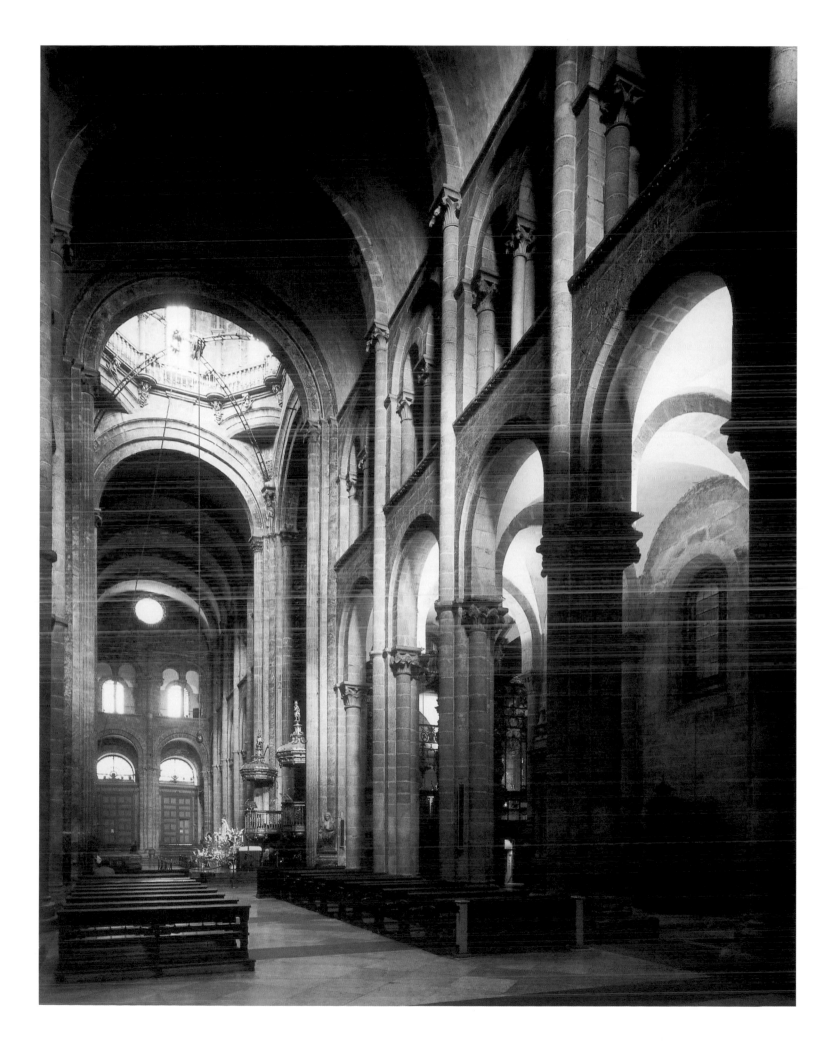

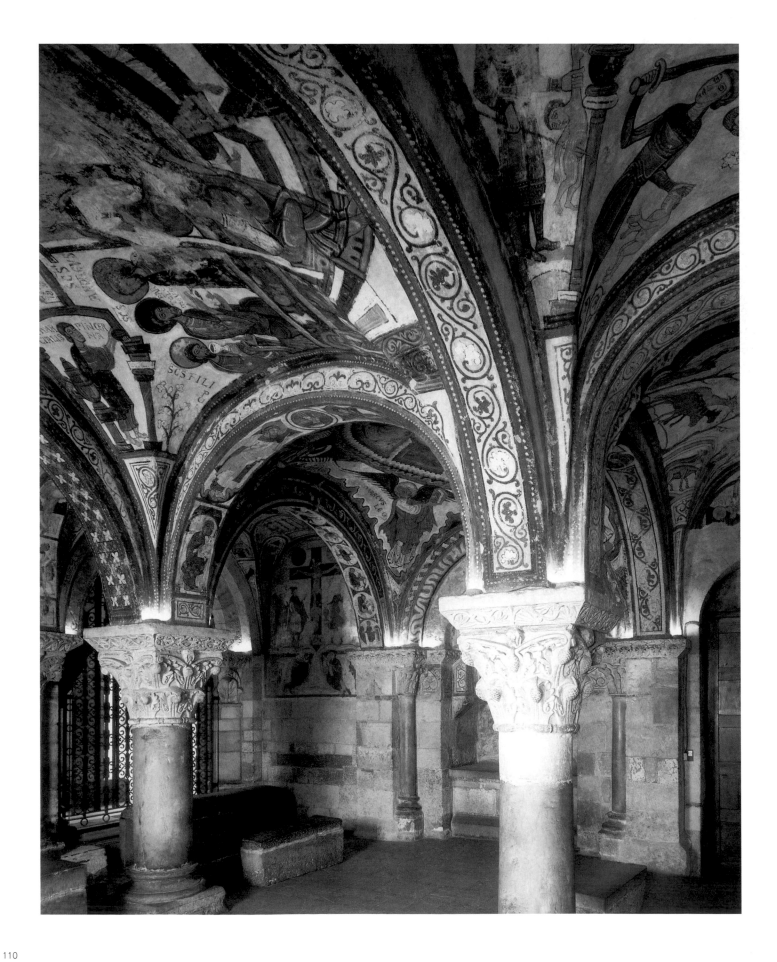

in 1125 on the site of a place of worship that had existed since Early Christian times. It is assumed that a student of the great Gislebertus carried out the stonemasonry work. The church's fifty capitals are decorated with plants, which in the Romanesque period were considered a symbol of order in creation. From the capitals' unusual layout, it can be inferred that the sculptural decoration was not meant for the enjoyment of the faithful, but was directed toward the monks. The decoration's leitmotif is here, too, the separation of Good and Evil.

Auvergne

The development of Romanesque art is the greatest aesthetic achievement of the Massif Central region. The ambulatory choir was invented there, an important new element of Romanesque architecture. The preserved archaic, simple building forms match the inhabitants' conservative taste.

While Saint-Saturnin church does not have a choir chapel, Saint-Nectaire (p.90) has two, and the churches of Notre-Dame in Orcival with its magnificent *Madonna and Child*, (p.147),

Panteón de los Reyes, Basilica of San Isidoro, León (Spain), 1063-14th century.

Tympanum of Puerta del Cordero, Basilica of San Isidoro, León (Spain), 1063-14th century.

and Notre-Dame-du-Port in Clermont have four choir chapels each. The church of Saint-Austremoine (p.91) from the middle of the twelfth century, the largest structure of Auvergne Romanesque style, has five choir chapels. All the above churches possess a transept with apses in the East; the western towers are supported by massive bays. The nave's barrel vaults are often carried by pillars. The side-aisles are reinforced with engaged columns, which frequently bear decorative capitals. The exterior walls often have encrustations of multicoloured basalt. The original frescos stand the test of time.

The interior of the largely Romanesque basilica of Saint-Julien, located in Brioude not far from Clermont-Ferrand, is marked by the red-and-white striped columns of Moorish inspiration.

Southwest France

Abbey Saint-Pierre in Moissac

The oldest and only preserved Romanesque cloister (p.105) is located in Moissac, on the banks of the Tarn River, and is a unique monument of Romanesque art in France. The monastery was founded in the seventh century and joined the Cluniac Reforms between 1048 and 1135. The Romanesque cloister, consecrated in 1100, and the church portal demonstrate the abbey's nationwide influence. In order to receive the ever-growing stream of pilgrims, Moissac II was built at the end of the twelfth century, but was burned down by an enraged army of Crusaders at the beginning of the thirteenth century. The cloister was rebuilt at the end of the same century, the abbey only in the fifteenth century. The only remaining portal of the former abbey church is the most magnificent in southwest France. Together with the cloister, some of the main works of European Romanesque sculpture can be found here.

Moissac I had two side-aisles, but no transept. The width of the first abbey corresponded to that of the rebuilt abbey of Moissac, which had been shortened by a third. Architecturally, Moissac is completely independent from Cluny. The pointing of the barrel vault is absent; Moissac II was a single nave hall of 14 metres in width, with two massive domes crowning the pendentives, which could harbour larger masses of people. The Gothic Moissac III abbey, which remains today, was consecrated in 1455.

Saint-Sernin of Toulouse

The pink-bricked basilica of Saint-Sernin or Saint-Saturnin (around 1077-1119) of Toulouse (p.101-102) is one of the best examples of Romanesque art in France. The original pilgrimage church was erected on the tomb of the hallowed Saturnin, Bishop of Toulouse, who was martyred in 250 A.D. The imperial basilica with five naves was an identical copy of that of Santiago de Compostela, and can be found on the pilgrimage route originating in Arles. Construction began in the eleventh century and continued

Nave, Cathedral of Salamanca, Salamanca (Spain), started in 1140.

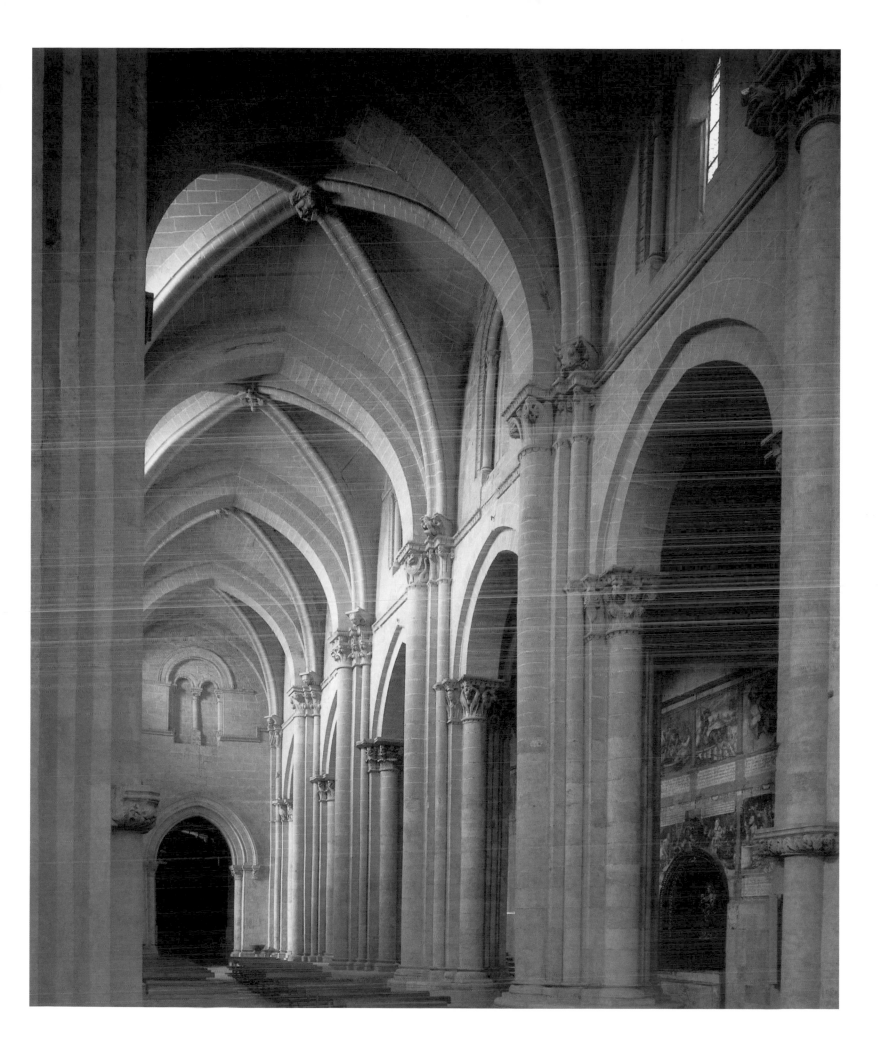

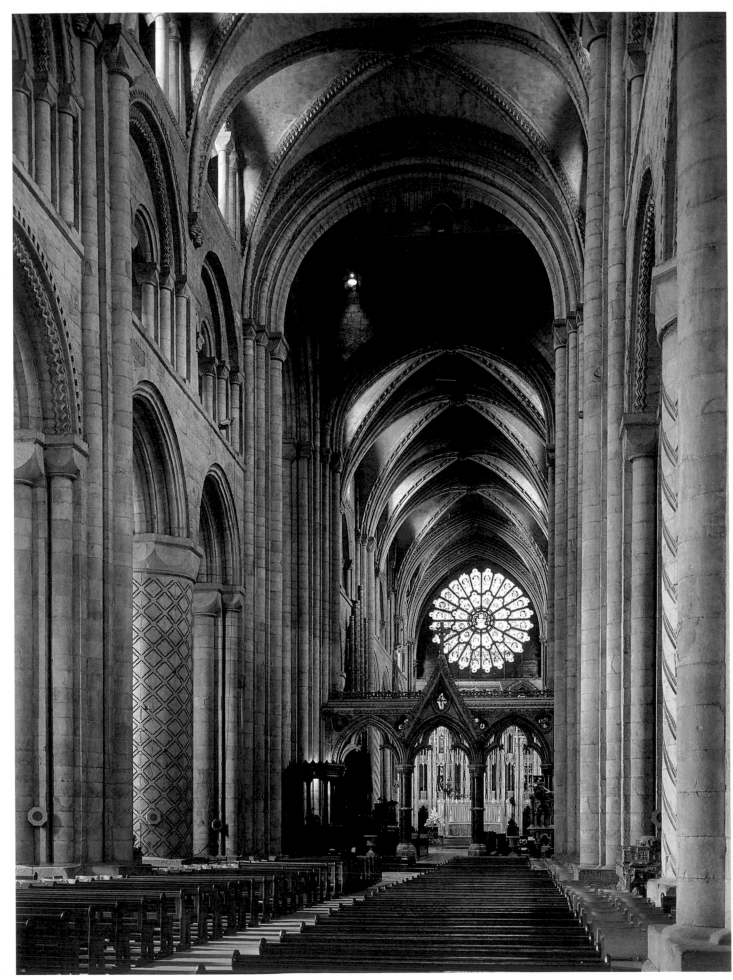

through the twelfth and thirteenth centuries, with the section from the pillared portal up to the southern point of the transept, the Miègeville door, dating from 1118. A complete renovation was undertaken by Viollet-le-Duc in 1860. The church measures 115 metres in length by thirty-two metres in width (a transept of sixty-four metres), with a height of twenty-one metres in the main nave. The tower reaches sixty-five metres in height and comprises five levels of arcades. The choir consists of an ambulatory and five radiating chapels; the axial chapel is elongated. More than 250 sculpted works decorate the interior, amongst which those of the high altar of Bernardus Gelduinus are particularly interesting. The *Majestas Domini* sculptures are artistically remarkable; two apostles and four angels, which are considered the first of this magnitude in Romanesque art. A choice piece of Romanesque sculpture is the *Ascension of Christ*, accompanied by four angels, which adorns the tympanum of the basilica. Since 1998, Saint-Sernin has been included in UNESCO's World Cultural Heritage.

Spain

Mozarabic Art, also known as the "Art of the Christians", denotes the creative work of those Christians who after the Moors' victory over the Visigoths in 711 A.D. were under Moorish rule. Typical of this epoch in architecture is the horseshoe arch of Visigoth origin, while the building forms of ribbed domes and arched consoles decorated with rosettes were introduced by the Moors. Aside from architecture, other forms of art such as gold work, ivory carving and the illumination of manuscripts richly adorned with Arabic elements and miniatures, were practised with masterly skill.

Mozarabic Art, however, did not reach Catalonia, since the Christian kingdoms of northern Spain were more under the influence of the French and Italians. The strong influence of the southern French Romanesque style was partly due to the participation of numerous French knights in the wars against the Moors. Several churches of the ninth century are preserved from the Pre-Romanesque time of King Alfonso II. Other churches, such as San Tirso and San Julian in Oviedo, or Santa Maria and San Miguel in Naranco dating from 800 to 850 A.D., show Early Christian and Byzantine influences. Only in the eleventh century did the influence of southern French building forms become noticeable, in particular in the construction of churches located on the pilgrimage route to Santiago de Compostela. By means of the organised pilgrimage movement to Santiago de Compostela, an excellent means of cultural transportation, ideas travelled from Spain to France and vice versa. The Romanesque style in Spain developed in very close connection with the pilgrimage route. A veritable building boom erupted there, of which the Cathedral of Santiago de Compostela is without question the most magnificent specimen, even though it is in reality a uniquely Catalan creation.

Nave, Durham Cathedral, Durham (England), 1093-1133.

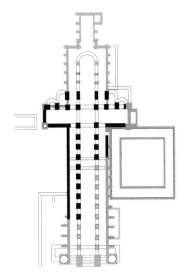

The Cathedral of Santiago de Compostela

The Cathedral of Santiago de Compostela (p.106-108-109), constructed between 1075 and 1128, is the most beautiful example of Romanesque architecture in Spain. It is located on the site of an older, smaller church from the eighth century, and is part of UNESCO's World Cultural Heritage. The cathedral was from the beginning one of the most important destinations for numerous pilgrims of the Occident, so the nave and side-aisles soon had to be lengthened and widened. The cathedral's height permitted the installation of a second storey, with side-aisles in which numerous pilgrims found room when the nave itself was fully occupied. This cathedral, as the most important place on the St James pilgrimage, since according to legend the relics of the Apostle James the Greater were found here in the ninth century in an ancient mausoleum, had decisive influence over the architecture all along the pilgrimage route. The *Botafumeiro*, a 30.5 metre long rope hanging from the ceiling, is notable. This *Botafumeiro* is a censer, whose smell is probably intended to mask the massive transpirations of the assembled crowds.

Sculpture is a stylistic and thematic connection between the various churches. The desire for redemption and reconciliation becomes a particularly prominent theme in such works as the *Portico de la Gloria* on the western portal, a masterpiece from 1188.

Further examples of Romanesque architecture in Spain are the Collegiate Church of San Isidoro in León (p.110-111) from the eleventh century, and the Old Cathedral in Salamanca (p.113), whose construction was commenced in the twelfth century in around 1140.

United Kingdom

In English Art History, this epoch of architecture strongly influenced by the Normans is not called the Romanesque, but the Norman Style. Its origins date back to 1066, the same year that the Normans led by William the Conqueror moved north across the sea and subjugated England. What they found there in ecclesiastical architecture were mainly wooden buildings, and some simple stone structures, whose forms were taken from wood construction. The Normans thus found a clean slate for their clearly more highly developed art, and cemented their rule during the relatively short time period from 1020 until 1200 with the erection of numerous abbey churches, cathedrals, and great monumental ecclesiastical edifices. Only the later structures, however, mostly from the first half of the twelfth century, survived relatively unchanged. These are in particular the cathedrals of Durham, Norwich (begun in 1096), Peterborough (begun around 1118), and Rochester (middle of the twelfth century). The basilicas of Oxford (begun around 1180), Canterbury (begun around 1070), St Albans, Gloucester (begun around 1096), and Ely (begun around 1083) are representative of the most important buildings of the English Romanesque.

The open roof trusses are characteristic of the English cathedrals, though they were later often replaced by vaults, as for example in Durham. The stylistic features of the Norman style include the extremely long nave, the west end flanked by two towers, the straight, closed-off

Horizontal plan, Cathedral and Abbey Church of St Alban, St Albans (England), 793 (monastery), 1077-1115 (church).

Exterior view with tower crossing the transept, Cathedral and Abbey Church of St Alban, St Albans (England), 793 (monastery), 1077-1115 (church).

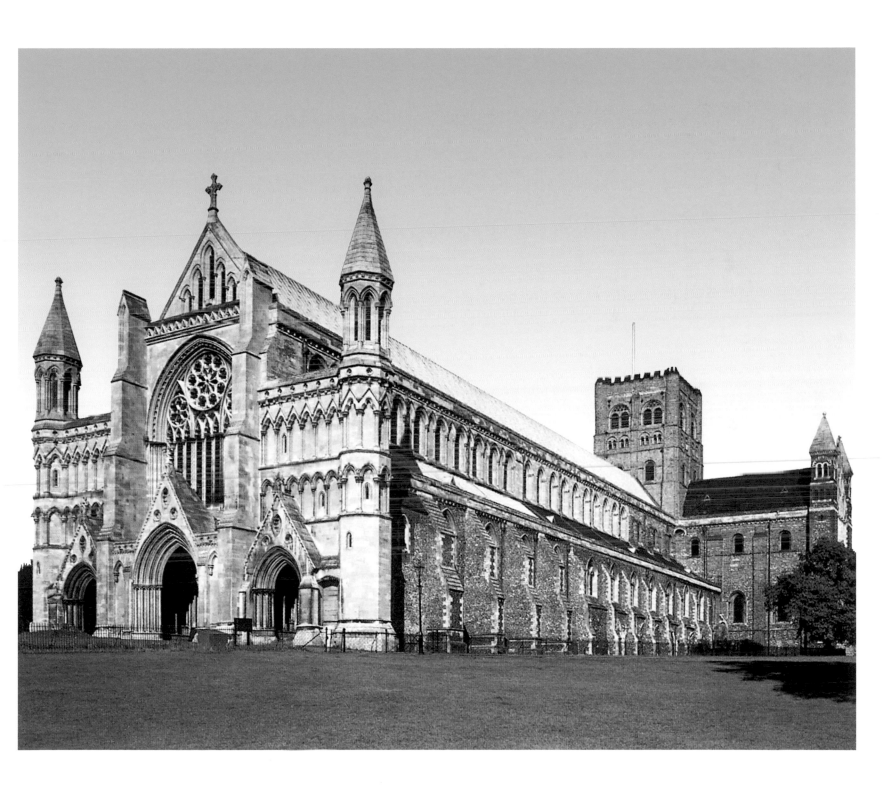

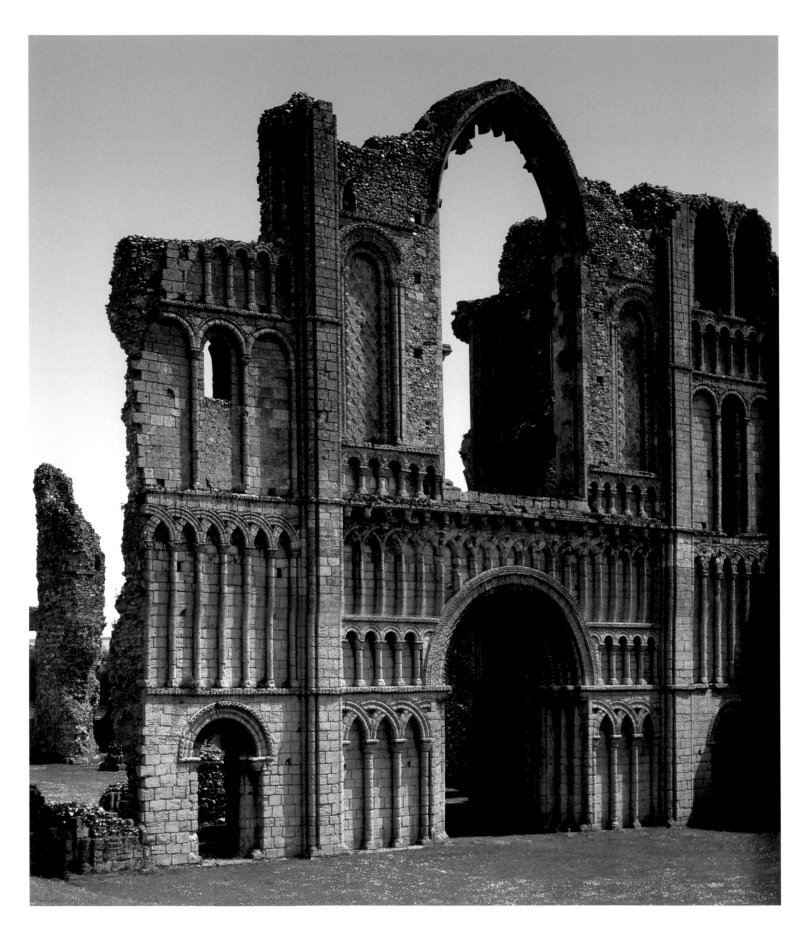

choir, and the massive tower above the crossing. The side-aisles have groin vaults. The main portals are adorned by geometric forms, mostly zigzag or beak friezes.

Of the Norman style's secular architecture, the large residential towers erected after the model of French Donjons are preserved until this day. The most important examples of this art is the oldest part of the Towers of London (the White Tower), whose construction began in 1078, as well as the castles in Norwich, Newcastle and Rochester.

Durham Cathedral

Durham Cathedral (p.114) (construction around 1093 to 1133) in North East England can be considered one of the most important buildings of Anglo-Norman ecclesiastical architecture. It served the dual purpose of defense against the rebellious Scots and religious purposes. Here are housed the relics of St Cuthbert, one of the most revered saints of the region, a shepherd who later became a monk and bishop, which had been saved from the Vikings by the monks. Only on the inside of the otherwise strict, fortress-like cathedral can one find geometric ornaments on the cylindrical pillars. In the choir of this cathedral, which impresses with its size, the first ribbed vault was installed, which later became of greatest importance for the Gothic style.

West façade, former clunisian prior, Castle Acre, Norfolk (England), started in 1066.

Exterior view of the remaining walls of the monastery and conventual church, Rievaulx Abbey, Rievaulx (England), founded in 1132.

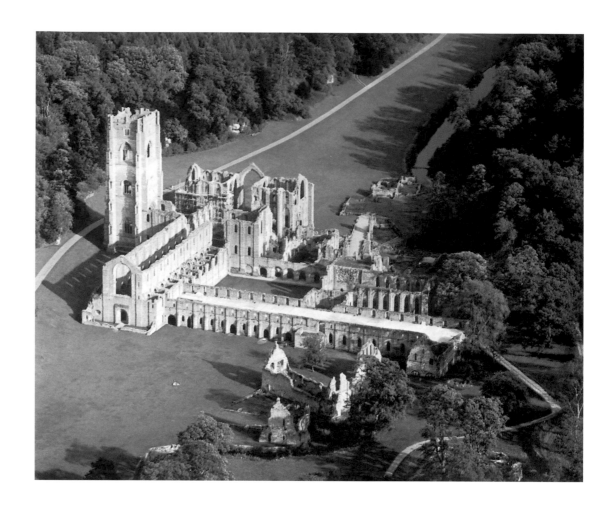

St Albans Cathedral

A further example of Anglo-Norman architecture is the abbey of St Albans (p.116-117), located some 35 kilometres north of London and commenced around 1080. It is one of the largest and most important abbeys in England, in which a draft of the *Magna Carta*, an agreement between John Lackland and the nobility, was written. The abbey bears the name of the Roman soldier Alban, who was executed around 324 A.D., the first Christian martyr in England. Founded in 793 A.D., the abbey was erected after the Norman victory according to French examples. With the exception of the nave's north wall, little remains of the original abbey of the time. It suffices, however, to provide an image of the grandeur and power of its architecture.

Aerial view, Fountains Abbey,
Ripon (England), founded in 1132.

Interior view of the ruined Cistercian
monastery, Fountains Abbey,
Ripon (England), founded in 1132.

Clonfert Cathedral

In Ireland, the small cathedral of Clonfert, near the River Shannon and Clonmacnoise, is the highlight of the Late Romanesque style. Clonfert was probably founded by the monk St Brendan in 560 A.D. This cathedral's marvellous western portal, with five richly ornamented engaged columns, which stretch over six arches, makes the cathedral a gem of

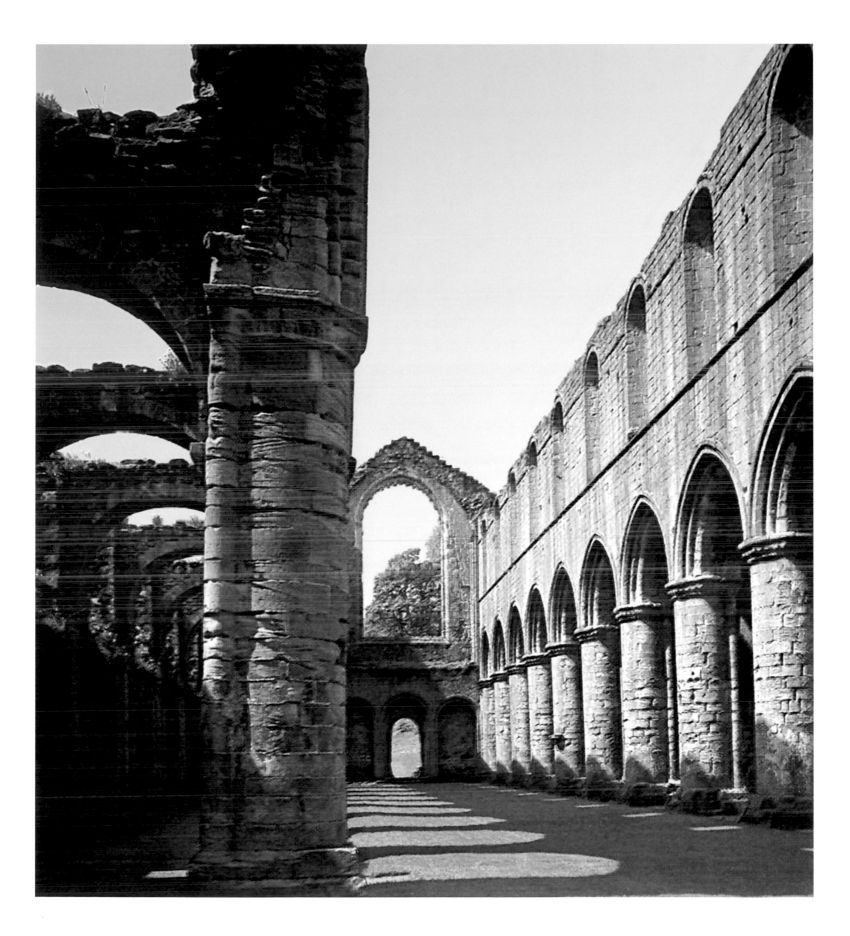

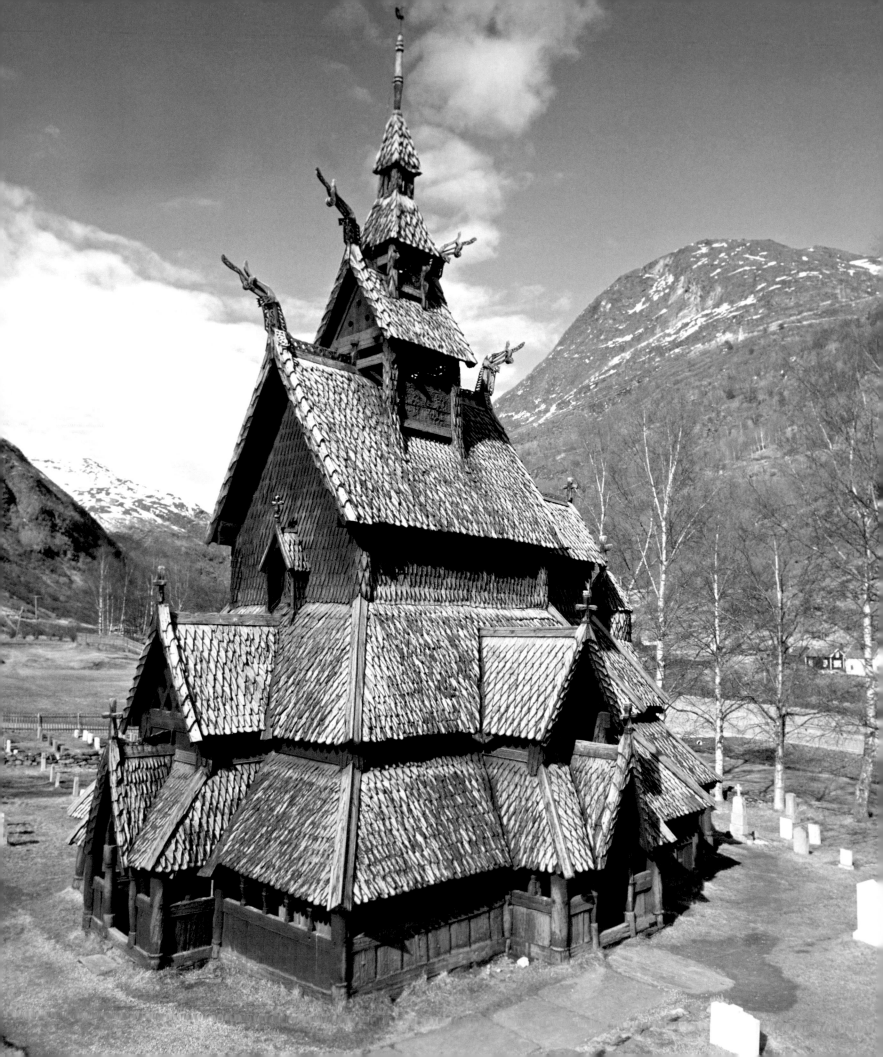

the Irish Romanesque. Burned down several times, but always rebuilt, most of the artefacts, such as the decorated arches of the side-aisles and the richly ornamented chancel arches, date from the fifteenth century.

Scandinavia

In the Nordic countries, ecclesiastical architecture is very often under German influence. Only the single-nave or double-aisle wooden and stave churches (also: post churches) in Sweden and Norway take a special position, of which eighty still remain only in Norway. One of the best known Scandinavian stave churches is the remote church of Borgund (Norway) (p.122), which was erected circa 1180.

Independent of foreign models, stave churches are constructed solely from the requirements of the materials and in prudent consideration of climatic conditions. A square or rectangular nave is surrounded by aisles separated by wooden columns. The columns support the roof, made rigid by beams and rafters. A small corridor was created between the nave and the shingle-covered exterior walls, in which the faithful could put down their weapons. An apse is adjoined to the rectangular choir. The entire building is generally surrounded by a low ambulatory open to the top. Every building part has its own, separate roof, so that, in a very decorative, but also incredibly practical manner for the distribution of the massive amounts of snow, one roof rises above the other, until the roof of the nave is crowned with a special ridge turret. The stave churches in Gol, Borgund, and Hitterdal are the richest of its kind.

Poland

The year 1039, which saw the return of the Polish King Casimir I from Hungarian exile, who had installed Krakow as Poland's capital, since the rest of Poland had been too heavily devastated by war and insurrections, is considered the beginning of the Polish Romanesque.

Little escaped the destructive mania of the Golden Horde, a Tartar Turco-Mongolian people, descendents of Genghis Khan, when they invaded Poland in the so-called Great Mongolian Invasion – they had besieged Krakow and modern-day Wroclaw in 1241 and had even progressed as far as Brandenburg – in the thirteenth century. Thus, only few examples of the then blossoming Romanesque art can be found in Poland.

The Romanesque church in the small village of Czerwinsk on the Vistula River is worth a visit. The basilica with two side-aisles and two tall towers retains its original twelfth-century Romanesque traits, even though it was renovated later in the Gothic, Renaissance and Baroque styles. The marvellous Romanesque portal dates from 1150; the Crucifixion Chapel is decorated by valuable Romanesque frescos.

Urnes Stave Church, Borgund (Norway), c. 1180.

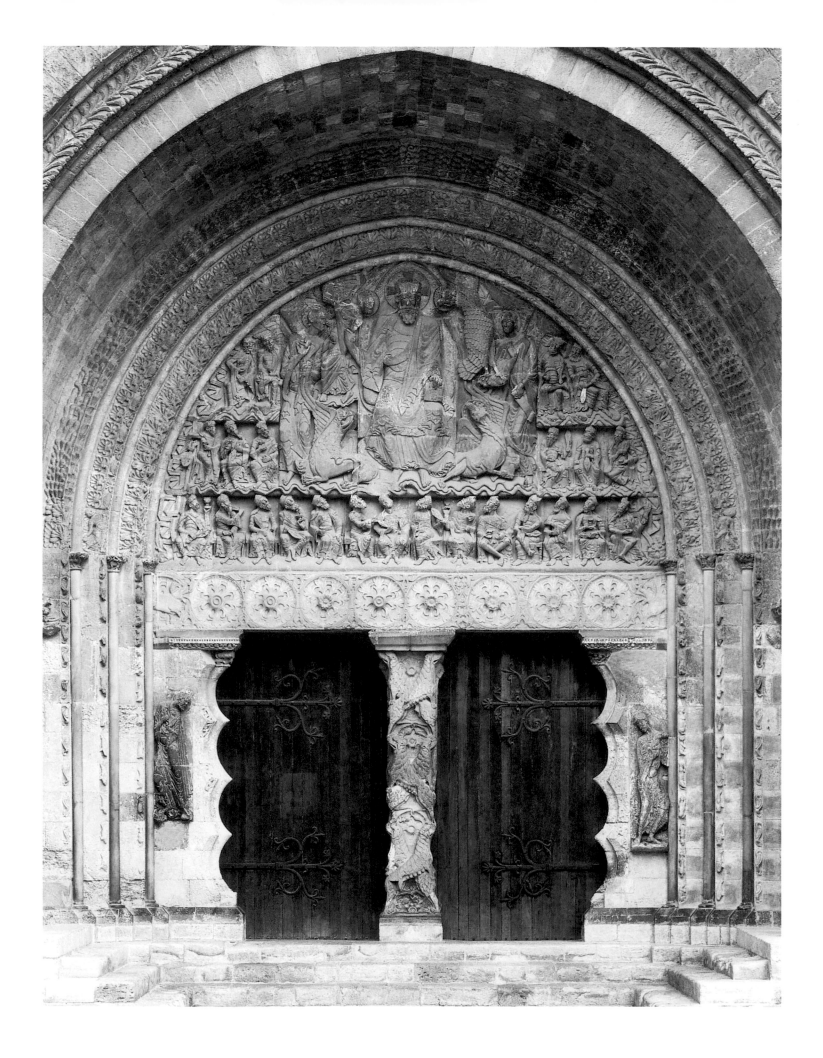

III. Romanesque Sculpture and Painting

Sculpture

The Romanesque style really belongs to the Middle Ages with its feudalistic society. At the time, there was no art in the modern sense; all art was religious, and the artist normally remained anonymous. Religion was at the centre of all areas of life. Only in the middle of the thirteenth century with the beginning of Naturalism was the Tuscan painter Giotto able to overcome the stiff, formal, unnatural style of Byzantine art, which had dominated until then.

The spiritual and social changes as well as the increasing appearance of trade and industry in Europe not only changed the people's view of the world, but also their image of themselves, and they now began to liberate themselves from the bonds of the church and medieval court order.

During the first half of the Middle Ages, which was dominated by Romanesque art, architecture was the dominant art, distantly followed by sculpture and painting. The latter two only served architecture and did not claim any independence for themselves. Their purpose was fulfilled when they were able to beautify the building in the locations designated by the architecture. This process followed certain rules, which never changed throughout the course of the Middle Ages. In Romanesque churches, sculptures were usually placed in the entrance portals, on the western front, on the capitals, or on lecterns. The tympanum above the entrance portal was often decorated with scenes of the Last Judgement.

Only at the end of the epoch had sculpture developed far enough to begin treading its own path separate from architecture. However, the Gothic style then rigorously stopped this development, and forced it more than ever before into the tightly-knit frame of architecture. The stonemasons did not strive for a realistic representation of the figures; they were stylised and only symbolic depiction was important to the Romanesque sculptor. The figures' bodies were largely flat, while the head was often portrayed three-dimensionally. At the time, freestanding sculptures were considered pagan by the spiritual authorities. Full figures were relatively rare, with the exception of crucifixes. Christ nailed to the Cross, however, was depicted as the victorious Saviour, rather than the suffering Man. The Crown of Thorns was often replaced by a secular crown.

South portal, Saint-Pierre Abbey, Moissac (France), founded during the 7th century.

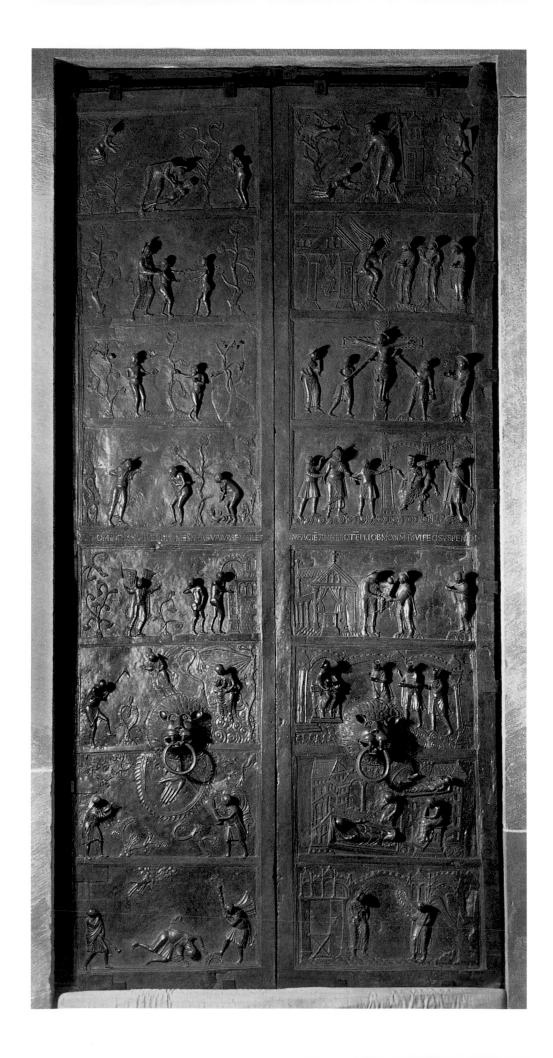

Western door, St Michael's Abbey
Church of Hildesheim, Hildesheim
(Germany), 1010-1033.
Bronze.

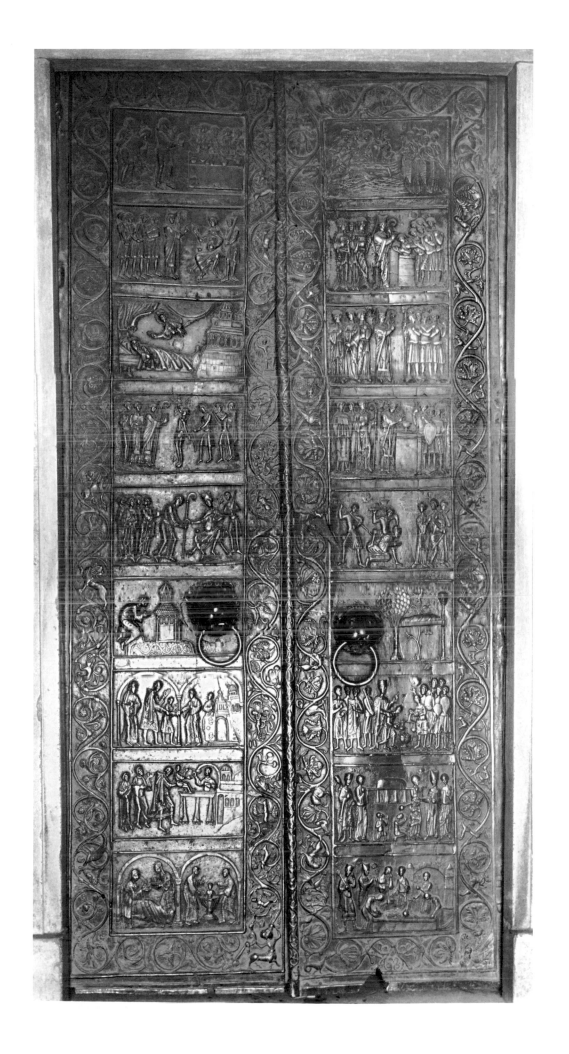

Royal Door, St Aldabert Cathedral,
Gniezno (Poland), c. 1180.
Bronze.

127

Stone Sculpture

Examples of stone sculpture have been found dating from the end of the eleventh century, though the earliest creations did not measure up artistically to those cast in metal at the time. Two reliefs with portrayals of St Michael and two Apostles in St Michael's Chapel in Hohenzollern Castle in the Swabian mountains (Baden-Württemberg) are considered the oldest works, along with two altarpieces depicting St Vincent's martyrdom and six Apostle figures in Basle Cathedral. They are, however, completely under the influence of Early Christian art, which developed from Antiquity. The first individual expression of sculpture striving for a breath of life can be seen in Westphalia, initially on baptismal fonts and church portal sculptures.

The Externsteine

Even towards the beginning of the twelfth century the abilities of these somewhat awkward sculptors, already guided by artistic intentions, had developed so far that a marvellous image like the relief of the *Descent from the Cross* could be created. It was carved into the largest of the so-called Externsteine; large individual sandstone rocks near Detmold (North Rhine-Westphalia). Since it is located next to the entrance to an underground chapel, which, according to its inscription was consecrated as a Chapel of the Holy Sepulchre in 1115, it probably also dates from this time. The lower depiction is in close dogmatic connection with the upper one. Sin entered the world with the disobedience of Adam and Eve, who are kneeling at the bottom on either side of the tree. The tree is enveloped by the demon of temptation, a fantastic snake-like animal symbolising sin. Only through Christ's sacrifice was the work of Salvation completed. From the tree grows the Cross, from which Joseph of Arimathea, who probably belonged to Jerusalem's Early Jewish Court, has just taken down the body of Christ. Nicodemus, a friend of Jesus, who was part of the group of Jewish Pharisees, has lifted him onto his strong shoulders in order to take him to the grave. He is followed by Mary, who, shaken by deep pain, bends over her son's head. Her head is missing, but her body's stature makes it obvious that the artist attempted to particularly stress her grief for the deceased in this figure. John, too, strives to attest to his pain in his posture and gesture. Even the Sun and the Moon, appearing as living beings reminiscent of the symbolism of Ancient art, join the grief of mankind and cry.

The well thought-out and well-balanced composition finds its conclusion in the appearance of God the Father, who gives a blessing with his right hand, while he takes in the deceased's soul in his left arm next to the flag of the Cross. The soul is depicted as a child, as was customary in medieval symbolism. This child figure is, like many other parts of the image, mutilated and weathered. But despite the imperfections in the portrayal of the figures, it makes a deep and moving impression on anyone who has compassion for the struggle of the artist's soul to express the thoughts that inhabit it.

The Golden Door of Freiberg Cathedral ("Cathedral of St Mary"), Freiberg (Germany), c. 1180.

Annunciation to the Shepherds, Birth of Christ, The Magi before King Herold and *the Adoration of the Magi,* west door panel, Church of St Maria in the Capitol, Cologne (Germany), 1049-1065. Wood, polychromy, h: 474 cm.

Door, Basilica di San Zeno Maggiore, Verona (Italy), 1120-1138 (church), 9th-11th century (doors). Bronze.

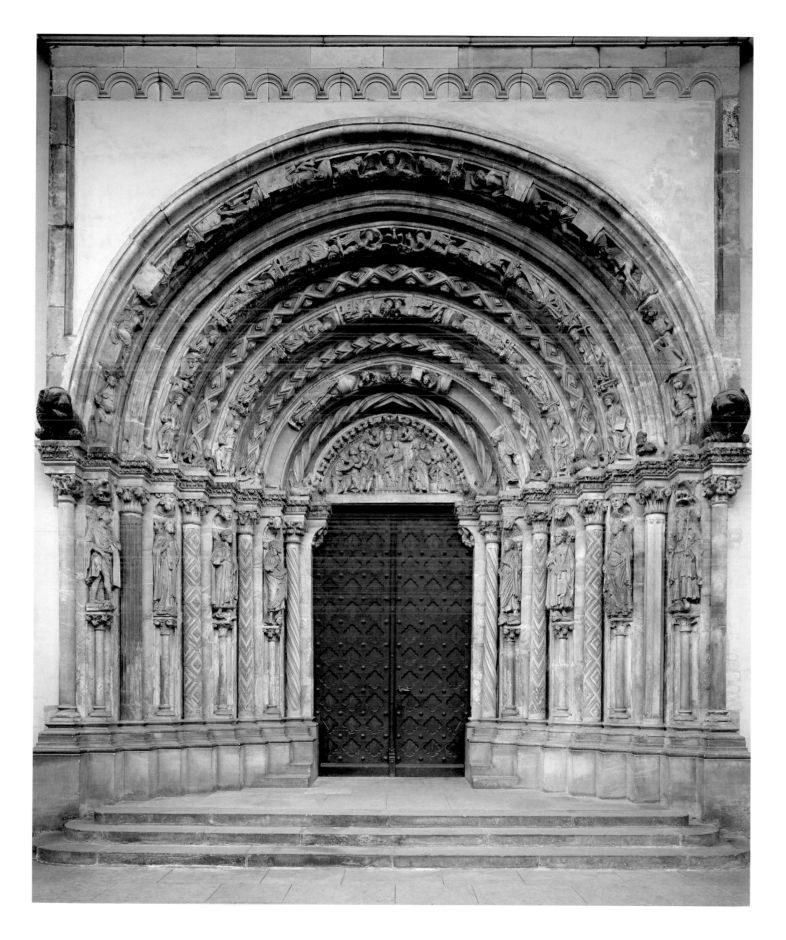

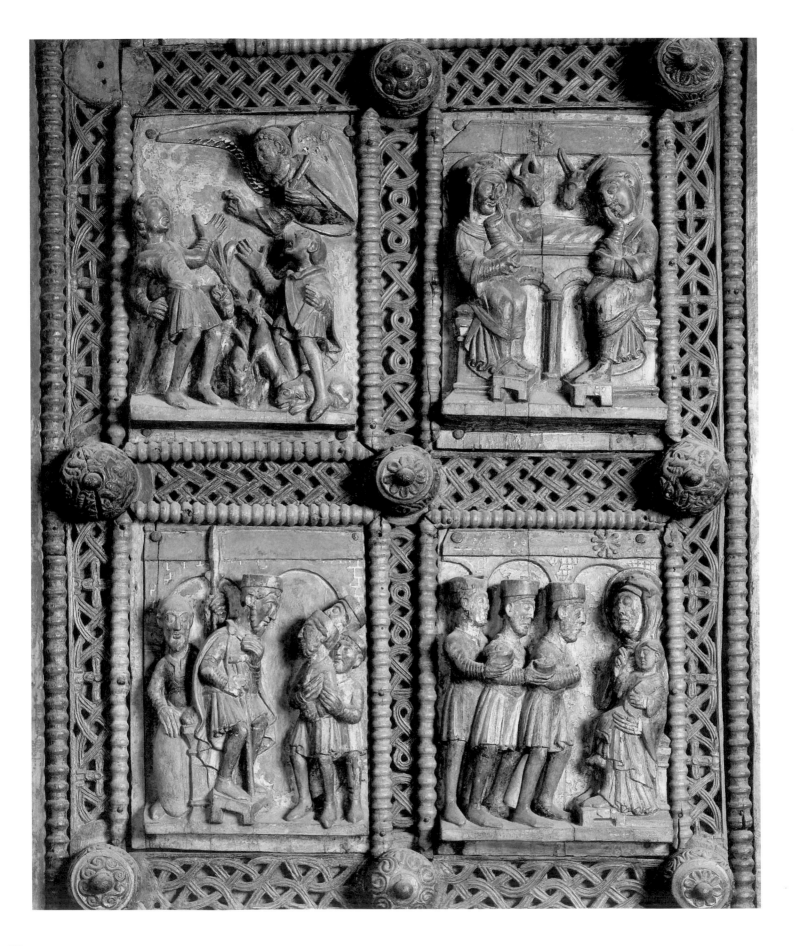

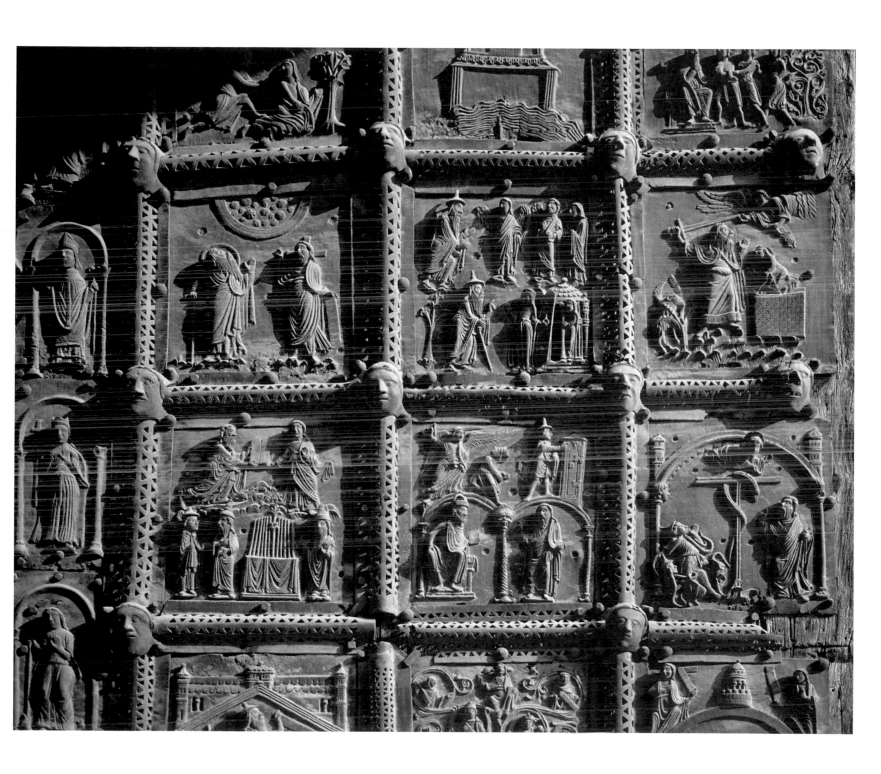

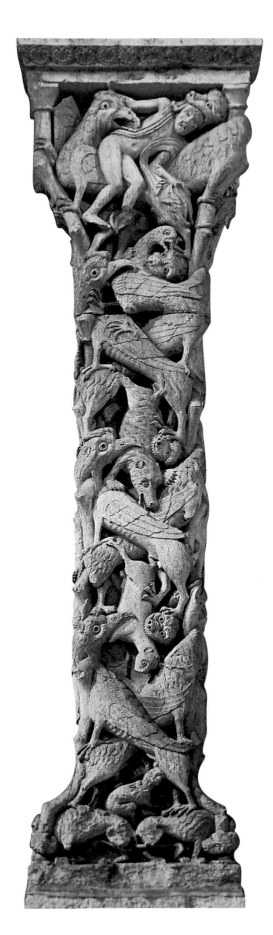

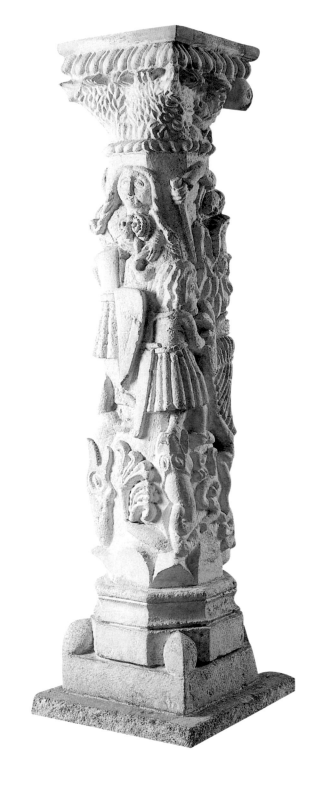

Column, reverse side of the façade,
Abbey Church of Sainte-Marie,
Souillac (France), 1120-1135.

Column sculpted in the form of a beast,
column of the crypt, St Mary and
Corbinian Cathedral, Freising
(Germany), c. 1200. H: 225 cm.

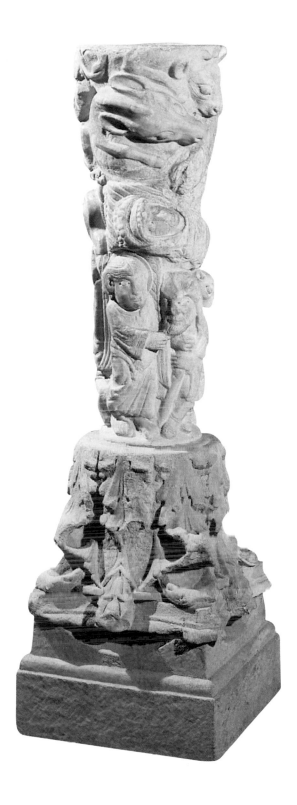

Scenes from the Birth of Christ,
columns from the baptismal font,
second half of the 12th century.
Alabaster and limestone, 87 x 58 cm.
Museo di Arte Sacra, San Casciano Val
di Pesa (Italy).

Principal pillar of the south portal,
Saint-Pierre Abbey, Moissac (France),
founded during the 7th century.

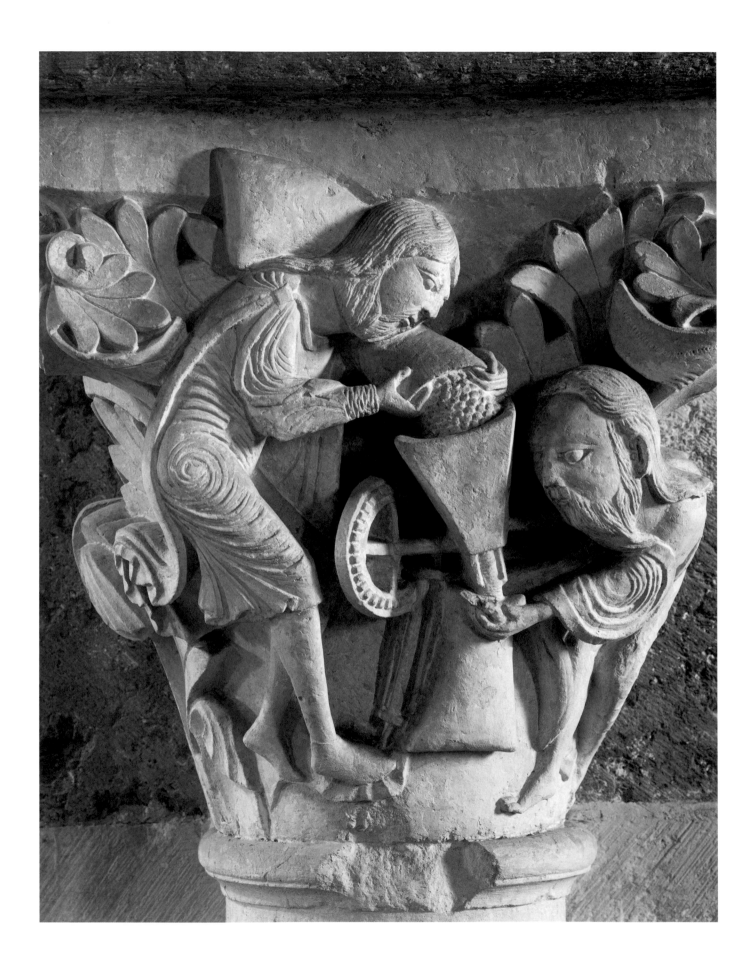

Although this execution in stone is unique in Germany and all over Northern Europe, it is not surpassed in artistic content by any other stonework executed in Germany during the entire twelfth century. What was achieved at the time in western Germany, in particular in the Rhineland and southern Germany, is much rougher, more rigid and lifeless in expression and form, so that these works cannot claim any artistic importance. Wherever greater skill is visible in form, such as for example on St Plextrude's tombstone in St Mary of the Capitol in Cologne, Early Christian or Byzantine examples must always be assumed.

Sculpture in the Twelfth and Thirteenth Centuries

What had first been attempted on a large scale in the relief of the Externsteine, whose use of form clearly originated in ivory carvings, was picked up again in Lower Saxony at the end of the twelfth century. A more easily workable material was discovered there, using stucco to form high reliefs and then painting them in natural colours. Thus congruence with the other coloured decorations of the church was achieved. These reliefs usually occupied the screens that separated the choir from the church interior. Christ, Mary and the Apostles were normally portrayed seated or standing as half-raised figures. They were often stiff in posture and in the treatment of the robes, but expressive in the animation of the heads, which was making ever more progress towards individualisation. The best-preserved images of this kind, in which a certain sense of beauty also shines through, are located in Hildesheim's St Michael's Church and in the Church of Our Lady in Halberstadt.

The Mystic Mill, capital,
Basilica of Sainte-Marie-Madeleine,
Vézelay (France), 878-1120/1150,
1190 (chancel and transept).

Capital adorned with figures, Church of
St Servatius, Quedlinburg (Germany),
c. 1129.

Capital of the cloister, Saint-Pierre
Abbey, Moissac (France),
founded during the 7th century.

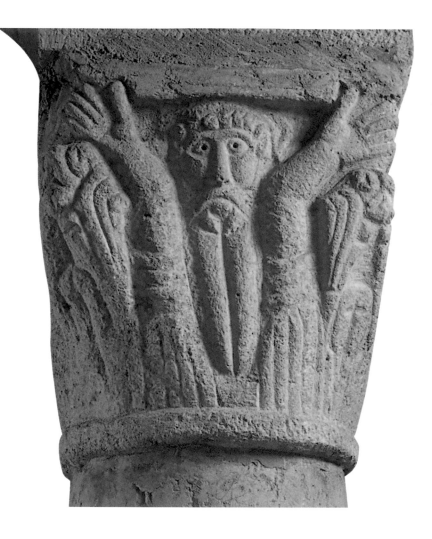

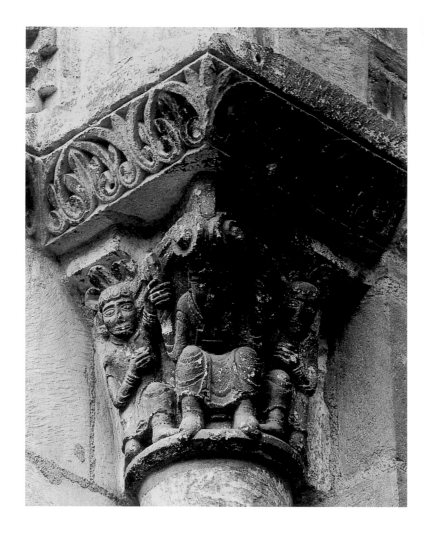

Men-capital, rotunda, Cathedral
Saint-Bénigne, Dijon (France),
10th-13th century.

Capital of the door of the Counts,
Basilica Saint-Sernin, Toulouse (France),
1077-1119.

Central Germany

The sculpture of the Romanesque period, however, only reached its fullest bloom and
freedom from the beginning of the thirteenth century. This period lasted until the
beginning of the last quarter of the century, when the Gothic style, which had already
taken over in architecture, also gained the upper hand in sculpture. The first works of
flourishing period can be found in Saxony, where the sculptures in the Stadtkirche (City Church)
of Wechselburg represent the beginning of the first development of a mature style, and
the Golden Door of Freiberg Cathedral (p.129) marks its climax. In Wechselburg, it is
the larger-than-life group of the *Crucified Jesus between Mary and John*, carved into wood
and installed, freestanding, above the high altar. Its predecessor is found in a similar
group in Halberstadt Cathedral. This, however, also includes the painted stone reliefs of
the chancel balustrade with Christ seated on a throne in the centre between Mary and
John, evidence of a first attempt to connect truth to nature in the exterior form with
beauty and a depth of emotion. This is exemplified in particular by Mary's noble head,
in which the son's pain and agony find a pure expression.

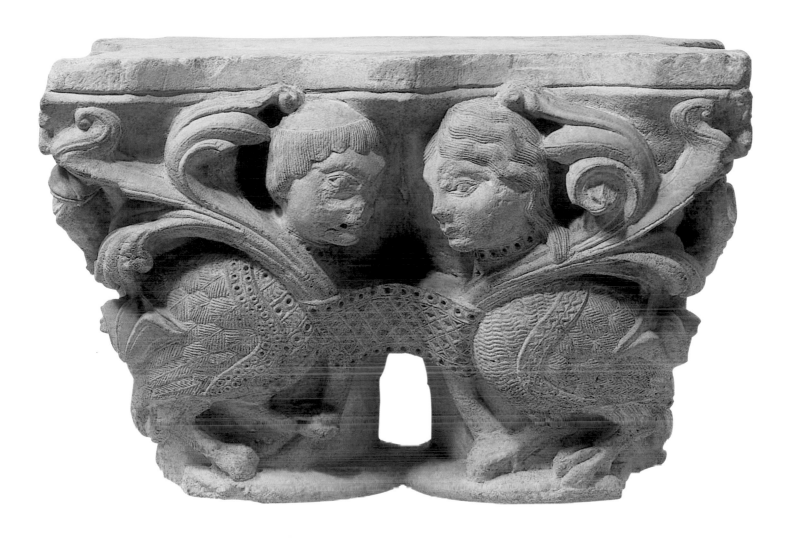

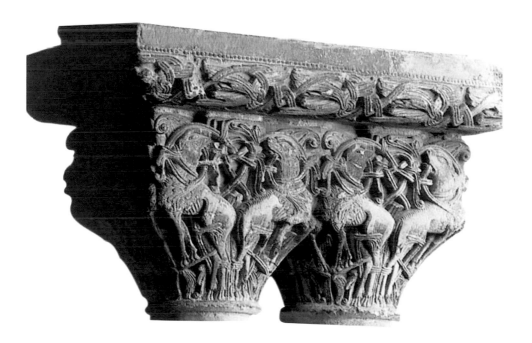

Harpies facing Each Other,
double capital, c. 1140-1145.
Limestone, 26.1 x 41.2 x 30 cm.
Musée national du Moyen Âge – Thermes
et hôtel de Cluny, Paris (France).

Double capital, cloister, Monastery of
Santo Domingo de Silos, Silos (Spain),
mid-12th century.

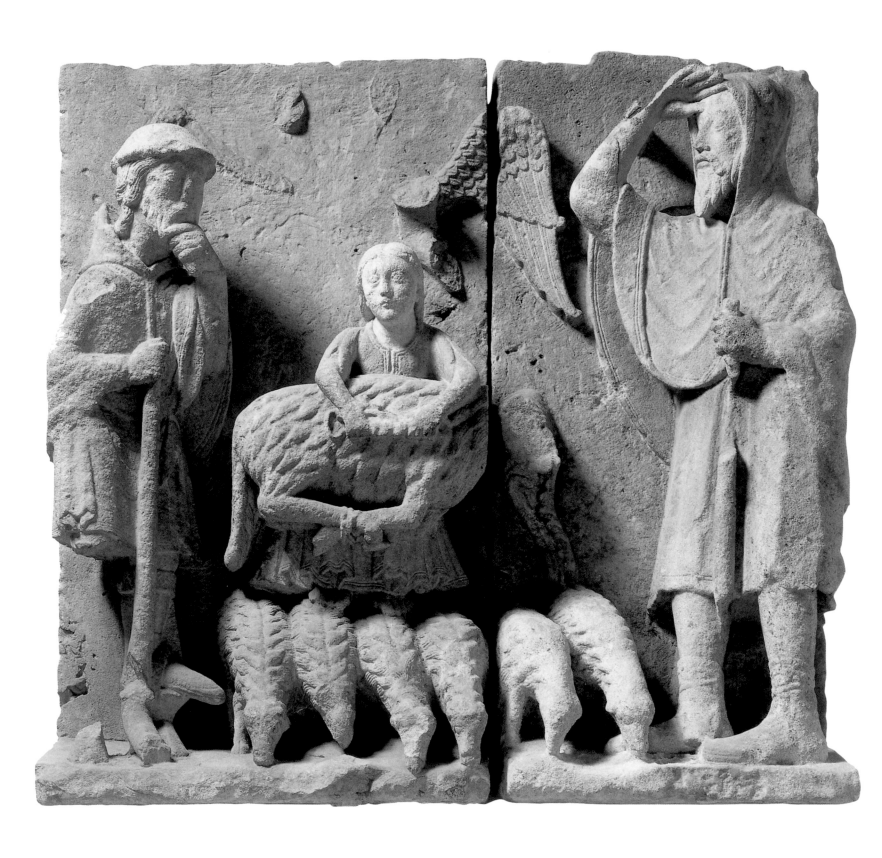

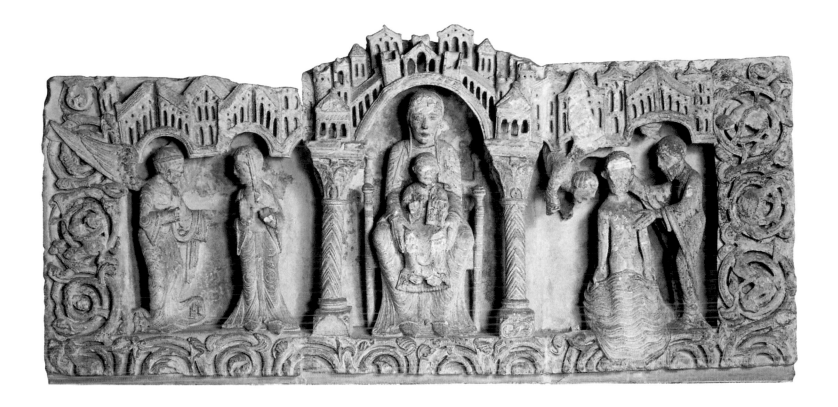

A no less magnificent achievement of three-dimensional art of the time is the rich ornamentation of the Golden Gate in Freiberg, which owes its name to the originally richly painted and gold-plated imagery. It is a masterpiece of sculpture and architecture, since the figurative and ornamental parts are integrated and subordinated with sensitive understanding into a perfect architectural composition. Mary with the Child on a throne, with the Magi approaching in Adoration, can be seen on the interior of the arch above the entrance. In the arch's vaulting, which rises above the portal's side walls, numerous small figures are standing on top of each other; Angels, Apostles and Prophets, with the Blessed leaving their tombs on Resurrection Day in the exterior framing of the arch. Finally, there are freestanding figures of eight characters from the Old Testament, made with great mastery, between the large columns of the portal, located on top of smaller columns.

A few decades later the Saxon sculptors achieved what the formal construction of the figures was lacking in detail, in the sculptures of Naumburg Cathedral. At the same time, these works also mark the shining climax of the overall development of German sculpture in the Middle Ages. The figures of the cathedral's founders and patrons, eight individuals and two pairs, as well as the large crucifixion group on the choir screen, and the eight smaller reliefs with portrayals of Christ's Passion on the upper choir screen balustrade, were achieved in careful observation of life. The former were installed on the pillars and columns of the western choir underneath richly formed and varied baldachins. The standing figures are also painted. For the first time, these sculptures show a realistic form of portrayal. With sensitivity to differences in character, the artist emphasised the crudely popular and, at the

The Annunciation to the Shepherds, high relief, from the façade of Notre-Dame-de-la-Couldre Church, Parthenay (France), mid-12th century.
Limestone, 131 x 74.3 x 57.5 cm.
Musée du Louvre, Paris (France).

Virgin in Majesty flanked by representations of the Annunciation and the Baptism of Christ, Île-de-France, second quarter of the 12th century.
Altarpiece in high-relief, limestone (in three parts) with polychromy traces, 906 x 184 x 19.5 cm.
Musée du Louvre, Paris (France).

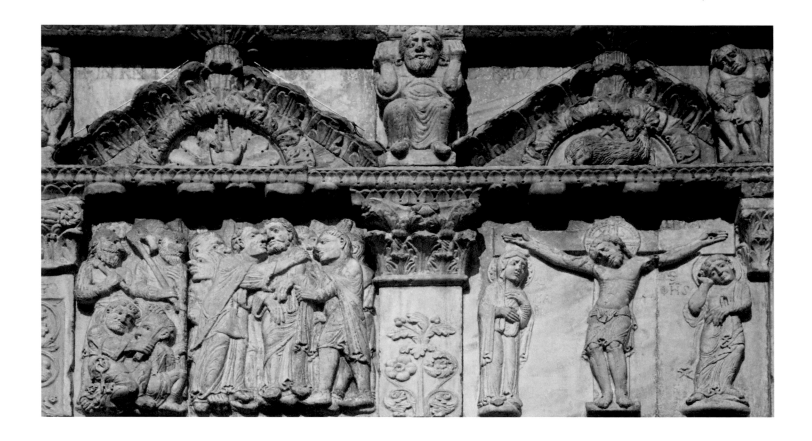

same time, was capable of taking advantage of each scene's dramatic momentum. This is demonstrated, for example, in the group in the foreground in *The Taking of Christ*, when Peter cuts an ear off the high priest's servant, who has fallen to his knees in fear. The images of the founders, too, are obvious representations of nature, in garment and posture as well as in the individualisation of the heads. But it is members of the upper classes, knights and noblewomen, possibly the descendants of those founders who 200 years earlier had laid the foundation stones with their donations, who served as models. The full splendours of knighthood and courtly life, which flourished throughout the middle of the thirteenth century, still linger on these figures.

Braunschweig and Magdeburg, too, have some magnificent sculptures from the second half of the thirteenth century. The figures on the double tomb of Duke Henry the Lion and his wife come very close in their refinement of conception and shaping of the heads and hands to the sculptures in the Naumburg collegiate church. Magdeburg has an equestrian statue of Emperor Otto I in its Alter Markt (Old Market), riding between two allegorical female figures, the symbols of a sovereign's virtues, the oldest equestrian statue installed in a free square in Germany. It dates back to approximately 1240. Its great monumental effect is unfortunately impaired by a cumbersome baldachin, which was added in 1657. As these figures were originally painted and gold-plated, which was taken into account in the renovation of the monument in modern times, the seated figures of the Emperor and his

Niccolò and Guglielmo, *The Kiss of Judas and The Crucifixion*, façade relief, Basilica di San Zeno ("San Zeno Maggiore"), Verona (Italy), 1120-1138 (church), 9th-11th century (doors). Marble.

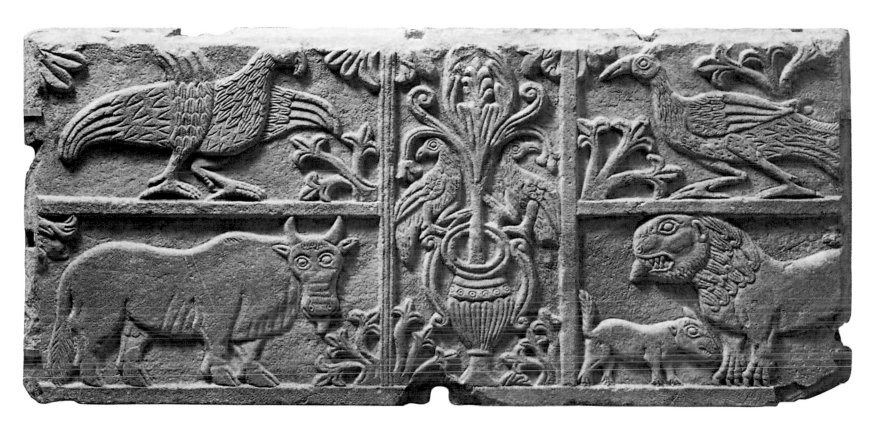

wife Editha in the cathedral's choir, which were probably created at the same time, still retain their colourful décor. The five Prudent and five Foolish Virgins on the Paradise Gate on the cathedral's north end belong to a later time, at the end of the century. They are still in close connection with the spirit of Romanesque sculpture in its last period of development, even though the portal's architecture is already completely Gothic.

Southern Germany

In southern Germany, the towns of Bamberg and Freiburg im Breisgau were the main strongholds of sculpture. On the other side of the Rhine, in the French town of Strasbourg, sculptors were mainly concerned with interior and exterior ornamentation. While foreign influences are undeniable in Freiburg and Strasbourg, where only few remnants of Romanesque sculpture survived, Bamberg was clearly under Saxon influence.

The sculptures in the cathedral can be divided into two groups. The older group, created around 1200, includes the two balustrade walls of the Georgchor (St George's Choir) with 14 high reliefs, of which twelve show pairs of prophets and Apostles in animated conversation, while the thirteenth and fourteenth depict Mary's Annunciation and St Michael the Archangel. In the rigid and lifeless treatment of the garments the effects of twelfth-century art are still visible, since a slavelike imitation of Byzantine works was common in

Antependium adorned with vegetal representations and symbolic animals (Italy), 8th-9th century.
Marble, 78 x 171 x 9 cm.
Musée du Louvre, Paris (France).

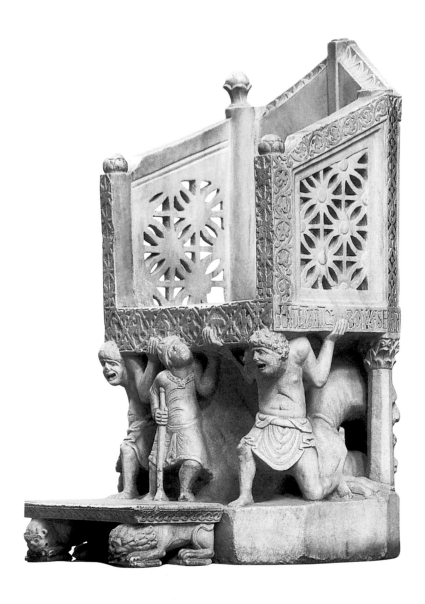

Elias Bishop's Throne, Basilica di San
Nicola ("Basilica of St Nicholas"),
Bari (Italy), 1087-1197. Marble.

Nicodemus da Guardiagrele, *Pulpit*,
Abbey Church of Santa Maria del Lago,
Moscufo (Italy), 1159. Stucco.

Renier de Huy, *Baptismal font*,
Saint-Barthelemy Church,
Liège (Belgium), 1107-1108.
Bronze.

southern Germany. In the characterisation of the heads, however, the artist took a great leap towards the immediate study of nature, far beyond his models. This is demonstrated in the great power and variety of the individual formation and accentuation of the individual heads.

The second, larger group includes exterior and interior sculpture, which match stylistically in such a manner that they can all be attributed to the third quarter of the thirteenth century, when the cathedral's construction was nearing its completion. The six life-size statues on the Fürstenportal (Princes' Portal) of St George's Choir are the most artistically important. They are so closely related to the Naumburg sculptures in their treatment of garments and the noble, idealised formation of the heads, that it is possible that a connection did exist between these two schools of sculpture. They are the first nude figures visibly formed after nature in German sculpture. The artist's means of expression for such a task, however, were very awkward, and his understanding of the organism of the human body was still limited. In the equestrian statue, too, which is located in the interior

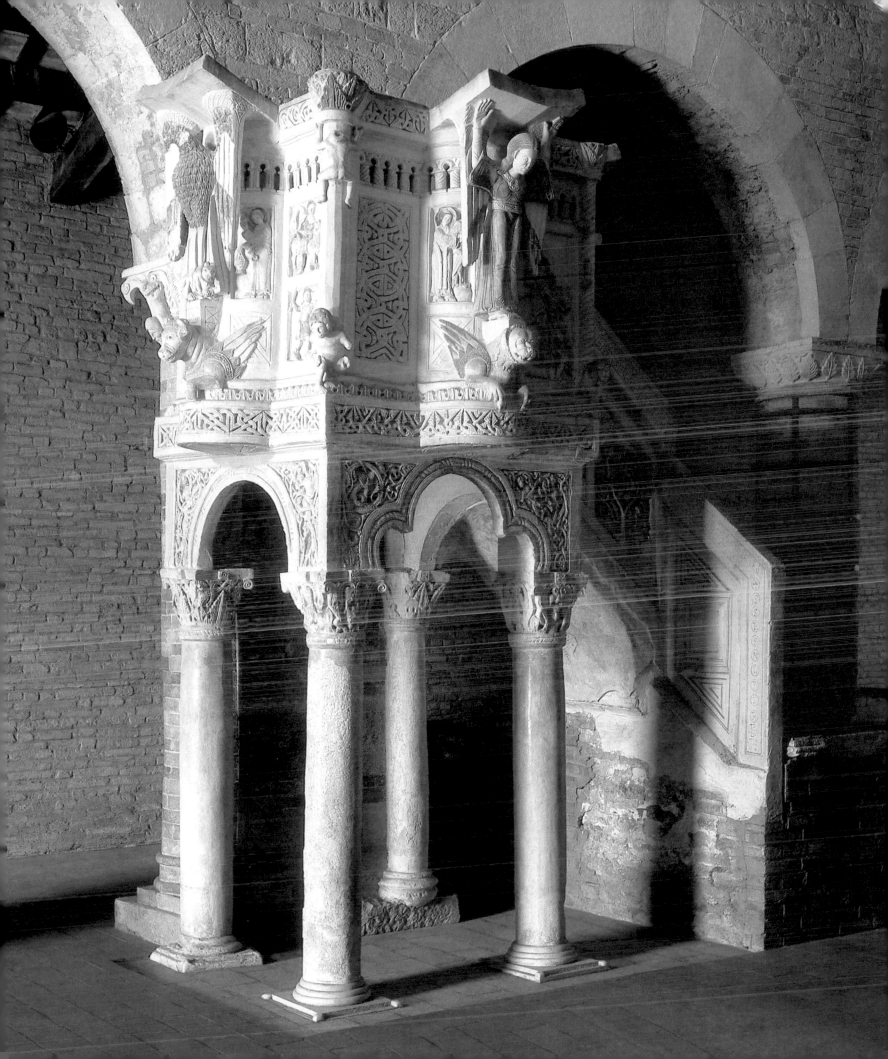

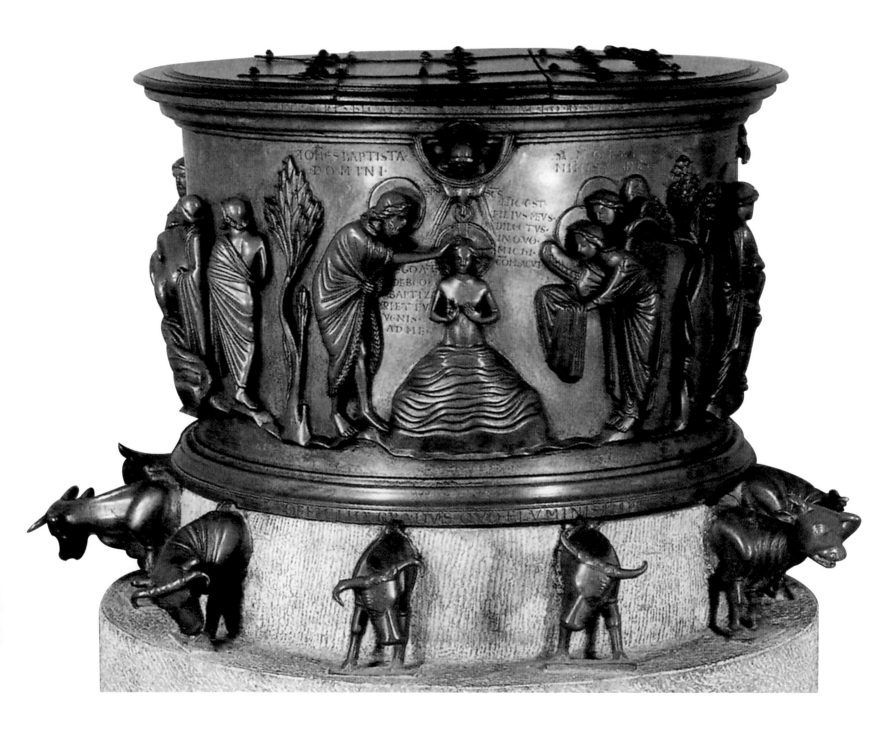

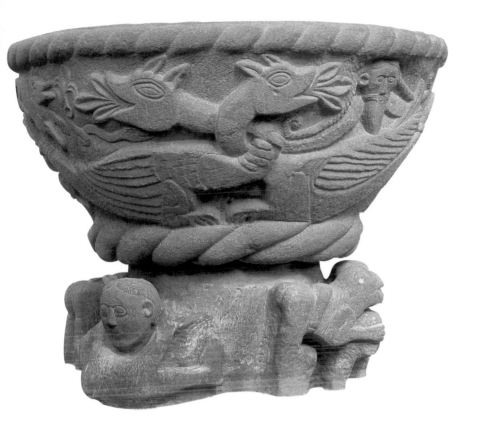

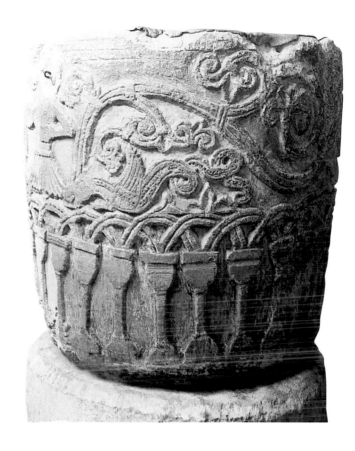

on a console on one of the pillars of St George's Choir, this conflict is clearly visible. The horse's body is stiff and wooden, but the head indicates the study of a model, and the rider's figure is filled with natural life and energetic power. It is not, as had been assumed in the past, Emperor Conrad III, grandson to Emperor Henry IV, but probably Stephen of Hungary, who had been canonised in the same year, having been raised by a missionary nun.

France

Romanesque Europe was just as multi-layered and multi-cultural as it is today. Almost every country, every province, and every region developed its own use of forms. In France, the use of sculpture in the Romanesque epoch is almost exclusively tied to architecture, and can thus be found as exterior decoration of churches, especially portals, but without having created any works of individual attraction. The architectural sculpture served the Christian gospel, and the individual artist was less important than the work. Most of what was created in France from the end of the eleventh until the end of the twelfth century, when the Gothic style took over and soon led to a splendid development also in sculpture, is mainly of decorative purpose.

An invention and considerable contribution of the French Romanesque are the figures on the portals of Romanesque cathedrals. Even today one can admire magnificent examples of

Baptismal font, Evangelical Lutheran Church, Freudenstadt (Germany), second half of the 11th century. Sandstone, h: 100 cm.

Baptismal font, Tower of St James Church, Avebury (England), beginning of the 12th century.

Enthroned Mary and Child from Rarogne, c.1150. Lime wood and paint, h: 90 cm. Swiss National Museum, Zurich (Switzerland).

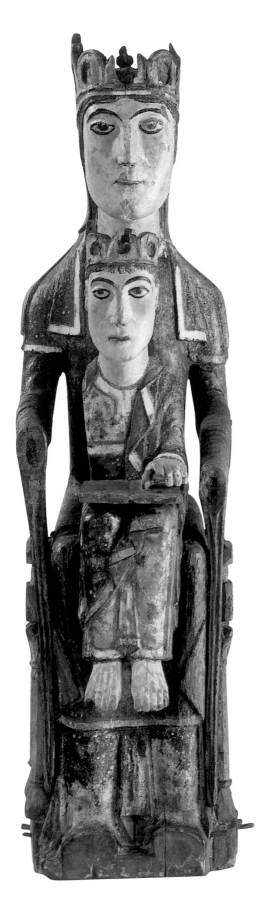

this architectural sculpture in almost unchanged condition, chiefly in the regions south of the Seine, such as in the cathedrals of Poitiers, Toulouse and Autun.

However, one cannot speak of a uniform development in the sculpture of the time. In the south, particularly in the Provence region, Ancient monuments kept the Roman and Early Christian use of forms alive, and in western France sculptural decorations blossomed in often confusing variety. A leading role was played by the sculpted capitals, which showcase the creative spirit and apparently innate decorative skill of the French. The churches of Saint-Gilles-du-Gard and Saint-Trophine in Arles offer splendid works demonstrating this wealth of sculptural power on their portals, which, however, still lacked any connection to nature and drive for individualisation. That can only be found in Burgundy and central northern France, particularly in Vézelay and Chartres.

Vézelay

In 878 A.D., four years after the foundation of this Benedictine abbey, the relics of St Mary Magdalene were transported to the abbey. Thus, in the eleventh century, Vézelay became one of the largest and most important places of pilgrimage in the western world, and remains so today. In 1120, it was destroyed by fire, but almost immediately rebuilt. Today, Vézelay is one of the most important ecclesiastical buildings of the Romanesque period, even though much of its original structure was destroyed by the Revolution of 1789.

Vézelay is famous for its capitals dating from 1125 to 1140, which depict biblical scenes in unique craftsmanship, in particular the illustration of Good and Evil. The most famous of the ninety-nine capitals is the *Mystic Mill* (p.134).

Moissac

The final breakthrough for sculpture only came under the rule of Gothic architecture. In Moissac, where the oldest tympanum (1120-1130) of the Romanesque period can be found (p.124), there are also remarkable freestanding images, which were long frowned upon by the church. The figures of the large relief are, like those of Autun and Vézelay, not static as usual, but dynamic and animated. The figure of Christ, one of the first of the Romanesque period, emanates a quiet dignity. The step portal – a portal embedded into the wall, which is framed by the surrounding projections – was developed to greatest perfection in Moissac. In wide forms, columns are inserted into the steps, thus making room for column figures. As seen later in Chartres, simple doors became a three- to five-portal entrance, which was often framed by life-size statues, and required a central pillar to support its great weight. On the portal are scenes of the Annunciation and Visitation of Mary; in the double tympanum above is the *Adoration of the Magi*. In the strip above, one can admire the *Flight into Egypt*. Barely preserved are the figures opposite, which depict Envy and Greed. On the right-hand side is Gluttony with its

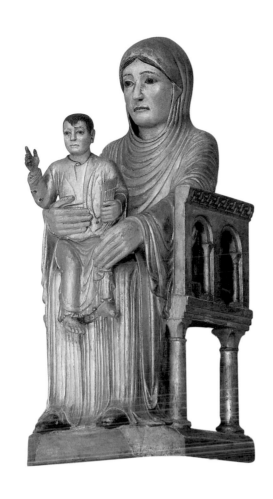

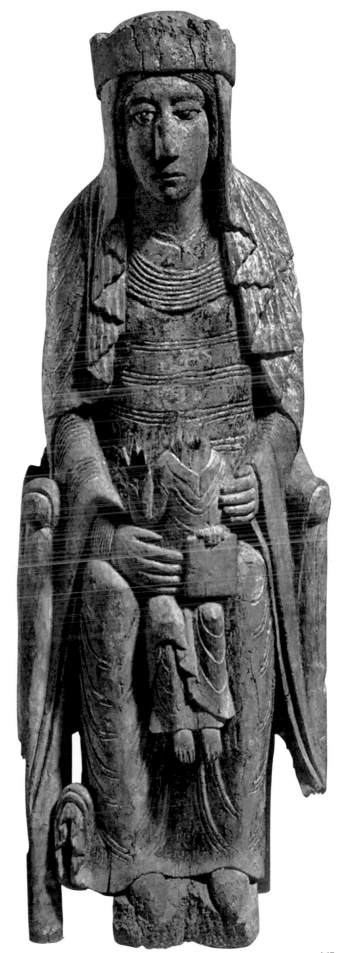

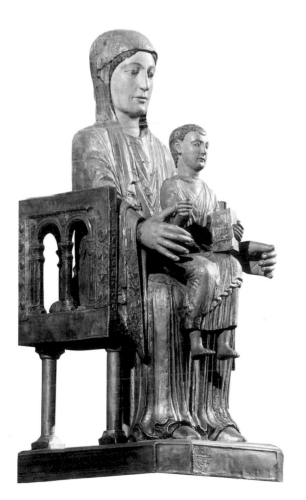

147

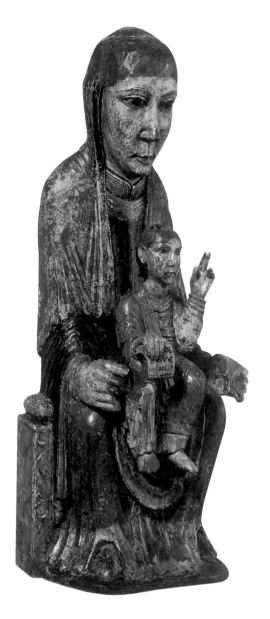

Madonna and Child, also known as
Notre-Dame-la-Brune, Saint-Philibert Church,
Tournus (France), 10th-12th century.
Partial wood decoration with traces of
polychromy, h: 73 cm.

Madonna and Child, Notre-Dame Church,
Orcival (France), c. 1170.
Walnut, silver, vermeil, h: 74 cm.

Enthroned Virgin with Child, 1130-1140.
Birch wood, painting and glass, h: 102.9 cm.
The Cloisters, New York (United States).

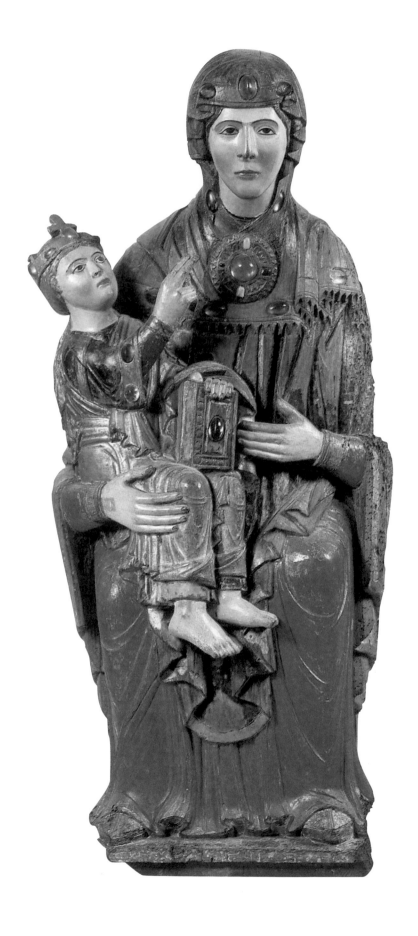

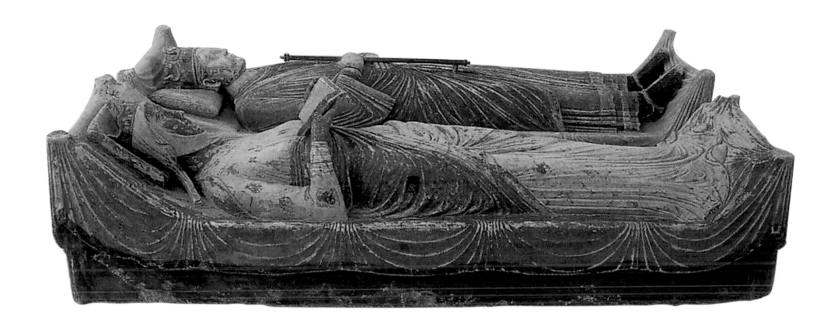

full belly. The reliefs of the remaining Seven Deadly Sins – Pride, Extravagance, Greed, and Lust – were intended to warn people against these vices. These reliefs were, of course, also a source of teaching. The example of Greed was to show that money and riches could not be taken into the Afterlife, as opposed to the power of the church, which went far beyond death.

The story of Lazarus from the Gospel according to St Luke is the topic of a further relief plate. The central pillar, too, which supports the large tympanum, is richly decorated with splendid figures. In Moissac are seen for the first time the intersecting lions on the Lion's Pillar (p.133).

The stretched figure of Paul the Apostle can be seen on the interior surface of the pillar. Like the statue of the prophet Jeremiah on the opposite side of the portal, these statues are of particular beauty and artistic maturity. The style principle of the lengthened body was pioneering, and was taken on in other abbeys such as Autun or Vézelay. In architectural sculpture, the proportionality of the body had little importance; the symbolism behind the figures was all-important. The folds of the garments were exaggerated and are thus called Romanesque garment figures.

The surprisingly large cloister (1059-1131) is also of high artistic quality. The abbey of Moissac is one of the main edifices of the Romanesque period, with more than eighty-eight capitals (p.135) richly decorated with figures and biblical scenes, and ten marble reliefs.

Italy

The development of Italy's sculptures was far behind that of Germany and France at that same time, individually as well as in general. The Italian works also showed different traits,

Virgin of Ger, Church of Santa Coloma, Ger (Spain), second half of the 12th century. Sculpted wood with polychromy in tempera, 52.5 x 20.5 x 14.5 cm. Museo Nacional d'Art de Catalunya, Barcelona (Spain).

Madonna di Acuto, c. 1210. Wood, polychromy, stones, h: 109 cm. Museo di Palazzo Venezia, Rome (Italy).

Recumbment Statues of Richard the Lionheart and Eleanor of Aquitaine, beginning of the 12th century. The Abbey of Fontevraud, Fontevraud-l'Abbaye (France).

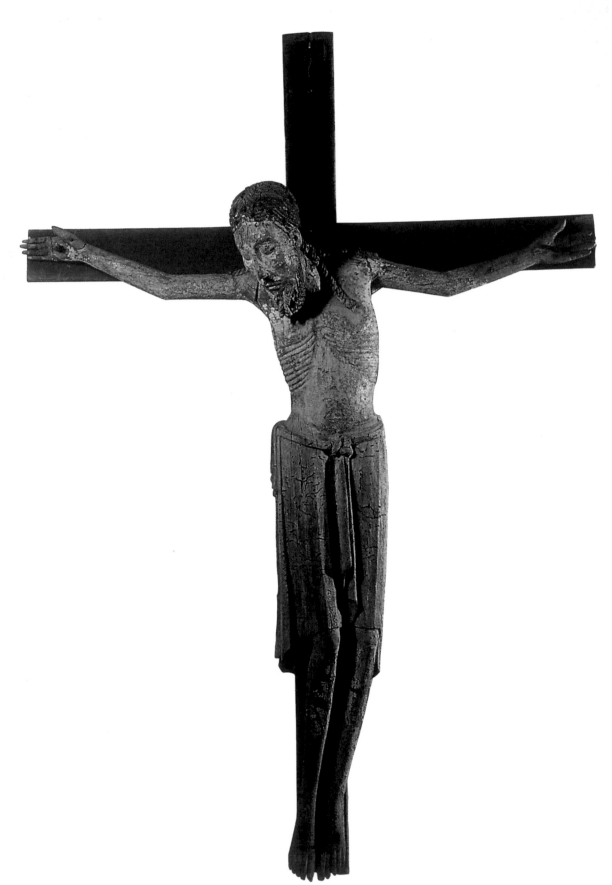

Christ at the Cross, Southern Germany,
12th century.
Wood with polychromy traces,
h: 95 cm, l: 78 cm.
Musée du Louvre, Paris (France).

Christ detached from the Cross also
known as *"The Courajod Christ"*,
Bourgogne (France), 12th century.
Wood with polychromy traces,
155 x 168 x 30 cm.
Musée du Louvre, Paris (France).

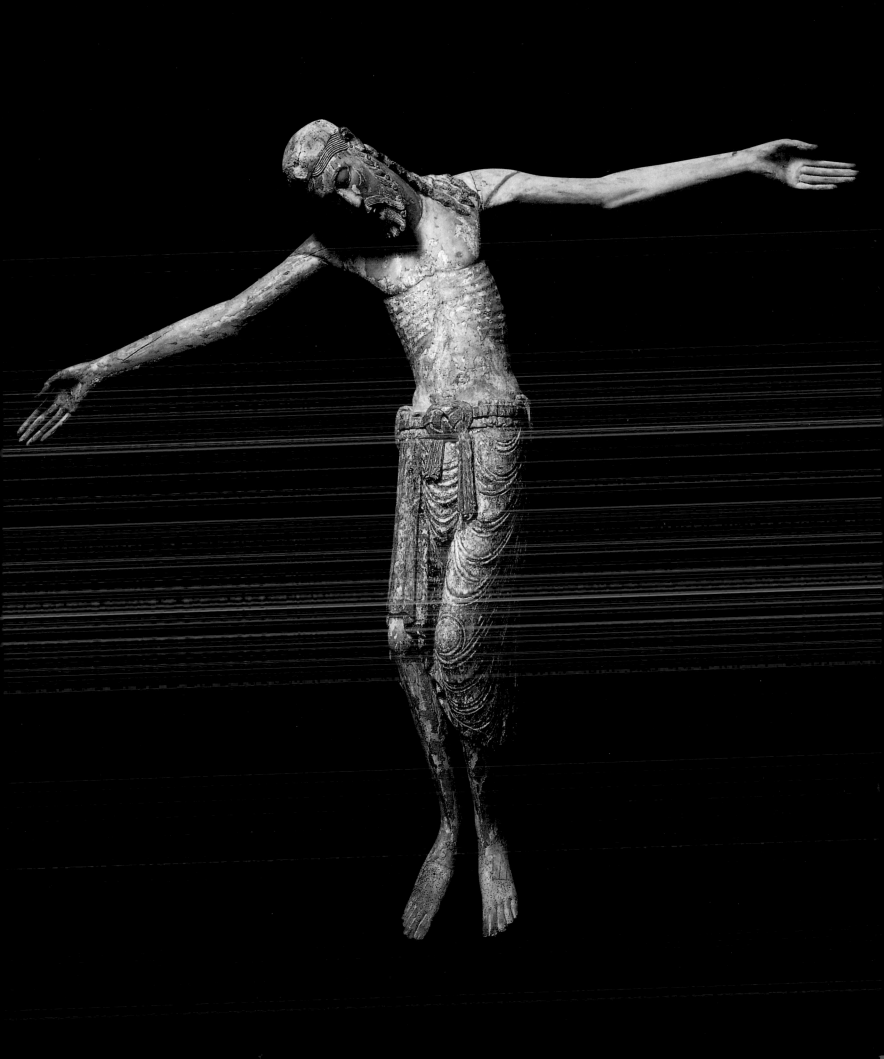

in a similar way to architecture. In northern Italy, German influence did not only dominate, German masters even worked there. Southern Italy was under Byzantine rule, and thus the Byzantine style was dominant there during the entire twelfth century. Only towards the end of the thirteenth century did a stronger feeling of independence break through in sculpture, which initially drew its power from the imitation of Ancient examples.

In Tuscany, a certain degree of autonomy, led by a better mastery of plastic forms and a striving for truth and life, began a little sooner. Of course, the sculptor had little opportunity to employ his powers in decorating churches. Even on the portals, a small number of reliefs and figures sufficed, on whose artistic design no particular importance was placed in comparison to that of the architecture.

Only when preaching became more and more dominant during mass, and thus freestanding chancels became necessary in the churches' naves, did a new field open up for sculpture. This development was favoured by the newly formed mendicant and preaching orders. At first the balustrades of these chancels were richly decorated with reliefs, busts and statues, then the columns bearing them and later the entire substructure. Tuscan sculptors acquired such skill in chancel decoration that they not only far surpassed all other sculpting in Italy towards the middle of the thirteenth century, but soon took on a new leading role, which ultimately led to the renewal of all the arts; the Renaissance. The example here, as in southern Italy, was taken from Ancient art. Its influence is clearly visible in the initial works of this new school, which had its main centre in Pisa. Their activity, however, falls into the period of the Gothic style.

In Rome, the use of sculpted art during the twelfth and thirteenth centuries was mainly limited to the interior decoration of churches with inlay work of purely ornamental character. The famous bronze statue of St Peter in Glory stands alone in St Peter's Cathedral. In the figure's posture and design of the garment it is formed after an Antique work, not without technical skill. The forming of the head, however, shows a certain striving for individual expression. In the past considered a work of Early Christian art, it is now regarded as a product of an 'antiquating' style, which appeared in various regions of Italy in the middle of the thirteenth century.

The Art of Woodworking and Gold, Silver and Bronze Casting
The first element used by sculptors was without doubt, after clay, wood. The most commonly used material was usually local wood, imports being rare and costly. The Middle Ages, and Romanesque art, made particularly good use of wood in statuary art. This material was in fact used for the decoration of churches, the creation of baldachins and other pieces for the altar. With somewhat crude brushwork, sculptures in the round were above all painted when intended to decorate the interior of a building. It is not unusual to find the remains of polychromatic works with traces of highlights in bright colours. Sometimes the wood was even covered with a layer of silver or gilt bronze. Romanesque depictions of the

Christ at the Cross, Bourgogne (France), mid-12th century.
Gilded bronze, 22 x 21.5 x 3.9 cm (tenon of the base included).
Musée du Louvre, Paris (France).

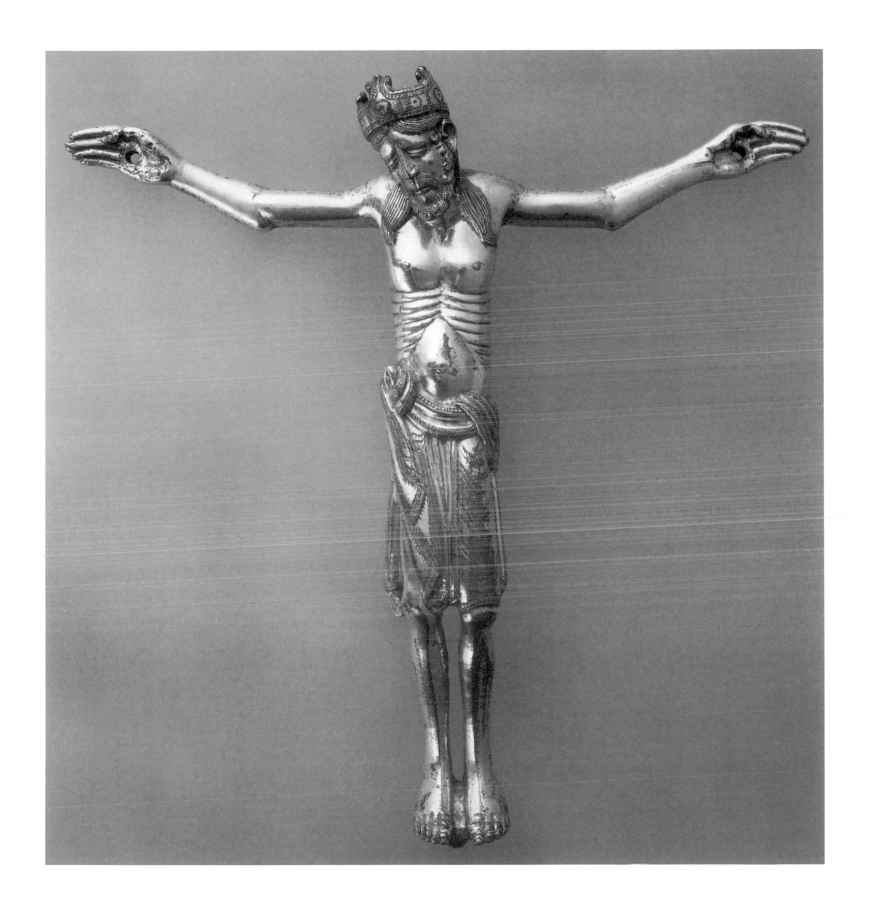

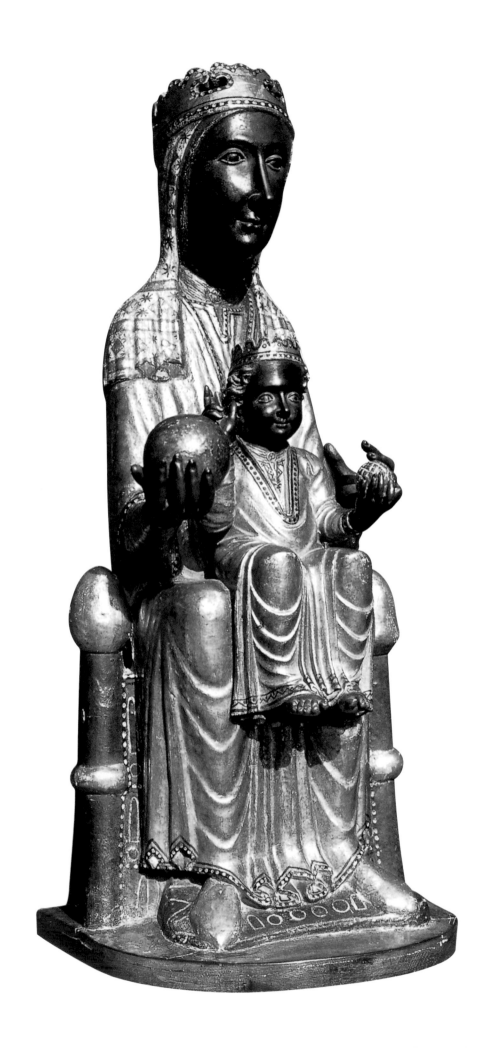

Virgin of Montserrat, also known as
La Moreneta, sanctuary of the black
Madonna, Abbey of Santa Maria,
Montserrat (Spain), beginning of
the 12th century.

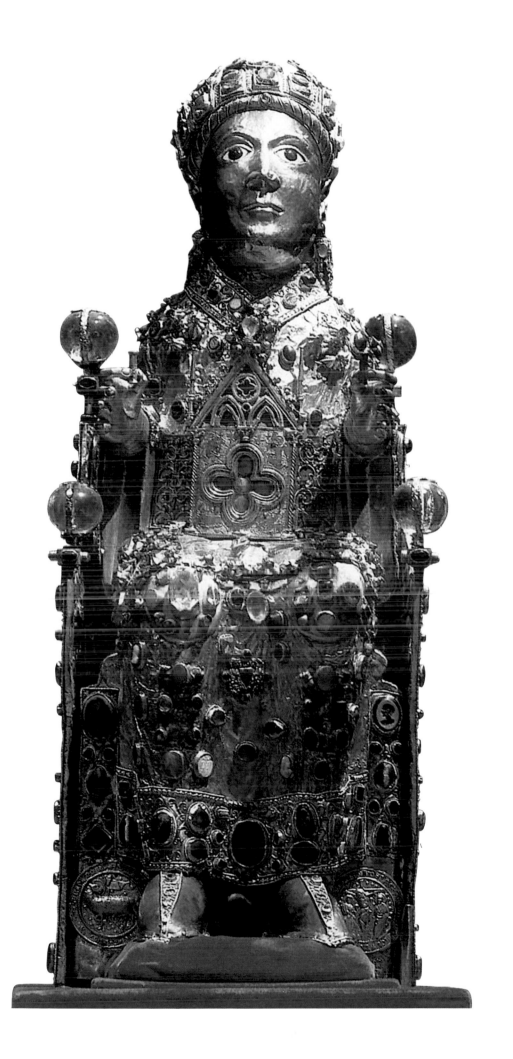

Gold Majesty of St Foy, Sainte-Foy
Abbey Church, Conques-en-Rouergue
(France), 9th-16th century.
Wood, gold leaves, silver, enamel and
precious stones, h: 85 cm.

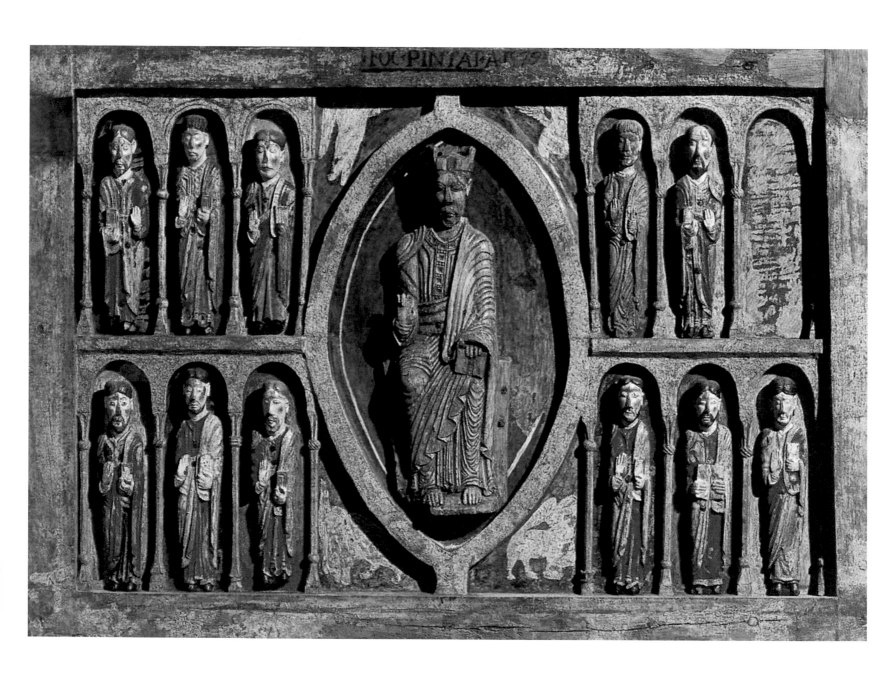

Virgin were often made from a single block of wood to which the sculpture of the Child would be added separately. As for statues of Christ in wood, they were generally made up of two or three separate pieces; two for the Cross, and one for the body.

However, the position of architecture was so dominant that even freestanding and movable works of art, which were created to adorn churches or for use during mass, were given architectural forms. These movable works of art included first and foremost the reliquaries, which were to receive the bones and other relics of saints and martyrs. Even if the reliquary statues were made of gold- or silver-plated sheet metal and of copper or cast bronze, it was not unusual for the core to be made of wood. But the damages wrought by time on these masterpieces had to be overcome, so for the most precious relics wood was used less and less in favour of more resistant metal. They were decorated with gold or silver reliefs, with enamel, crystals and gemstones. The reliquaries were mainly created in the shape of churches and chapels, with roofs and gables, sometimes even with turrets.

By decorating these reliquaries, designing and ornamenting chalices, chandeliers, crucifixes, monstrances, ciboria (host containers) and other devices of worship with figurative and ornamental imagery, the art of goldwork, a highly developed art form in Pre-Romanesque and Romanesque times, resulted in a myriad of pieces, many of which demonstrate a high degree of artistic perfection.

Nicholas of Verdun, a Lorraine artist, was the most important goldsmith of the Romanesque period. He carried out his work as a travelling goldsmith in the Danube, Rhine and Meuse areas. His main works are the *Reliquary of the Magi* (p.161) at Cologne Cathedral, which still attracts scores of visitors today, as well as the altar in the Augustinian Collegiate Canon Church of Klosterneuburg near Vienna (p.164–165). It is considered the most important and most completely preserved work of medieval enamel art. It contains a typological juxtaposition of scenes of the Old and New Testament in three rows of fifteen copper image plates. In his creative implementation of Ancient, Rhineland and Byzantine forms, Nicholas of Verdun had a crucial effect on High Gothic sculpture.

Renier of Huy died in about 1150. He was a goldsmith and bronze caster in Neufmoustier, who lived in Huy in modern-day Belgium. Almost nothing is known about his life. His researchers' strong interest in him is mainly based on one work, which names him as the creator of the Liège *Baptismal Font* (since 1803 in St Barthélemy, Liège), one of the most important works of medieval art (p.144).

Finely worked bronze doors were created in southern Italy during the eleventh century, and a century later in northern Italy, including the magnificent bronze door of San Zeno Maggiore in Verona (p.131).

The Germanic people had mastered metalwork prior to their contact with Occidental and Roman culture. Thanks to these skills, they were able to absorb and implement the new forms into metal more easily than into the brittle, stubborn stone that was difficult to work. Thus, during the early period of the Romanesque Middle Ages, metal sculpture dominated,

Altar, Abbey Church Santa Maria,
Taüll (Spain), 1123.
Pine wood and polychromy in tempera,
135 x 98 cm.
Museo Nacional d'Art de Catalunya,
Barcelona (Spain).

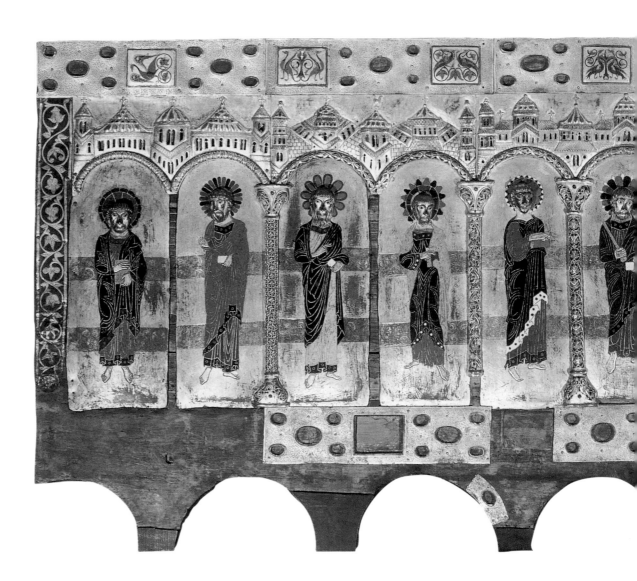

Reliquary of Santo Domingo de Silos,
back plate, c. 1160-1170.
Enamel and copper.
Museo Arquelógico Provincial, Burgos
(Spain).

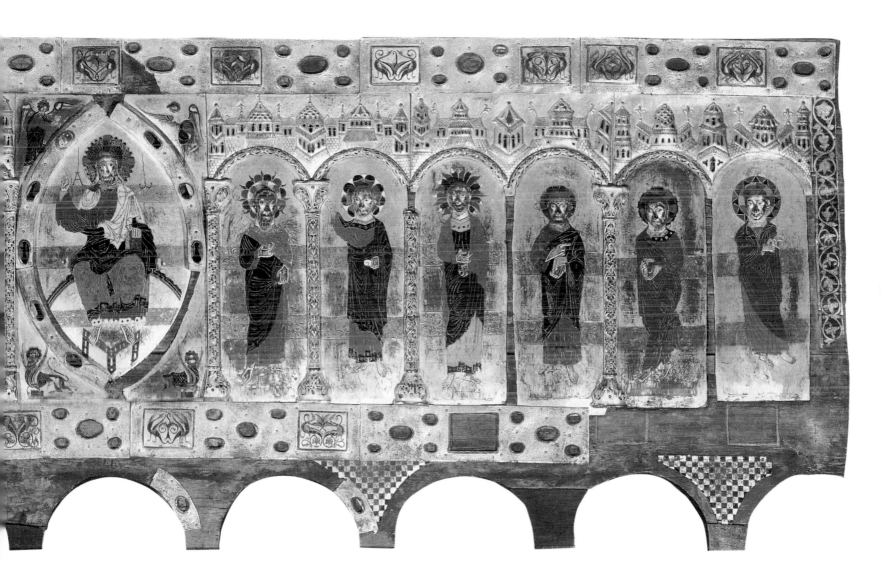

parallel to which the art of ivory carving for the lids of liturgical books, vessels, crucifixes and so on was carried out for ecclesiastical purposes. Here, too, the laws of Ancient forms were generally applied and were often followed by unskilled hands.

Frequently, works of almost childish roughness and awkwardness were thus created. But over the course of time, the unpractised craftsmen were able to channel some of their spirit and emotions into the learned forms. The oldest sculpted monument, in which a first stirring of the spirit is noticeable, is the metalwork which was executed under the direction of Bishop Bernward of Hildesheim, who had an appreciation for art – he was of old Saxon high nobility – and probably under his instructions. This includes the cathedral's bronze door, completed in 1015, which depicts the story of the Creation and the main events in the Life of Christ in eight panels each. *Bernward's Column* erected on the Cathedral square is shaped after the *Trajan's Column* in Rome, and also depicts scenes from the life of Christ on the relief band, which wraps around the column shaft in spirals. The execution of the individual figures and the ornaments, in particular the landscaping, is still relatively awkward. The artistic intentions were stronger and more vivid than the technical skills. The artist took such interest in each event that he wanted to design it according to his personal views. In the way Eve's hair flies in the wind, he meant to hint at the storms to which the first humans, driven out of Paradise, would henceforth be exposed. He let the elements speak in the same clear manner in Cain and Abel's sacrifice, where God's hand mercifully stretches towards Abel. While Cain's cloak billows in the wind, Abel's gown falls in quiet folds along his body. Both works, the doors and *Bernward's Column*, are today part of UNESCO's World Cultural Heritage.

Despite the many defects in artistic execution, the products of Saxon foundries had such a good reputation thanks to their technical qualities that they were also commissioned from abroad. Thus, the metal doors of the cathedral of Gniezno in Poland (p.127) and those of St Sophie's Church in Nizhny Novgorod in Russia, among others, both dating from the twelfth century, are of Saxon origin. The doors of Augsburg Cathedral, which were completed in around 1060, however, indicate a Byzantine origin with their thirty-three reliefs of symbolic and biblical scenes. The doors were either cast in one piece, or plates mounted onto a wooden core, and decorated with reliefs. Apart from church doors, tomb plates, on which the deceased's figure was portrayed in bas-relief with a three-dimensional head in an upright position, were also cast in metal from the second half of the eleventh century. Some of these tomb plates were already monuments of a higher artistic value.

Painting

Painting dominated sculpture for a long time. It was either employed as mural art for the decoration of churches, or as illumination for the ornamentation of religious scriptures.

Nicholas of Verdun, *Reliquary of the Magi*, 1191. Oak wood, gold, silver, copper gilding, enamel, precious and semi-precious stones, encrusted with gems and cameos, 153 x 110 x 220 cm. Church of St Maria in the Capitol, Cologne (Germany), 1049-1065.

Candlestick: Woman on horse. Magdebourg (?), mid-12th century. Gilded bronze, h: 20 cm. Musée du Louvre, Paris (France).

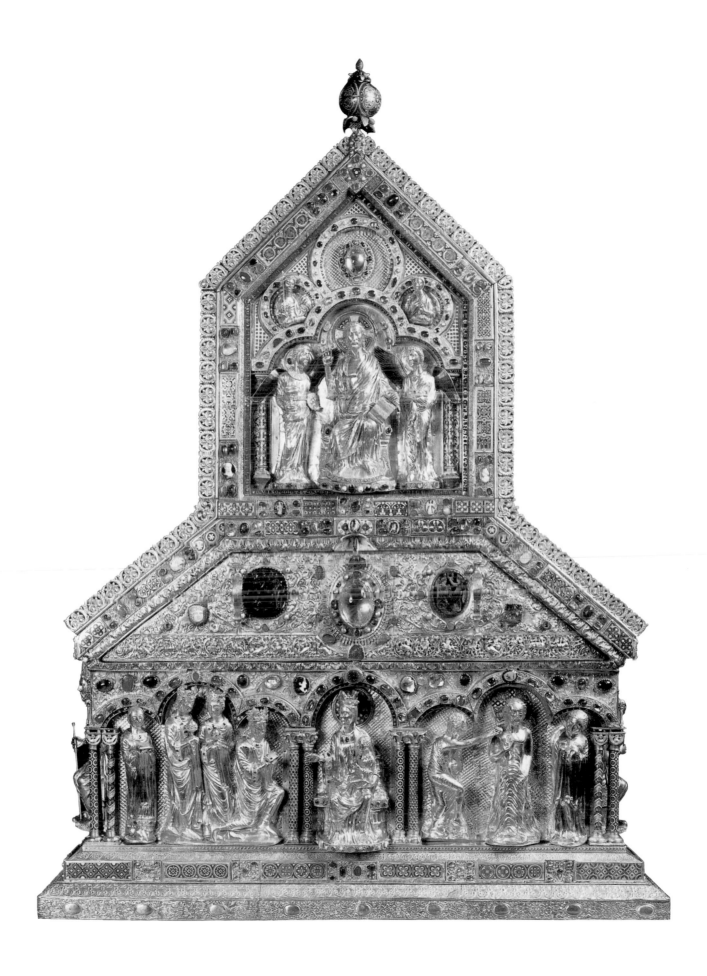

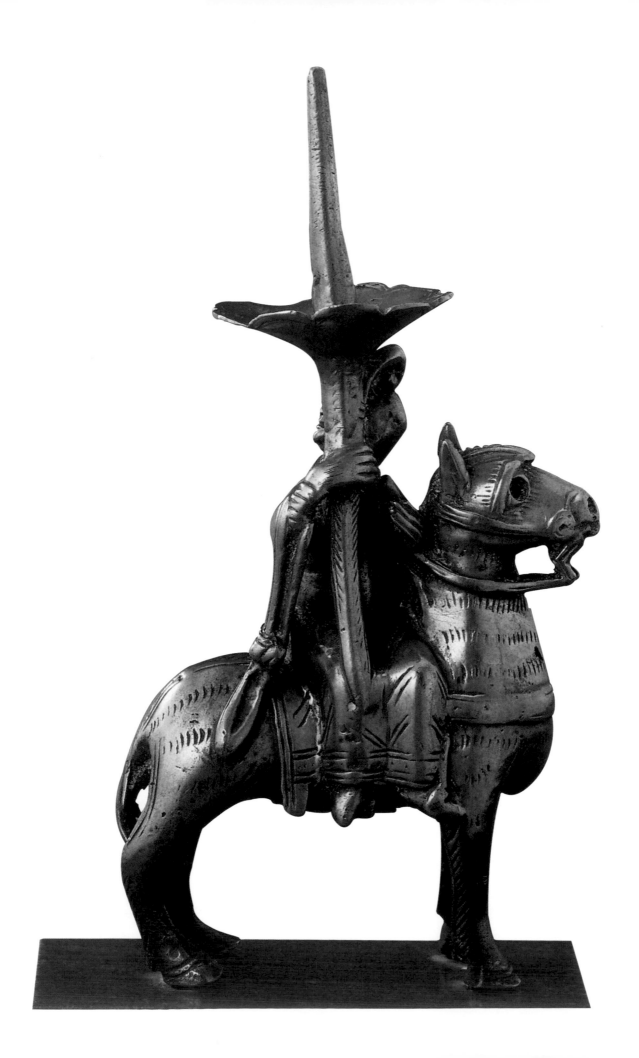

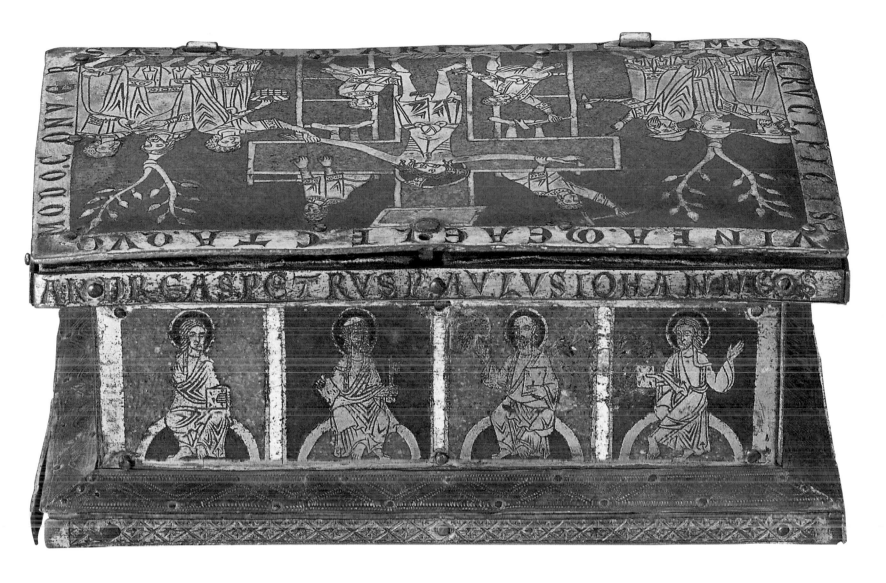

The themes and formal principles were the same for murals and illumination. In Italy, mosaics influenced by Byzantine art were also used as wall decorations. Elements of Byzantine style reached Central Europe mainly in the course of the Crusades.

Since the population was largely still illiterate, biblical scenes were depicted in series. In a series of images in the form of monumental frescos, stories were told in order to enlighten the faithful about the Holy Scripture. These huge series of frescos, of which only a few lasted through the centuries, usually had a standard program of images, the *Majestas Domini*. All over Europe, one finds the motif of the Saviour returning triumphant at the end of the world in apse images. Art, thus, had not only a decorative, but also a teaching purpose. The apse and walls of the nave, in particular, were painted. In some regions, ornaments and geometric patterns on the ceilings and columns of the church were customary. Frequently, blue, red, white and black were employed; a golden background symbolised the Celestial.

Christ Nailed to the Cross and Twelve Apostles, Westphalia (Germany), c. 1170-1180.
Portable altar, gilded copper, engraving, enamel, 8.6 x 14 x 21 cm.
Musée du Louvre, Paris (France).

Nicholas of Verdun, *Verdun Altar,* Klosterneuburg Monastery, Klosterneuburg (Austria), founded in 1114.
Enamel, gold.

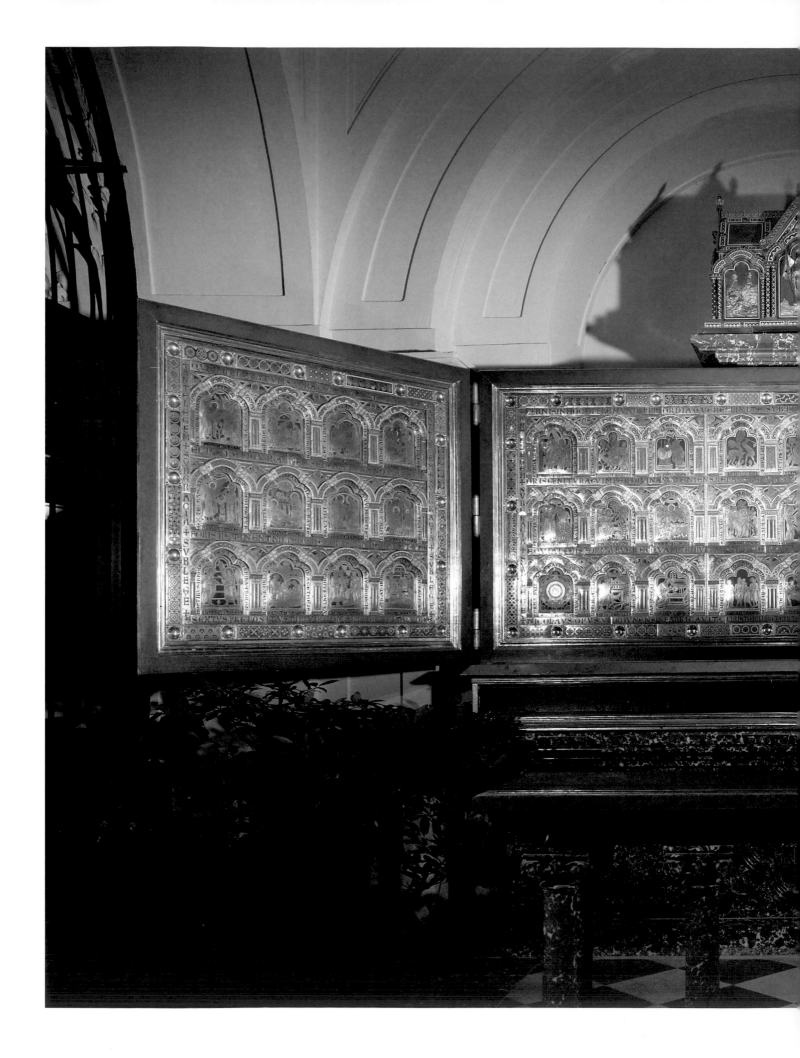

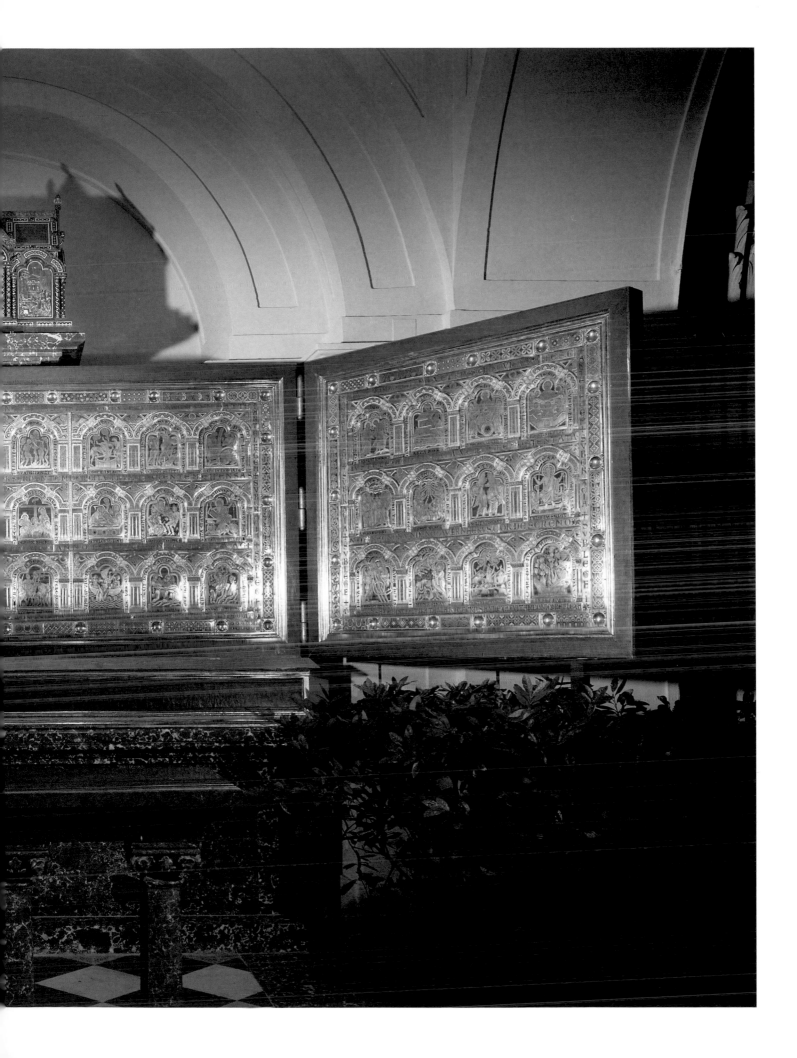

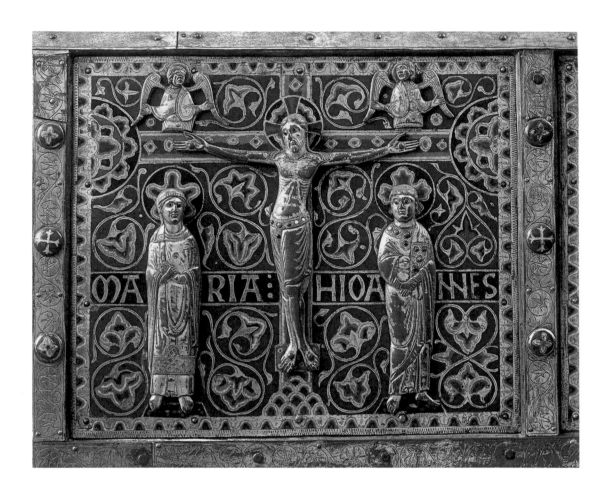

Of the wall frescos in Romanesque churches only few remain, since they were either painted over later or destroyed in fires. In Austria, remnants of Romanesque frescos can be found primarily in the provinces of Carinthia and Styria. The proximity to Antiquity, which had remained visible in Carolingian painting, was lost; the work was carried out in a less magnificent and representative manner. It is marked by its two-dimensionality and lack of depth, its solid outlines, its emphasis on symmetry in the arrangement of objects and its expressive gesticulation. Here, too, the corporeality of the figures is negated, and replaced by the symbolic function of colour and proportion. The size of the figures depicted corresponds to their importance within the image. This is called the "perspective of importance".

The Bible was only available in Greek or Latin during those centuries, and preaching during mass thus only took place in Latin. In order to teach the illiterate about the Holy Scripture, the walls of Romanesque churches were covered with monumental frescos, in which the chalk paint is applied to wet plaster. This is also called *biblia pauperum*, the Bible for the "intellectually poor" (that is, those not able to read or write).

Painting on moveable objects – mostly wood during the Romanesque period – panel painting, started slowly on its way through Occidental art. Different materials such as brick,

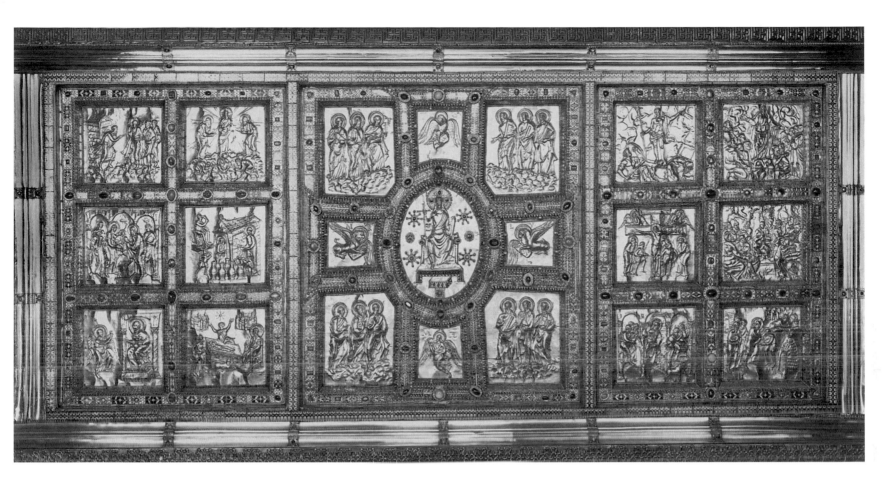

marble or stone were used in alternation so that decorative colour effects could be achieved. Large-scale tapestries were also used for the pictorial narration of biblical or historical stories.

Illuminated Manucripts

Anyone who has had the privilege of handling a medieval illuminated manuscript will have felt an immediate connection with history. In these works can be found the skilled creations of then famous, now largely unknown authors from the fields of philosophy, theology, and natural sciences, of romances of chivalry and courtly poetry, of scholars and humanists or of theologians translating and commentating ancient classics. In these manuscripts are the tales of travellers who detailed their fantastic voyages, as well as those of chroniclers who wrote descriptions of historical events with fervour for their descendants.

These miniatures, safely stored in the pages of books, were protected from light, air, dust and humidity, and were thus able to preserve their original colouring in its original brightness. Other important reasons for the excellent preservation of these miniatures are the elaborate techniques of the painters, as well as their extraordinary care and conscientiousness.

Overall interior view, gold altar, Basilica of Sant'Ambrogio, Milan (Italy), 379-386 (continual restorations until 1099).
Gilded repoussé silver.

For the monks in the scriptoria, their work was one of devotion and reverence, which did not tolerate carelessness. There were copiers, who worked incessantly from dawn until dusk in medieval workshops, writing down the texts of the Holy Scripture painstakingly again and again in breathless silence.

The illuminated manuscripts were made for the aristocracy and high clergy. The miniatures were made for lay readers; they were intended for the intellectual upper class of society.

The general populace's illiteracy and the high prices of unique manuscripts strongly limited the audience of people to whom the painter could address his work. The elite character of the miniature, however, did not lead to a stiff technique. Quite the opposite, when the production of books gradually became the task of town craftsmen, discoveries in painting technique were made more and more often, particularly in the miniatures, which then influenced all the arts. The formation of a new language of art – the composition of space, the representation of mass, movement and volume – largely originated from the workshops of the book illuminators. The illustrative function of the miniatures led the painters to narrative, not only depicting the space, but also the course of time.

Miniatures also played a great role in the emergence of new genres, predominantly in landscape and portrait painting. This is understandable, since the free subjects and broad range of topics are farther-reaching in miniature than in panel painting. One cannot but admire the boldness, creative energy and inventive spirit of these book illuminators, for it was they who furthered the art of painting, even though they were bound by strict traditions and examples. One after the other, they contributed something new to the drawing, the colouration or the decorative motifs, by integrating ever more insistently into their creations observations from their daily lives.

The illustrated book and other products of craftsmanship are some of the most mobile types of art. Merchants brought back illuminated manuscripts from their travels, along with other goods. Princesses who were married abroad had works by the best book illuminators in their dowry, and sons, who received new estates, took inherited books with them. In this manner, the illuminated manuscripts travelled throughout Europe and paved the way for new ideas and new movements of style and taste. The miniature is not only closely interlinked with panel painting, but also with sculpture and glass painting, since the illuminated manuscripts served as sources of inspiration for themes, figures and iconography when composing the sculptural décor of Romanesque and Gothic cathedrals.

The illumination of manuscripts is a very important stage in the history of book design. The initials are of varying size, content and character, the sections behind the text are painted in gold and colour. There is horizontal ornamental decoration in the area of a line of text and there are borders saturated with rich vegetation ornaments, portrayals of real and fantastic beings, human figurines and various monsters, a filigree ornament transitioning towards the edge, extended compositions on the lower edge and finally independent illustrations in the form of miniatures. If the manuscript was to be

Introductory page with initial history (probably Pope Gregory I), The Venerable Bede, *Ecclesiastical History of the English People (Historia Ecclesiastica Gentis Anglorum)*, c. 731. Parchment, 27 x 19 cm. Northumbria (England).

Bible according to St John (introductory page), *book of Gospels (Tetraevangelium)*, end of the 8th century. Parchment, 34.5 x 24.5 cm. Northumbria (England).

First Table of Contents, *book of Gospels (Tetraevangelium)*, 10th century. Parchment, 29.7 x 22.5 cm. Tours (France).

maxxius litteras pro hortatus ad
fidem...

XI Ut coniugem eius æthelburgam christi-
lam salutis illius sedulam adnun-
ciatam monuerit.

XII Ut eduini per uisionem quonda
sibi exuli ostensam sit ad credendum
prouocatus.

XIII Quale concilium idem cum pri-
macibus suis de suscipienda fide christi
habuerit. Et ut pontifex suus aras
suas profanauerit.

XIIII Ut idem eduini cum sua gente
fidelis sit factus. Et ubi paulinus
baptizauerit. Et idem christi sit cultus.

Ut prouincia orientaliū anglorum
Ut paulinus in prouincia lindissi
predicauerit et de qualitate regni eduini.

Ut idem ab honorio papa et hortatoribus
litteras acceperit. qui etiam paulino
pallium miserit. Et domnibus ecclesiae

Ut honorius qui iusto in episcopatu
successit. ab eodem papa honorio pallium
et litteras acceperit. Et eius litterae

Ut primo idem honorius. Et post iohan-
nes rector officii pascha simul heresi pela-
giana his scripserit. et redibus huius scripsit.

Ut occidente paulinus cantuariorum
ecclesiae presulatum suus ceperit.

His temporibus idest anno dominicae
incarnationis dc v beatus papa
gregorius post quam sedem romanae
et apostolicae ecclesiae xiii
annos menses sex et dies decem glo-
riosissime rexit defunctus est
atque ad aeternam regni caelestis
sedem translatus. De quo nos con-
uenit quia nam idem anglorum gente
de potestate satanae ad fidem christi
sua industria conuertit latione sua
in nostra historia ecclesiastica facere
sermonem. Quem recte nostrum appella-
re possumus et debemus apostolum
quia cum primum in toto orbe gere-
ret pontificatum et conuersis iam
dudum ad fidem ueritatis fuisset prae-
latus ecclesiis nostram gentem ea-
tenus idolis mancipatam christi fecit
ecclesiam. Ita ut apostolicum illum

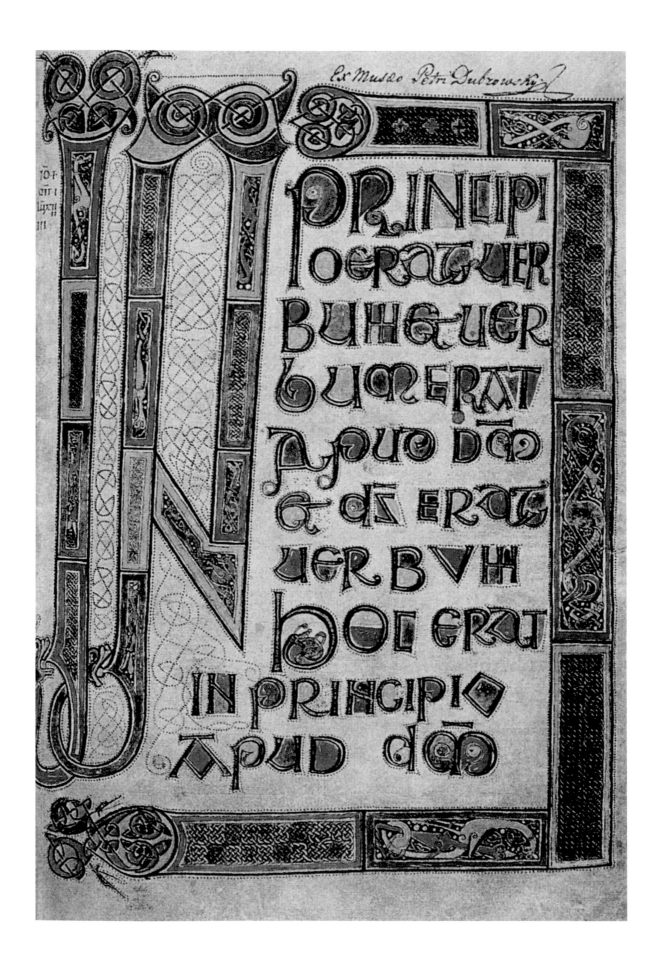

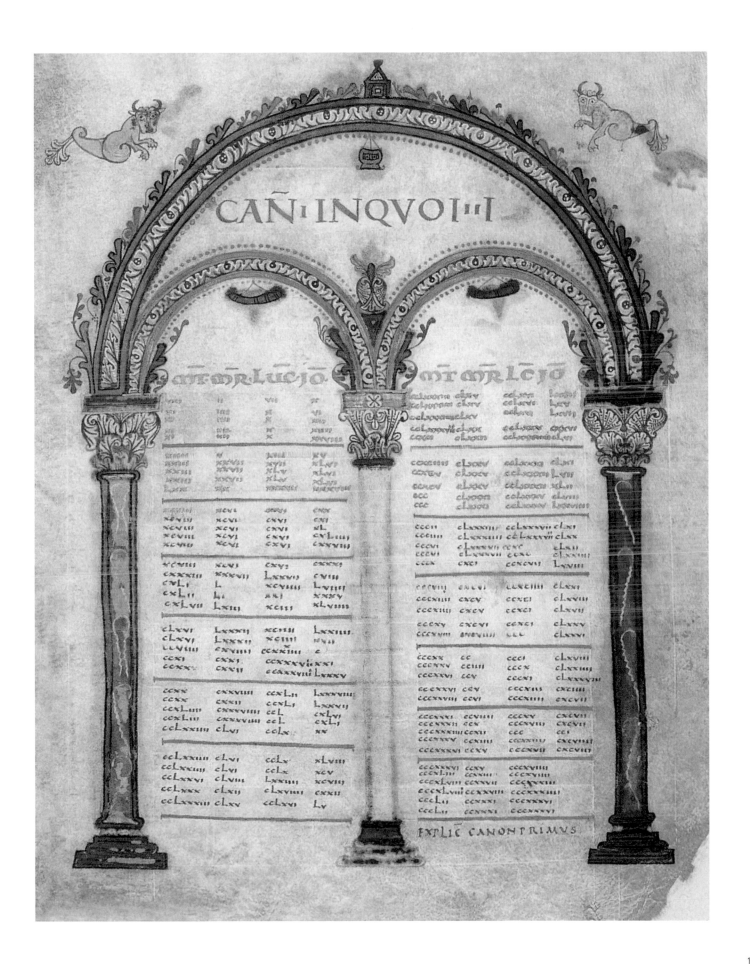

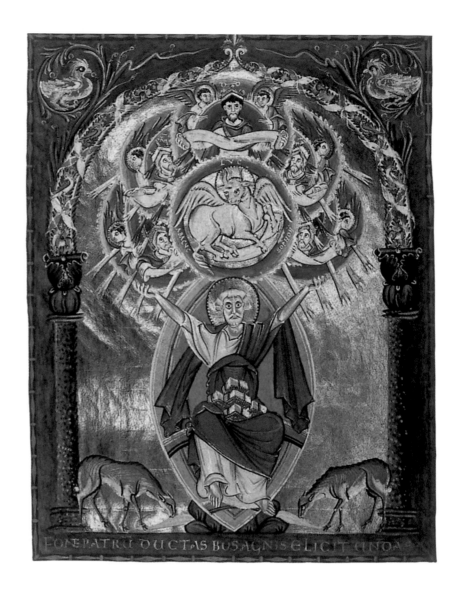

Gospels of Otto III, c. 1000.

Illuminated Manuscript.

Bayerische Staatsbibliothek, Munich

(Germany).

decorated or illuminated, the writer left space for initials, fields, medallions and half- and full-page illustrations. Sometimes, notes were left for the painter next to these empty spaces on the edge, with regard to the subjects, or "histories", as they were called then, to be illustrated.

While Byzantium retained the traditions inherited from the ancient world in the artistic design of books, the illumination of codices in Western Europe only emerged in the sixth century. The first manuscripts with illuminated texts appeared in Italy and in the area of modern-day France. Here, an artistic culture developed from the end of the fifth until the middle of the eighth century, which was named "Merovingian Culture" after the ruling dynasty.

The few surviving manuscripts from the middle of the seventh until the second half of the eighth centuries show that the graphic style was predominant in Merovingian illumination. This reflected the influence of late Roman art, that of Lombardy and northern

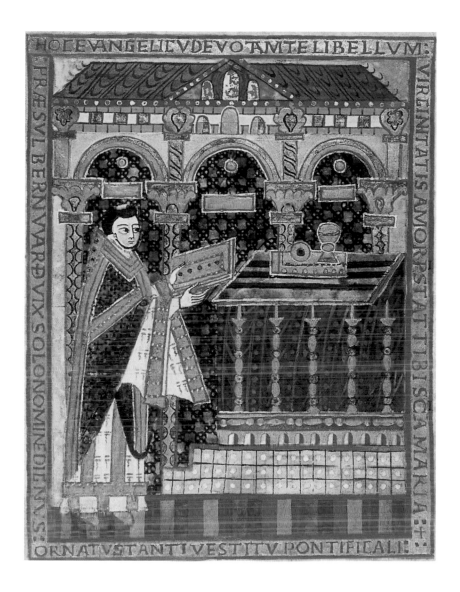

Italy (figurative depiction and architectural motifs) as well as that of the Orient, mainly of Coptic Egypt (colour and ornamentation). The leading centres for the production of manuscripts were the monasteries of Fleury and Tours (Loire valley), in Luxeuil (Burgundy) and in Corbie (Picardie). A good example of the illumination of Corbie is a sheet from the circular letter of Jerome, where a depiction of a man can be seen which is extremely rare for the Merovingian epoch. This miniature demonstrates the main features of Merovingian illumination, notably swift and emotional drawing.

The art of miniature developed in the most succinct and original manner in the British Isles after they had been converted to Christianity. Lately, this art was termed "insular illumination". The insular book painters used and developed the local ornamental traditions of decorative craftsmanship. They succeeded in using these traditions creatively in decorating the manuscripts by subordinating the limitless wealth of the geometric, plant and zoomorphic patterns, the dynamic independent development and

"Bernward offering the manuscript", taken from *The Gospels of St Bernward*, c. 1015.
Illuminated manuscript.
St Michael's Abbey Church,
Hildesheim (Germany).

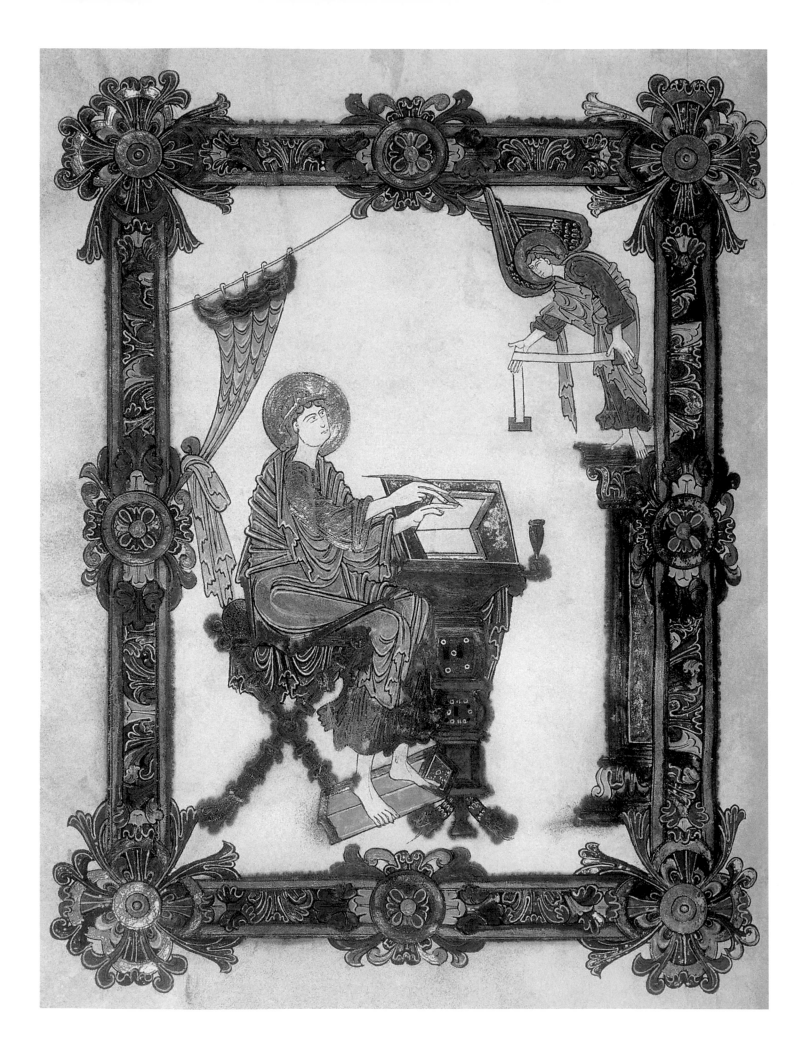

variation of interlacing motifs to the rectangular sheet form of the codex. The monasteries in Ireland and in the Anglo-Saxon state of North Umbria became centres of this art, in whose scriptoria the first masterworks of Western European illumination were created.

The insular influence can still be felt during the Carolingian era, during which the history of the miniature reached the next level of creative exploration and artistic achievement. For approximately 150 years, from the end of the eighth century until the beginning of the tenth century, a type of art, which is sometimes called "Carolingian Renaissance", flourished in the lands of the Frankish Empire created by Emperor Charlemagne. This occured mainly in the areas of what was to become France, Germany and southern Flanders. The political and ideological program planned a "renovatio" of the Western Roman Empire as a counterweight to the eastern Roman, Byzantine Empire. Culturally, this led to a similarly clear aesthetic program, which included an effort to revive Antiquity.

Among the monuments of Carolingian art that survive today, the miniature without a doubt takes first place with its wealth and succinctness, in which the artistic ideas of the era were expressed. The independent value of the illustrated miniature, in which a tendency to depict the human body in a corporeal manner becomes noticeable, rises. The wish to match the Byzantine emperors and even surpass them in splendour led to an abundant use of gold and silver in design.

During the reign of Charlemagne and his successors several book manufacturing centres developed. Charles the Bald, King of the Western Frankish kingdom and Roman Emperor – where "bald" does not stand for his lack of hair, but is to be understood as "without land" – particularly loved beautiful books. Aside from the palace workshops in Aachen, Charlemagne's favourite city, the art of illumination also flourished in other areas of the Rhine valley, such as Metz, Reims and Tours.

"Greek" modelling, a specific painting technique in which gold and silver letters are drawn onto purple parchment, distinguishes the manuscripts published up until the end of the ninth century. The Sacramentary was created in St Amand monastery, where books for the entourage of Charlemagne were created. This particular branch of Carolingian miniature from the second half of the ninth century is sometimes called Franco-Insular Miniature, since it employed ornamental motifs from the British Isles.

The vivid traditions of Carolingian Renaissance during the tenth century can be gleaned from the Tetra-Gospel of Tours. Here, in the monasteries of St Martin and Marmoutier, possibly the most productive workshop for the creation of manuscripts had existed since the time of Abbot Alcuin. He was born in England and served as Charlemagne's advisor, and headed the monastery from 796 A.D. until 804 A.D. It reached its culmination during Abbots Adalard and Vivien. Having been destroyed by the Normans in the middle of the ninth century, the school of Tours took a renewed upturn

St Matthew, Gospel of Grimbald, beginning of the 11th century. Illuminated manuscript. The British Museum, London (England).

and succeeded in preserving its most essential features. These included a logical and clearly designed composition, the use of ancient ornamental motifs, the correspondence of clear forms of initials and frames with the text.

The history of miniature painting during the Romanesque era can be considered great. The masters of illumination in all likelihood never again reached this degree of fusion of all elements. These were the book format, the proportion of text and letters, the structure of the sheet and the two-dimensional miniature, the historic initials, the harmony between the black text and the white parchment, as well as the multicoloured decoration. Here, gold started to take on an ever greater role, in particular the shiny gold leaf, which adhered to the sheet. Some general traits of Romanesque art – the laconic and expressive silhouette, the local colours, the monumentalism, the rhythmic arrangement of the stable composition and the trend towards symmetry – proved to be very favourable for the achievement of such unity. This period was probably the strictest in the development of illumination, when the masters made creative use of the old models of Carolingian and Byzantine miniatures, and thus created their own language of art with a firm set of durable symbols and stereotypes.

The design of the sheets became more sparing and collected; it penetrated, if you will, the individual miniatures, but in particular the initials, which formed the core of illumination in Romanesque manuscripts. In the historic initials of monumental Bibles, which often came in multiple volumes, copied in the monasteries in large letters, figurines of acrobats and various fantastic beings appeared often, interlaced with the ornaments (Weissenau Bible).

The figures were simple and limited to the necessary. Vivid, bright colours and strong outlines were used. Red and gold symbolised the highest honour. A person's size within the image was dependent on his or her importance ("perspective of importance"). Thus Jesus was always depicted larger than an angel, the eyes and hands often overemphasised as a representation of expression. The figures are barely animated; they only show a few typical gestures. Sometimes they are arranged symmetrically and are animated by small deviations. The depicting of the halo was adopted from Byzantine art;

Beginning of the second *Book of Kings*, Bible with prologue (Biblia Sacra cum prologis), second half of the 12th century. Parchment, 46.5 x 33 cm. Weissenau (Germany).

garments were portrayed with few, stylised folds. Spatial depth and shadows were neglected; naturalistic depiction was not the aim. The portrayals were usually rigid and solemn. Christ Crucified was a popular motif. He is, however, not portrayed suffering or pitiful, but as Saviour. Another frequently encountered motif is Mary with the Child in Glory. In these depictions, it was not the motherly relationship with the child that was to be emphasised, but the role of Madonna as the mother of Jesus Christ. The artistic and spiritual intensity still touches the viewer today.

In the Romanesque period, the themes in illuminated manuscripts began to expand. More and more texts of ancient authors were copied, more chronicles and biographies, as well as various educational, legal, geographical and natural philosophy works appeared. One example is a "bestiary" of the period of the great bloom of the English Romanesque miniature. The use of old iconographic patterns is enriched here by the realistic observations of the artist in his depiction of beings he knows well, but its figures, too, are constructed heraldically and glued, so to speak, to the surface of the parchment sheets. They form an inseparable whole with them. The occasionally expressive movement freezes for eternity and results in the typically Romanesque impression of "mobile stability". The miniatures in their rectangular frames form a unified module with the text, subordinated to a certain sheet format, where the entire codex illumination focuses in these miniatures. The periods of the Romanesque miniature vary between the national schools.

While this period comprised the eleventh and twelfth centuries in France and Great Britain, and transitioned into the Gothic style as early as the beginning of the thirteenth century, the eleventh century in Germany is still closely linked to the Ottonian circle. Yet masterworks of Romanesque art were produced there in the thirteenth century. Among them are the *Books of the Prophets* from the Benedictine monastery of Weingarten, founded in the eleventh century, which were illuminated in the first quarter of the thirteenth century by the master of the Berthold missal. Romanesque illumination is almost exclusively monastic.

The Announcement to the Shepherds, Book of Common Prayer of Rheims (Missale Remenense), 1285-1297. Parchment, 23.3 x 16.2 cm. Paris (France).

Books were the "monastic culture's" most important instruments. This is why the design character of the manuscripts was not only influenced by a religious view of the world, but also by the traditions of the order, the abbey and the Prior's taste, and the manuscript examples stored in the monastic libraries. Yet all these influences and effects could not impede the artist's individual talent.

The history of French miniatures as an expression of national art only began in the tenth century and with the Capetian dynasty which, named after Hugo Capet, ruled until 1328. Until this time there were only a few, though important, sources of book manufacture in the area of modern-day France (for example Reims and Tours). But from the thirteenth century, French illumination flourished and without doubt took first place within Western Europe, dictating the art to other national schools.

The development of the medieval artistic landscape in Italy during the Romanesque period can only be understood in connection with the works of miniature painting, that is, the illustration of mass, song and gospel books for use in churches and monasteries. Early on copies of works of Greek and Roman authors and textbooks were introduced into these books. When secular poetry emerged from the middle of the twelfth century under the influence of the burgeoning idea of knighthood, it quickly made a splendid rise. It culminated, on the one hand, in the lyrical poetry of the minnesingers, and in splendid narrative poetry on the other, and the manuscripts of this poetry were also artistically decorated in the manner of ecclesiastical manuscripts. Pen and ink drawings, however, were preferred over colour painting on golden background, since they allowed for greater speed in production, freer movement and an expression which did better justice to the depiction of contemporary figures and events than miniature painting, which worked with traditional types. Sometimes, these pen and ink drawings were lightly coloured, and can thus be regarded as the predecessors of the later art of wood engraving, on whose earliest products the outlines were also filled with colour, that is "illuminated".

Glass Painting

The glass painting of the Romanesque window rosette, much simpler than later in the Gothic period, was intended to give the faithful a first impression of Heavenly Splendour. The origins of glass painting can probably be found in the Ancient Persian Sassanids. Since the early Middle Ages it was used both in ecclesiastical and secular architecture. Two different methods were used to produce it; either a drawing was applied to coloured glass, or colourless glass was painted with vitrifiable pigment. The colours, which initially existed in powder form, also included the use of diffusion paint for glass etching, as well as precious metal colours, alongside the vitrifiable pigment mentioned above.

Adam Naming the Animals,
Bestiary (or *Bestiarum vocabulum*),
end of the 12th century.
Parchment, 20 x 14.5 cm.
England.

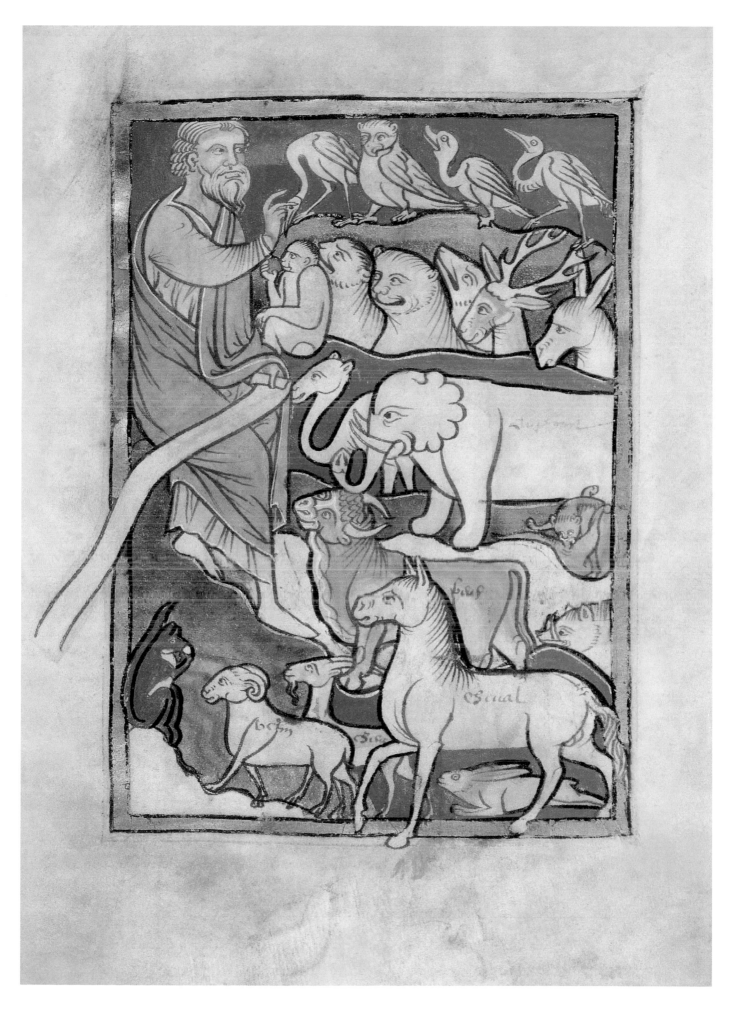

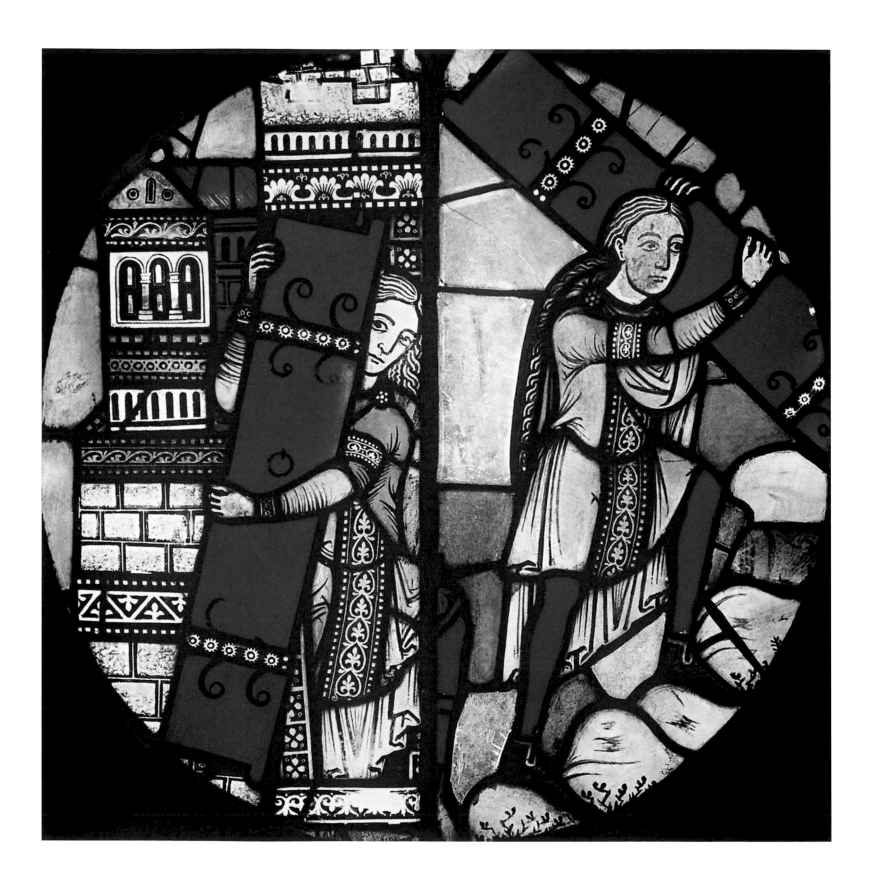

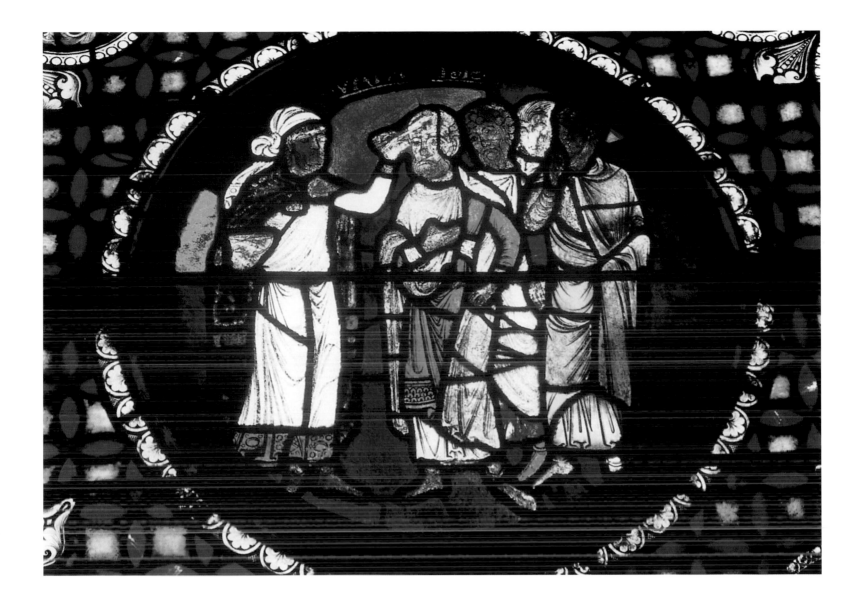

The stained-glass windows completed the décor of the church interior, so that the painted wall areas were not interrupted by the window openings, which provided light. The so-called "glass painting of the Middle Ages" is actually a branch of mosaic art, since the images were first designed on paper or parchment as a whole and then put together from a mass of small, coloured and cut-to-size glass tiles. These were connected to each other by lead frames, which at the same time formed the outlines. The intricate details of the drawings were applied in black lead glass and fused with the glass tiles by burning.

In the production of glass and its composition, special attention had to be given to the necessity for full transparency, and the medieval glassmakers demonstrated a degree of skill in this, which later was not often achieved. The magic of the light effect, which glowed through the glass paintings in the medieval churches, was rightfully compared to

Samson and the Gates of Gaza,
1180-1200.
Stained glass window from Alpirsbach Abbey.
Landesmuseum Württemberg, Stuttgart (Germany).

Stained Glass Window of the Passion (lost), 1140-1144.
Located originally in Ambulatory from Saint-Denis Abbey, Paris (France).

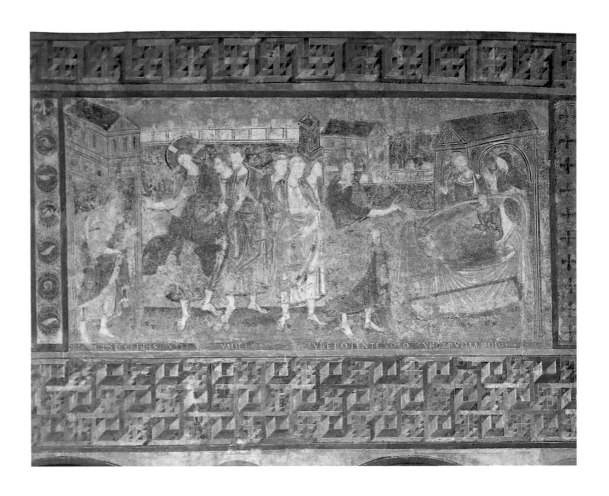

Healing of a Lame Man, c. 980.
Mural painting.
St George Church of Oberzell,
Reichenau (Germany).

Christ in Glory, 1120.
Mural painting.
Apse, St Peter and St Paul of
Niederzell, Reichenau (Germany).

the glitter of cut gemstones, and this luminous power remained the old glassmakers' and glass painters' secret. Even though they placed figurative images, which were then surrounded with an ornamental frame, in the centre of their windows as early as the tenth century, it took a long time before they achieved a freer treatment of the human form.

Since glass windows were exposed to a much higher degree of destruction than wall paintings, only a few glass paintings remain from Romanesque times. Probably the oldest glass paintings are five windows depicting prophet figures in Augsburg Cathedral from the end of the twelfth century, which in their rigid posture take second place behind the painting of the time, which is largely due to the brittle technique. In the following period, too, individual figures or ornamental patterns reminiscent of oriental rugs were considered sufficient. Only the glass painters of the Gothic period dared to approach more comprehensive composition rich in figures, which competed with mural painting and eventually surpassed it in the crowding of the figures in a small space.

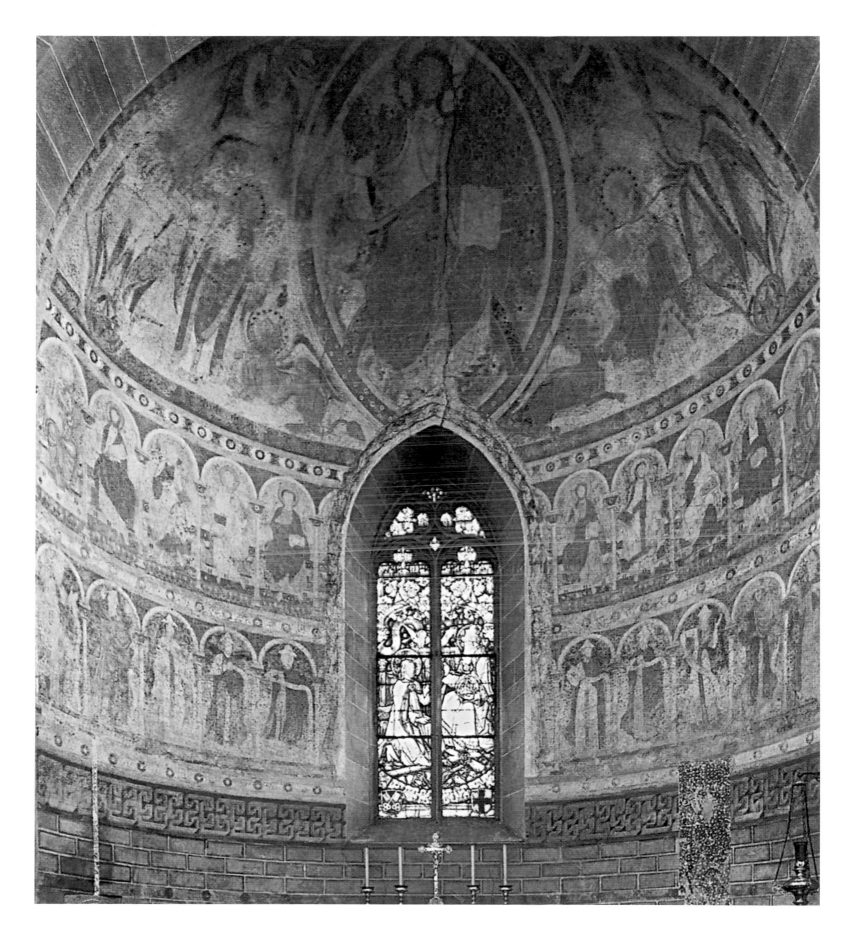

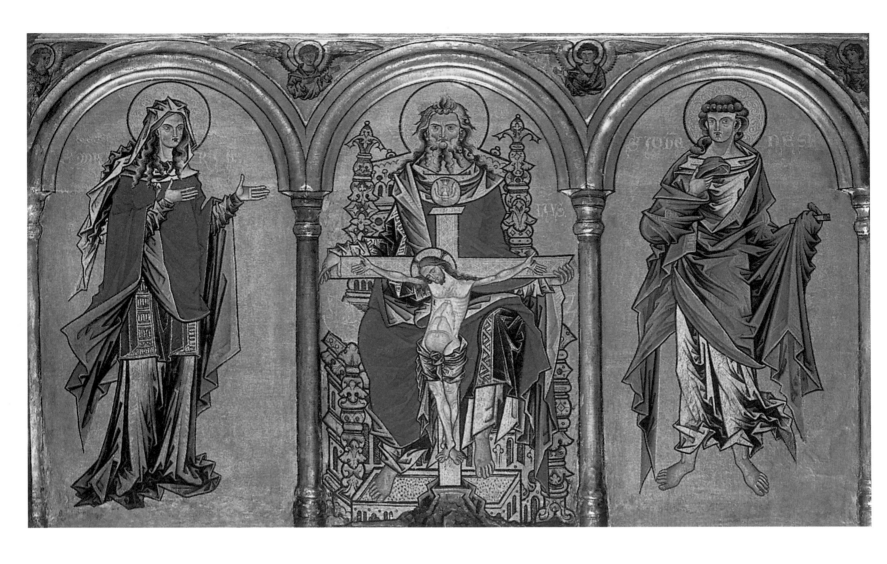

Mural and Panel Painting

During the Romanesque period mural painting was no less important than illumination.
It is known that not only the walls and vaulted ceilings of the interiors of churches, but
also the pillars and columns, were covered with figurative and ornamental painting. The
figurative images expanded into cohesive series of images, whose content was dictated by
the church's clergy according to certain dogmatic guidelines. Unfortunately, those murals
were largely destroyed, and the few remnants are so disfigured by weathering or later
painting-over that one cannot obtain a full impression of the high importance and rich
content of Romanesque mural painting. It is clear, however, that as with architecture and
sculpture, mural painting began under the Carolingians and stems from Roman and Early
Christian art. This developed similarly into miniature painting, which, as the art form
that matured earlier, often influenced mural painting.

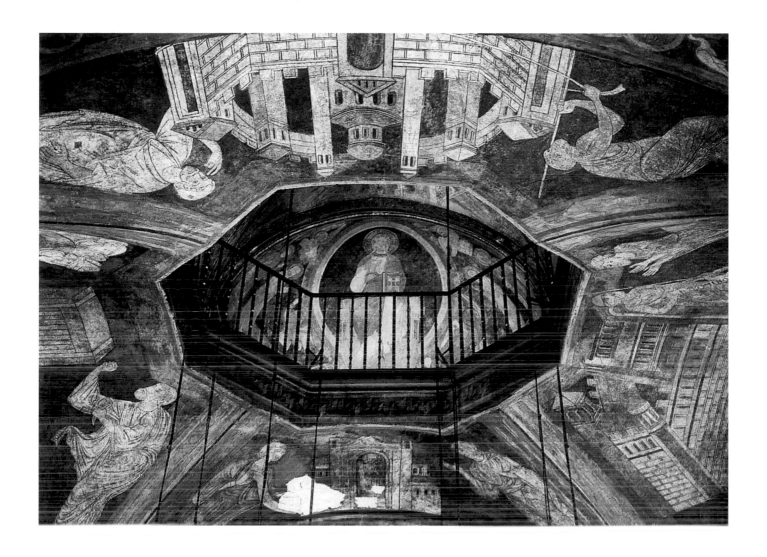

The oldest surviving monuments of medieval mural painting in Germany are the paintings in the nave of St George's Church in Oberzell (p.40), located on the island of Reichenau in Lake Constance, which were discovered underneath layers of whitewash. Executed at the end of the tenth century, they depict Christ's Eight Miracles, and give testimony to the lively connection with Carolingian art in the noble posture and movement of the figures, the treatment of the garments, and the grandeur of the composition.

The second-oldest mural paintings, those of the lower church in Schwarzrheindorf and those of the chapter house in Brauweiler abbey near Cologne, were not made until the middle of the twelfth century. They show that in the meantime painters had learned to strive for greater richness and expression, without losing their sense of solemn effect. This increased in the following years, while the form of exterior depiction became gradually freer and more animated, and the expressions in the faces became deeper. The height of the development of Romanesque mural painting in Germany best

Heavenly Jerusalem and Christ in Glory, c. 1180.
View of the church from the base, St Maria and St Clement's Church, Schwarzrheindorf (Germany).

Biblical Cycle (detail). Fresco. Abbey of Saint-Savin-sur-Gartempe, Saint-Savin-sur-Gartempe (France), 1040-1090.

Overall view of the wooden ceiling, St Michael's Abbey Church of Hildesheim, Hildesheim (Germany), 1010-1033.

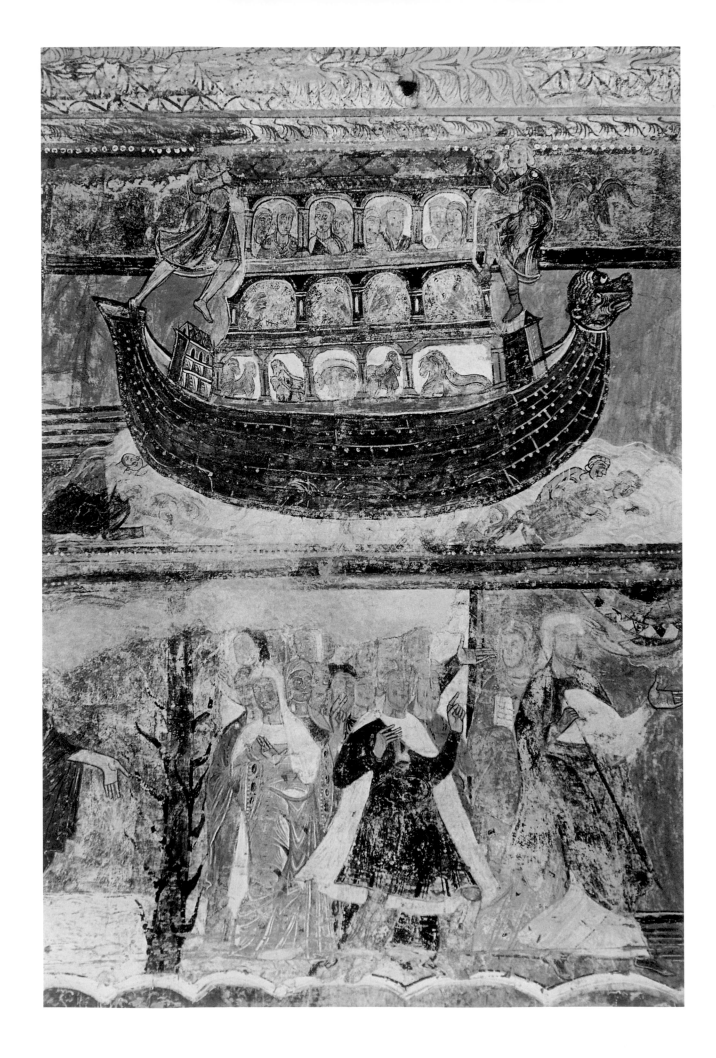

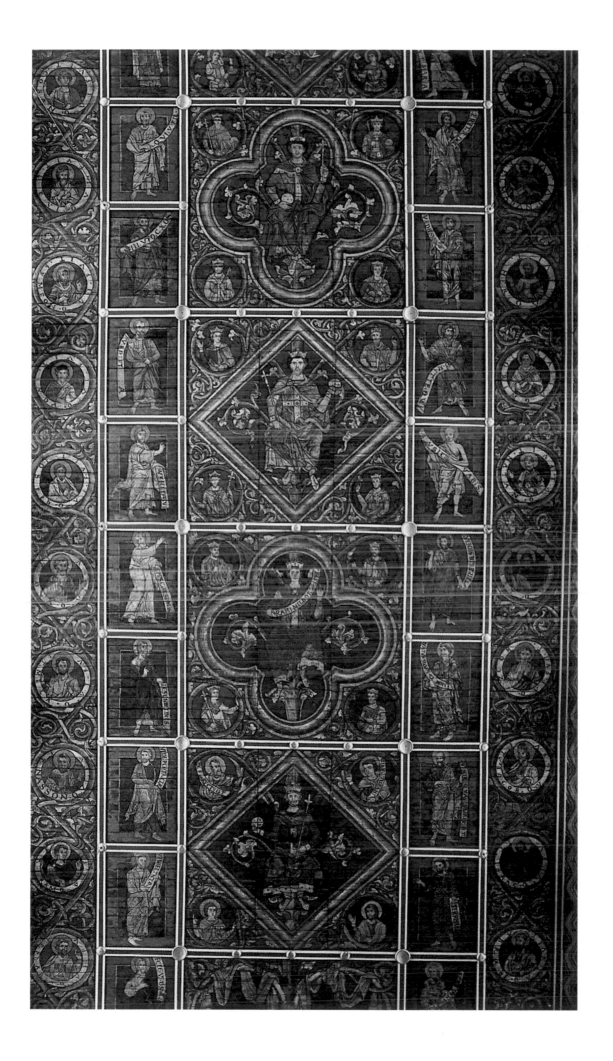

...LELMI:DVCIS:PVG...NANT:CONTRA... DINANTES:ET:CVNAN:CLAVES:POR...

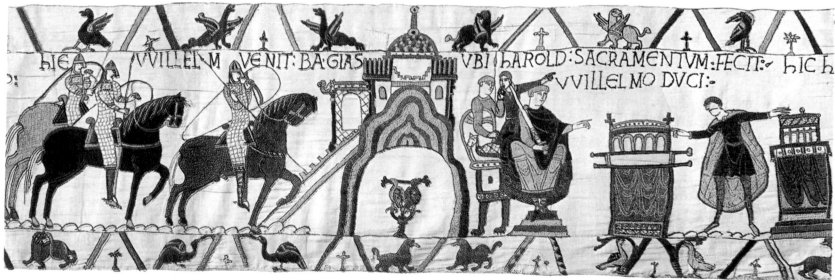

:HIC WILLELM VENIT:BAGIAS UBI:HAROLD:SACRAMENTVM:FECIT:· HIC h...
VVILLELMO:DVCI:·

188

demonstrated by the mural paintings in Braunschweig Cathedral, which date from the first half of the thirteenth century. Important remnants survive today in the choir and transept, although heavily painted over and partially amended.

Germany

In Germany, panel painting was cultivated during the Romanesque era. A rare example of this is a three-part picture of the Wiesenkirche in Soest, which was transferred to a Berlin museum, and originally served as an altarpiece. It is painted on parchment mounted on oak and depicts the Crucifixion in the centre. Christ Before Caiaphas (translated as "interpreter" or "seer"), a high priest appointed by the Roman procurator from 18 A.D. until 37 A.D., is on the left, and the three Marys at Christ's Tomb on the right, the style almost completely under Byzantine influence. Thus, this art was either introduced in Germany by Byzantine artists, or local artists imitated Byzantine panel paintings, brought to Germany by the busy traffic from Byzantium, which had been initiated and maintained by the Crusaders. The spirit of German art, however, which awoke in the course of the twelfth century, soon liberated itself from foreign models and sought to find an expression of its own in this field.

France

The mural paintings of this period were governed by the same artistic principles as miniature and glass painting. They consisted of religiously inspired imagery and content with late Antique and Byzantine influences. The panel picture painted on wood was still an exception at that time. Furthermore, little of the great painting series of this era remains, since they were either destroyed by humidity or painted over. One of the exceptions is the Romanesque abbey church of Saint-Savin-sur-Gartempe (p.87) in Poitou from the eleventh century. Inside this magnificent work of Romanesque art, numerous murals from the eleventh and twelfth centuries can be admired. They are extremely well-preserved.

Tavant, in the heart of the vineyards of Chinonais on the Vienne River, is famous for the Romanesque frescos in the church of St Nicholas from the eleventh century. Scenes of David are depicted in the crypt, also. The other murals of Ebruil, Ennezat, Lavaudieu and the two small churches of Cirgue and Brioude, all in the Auvergne region, are worth viewing, even though only little is left of the original murals.

Italy

In Italy, mural painting as well as the art of the glass mosaic was almost exclusively under Byzantine influence during the eleventh and well into the twelfth century. In St Marco's Basilica in Venice (p.191), where the greatest and largest mosaics are located,

Battle around a Motte (top), *Harold vowing to William the Conqueror to help in the Conquest of England* (bottom), 1077-1082.
Embroidery in thread and silk on linen cloth, h: 50 cm, L: 70 m.
Bayeux Tapestry. Musée de la Tapisserie de Bayeux (with the special permission of the Town of Bayeux).

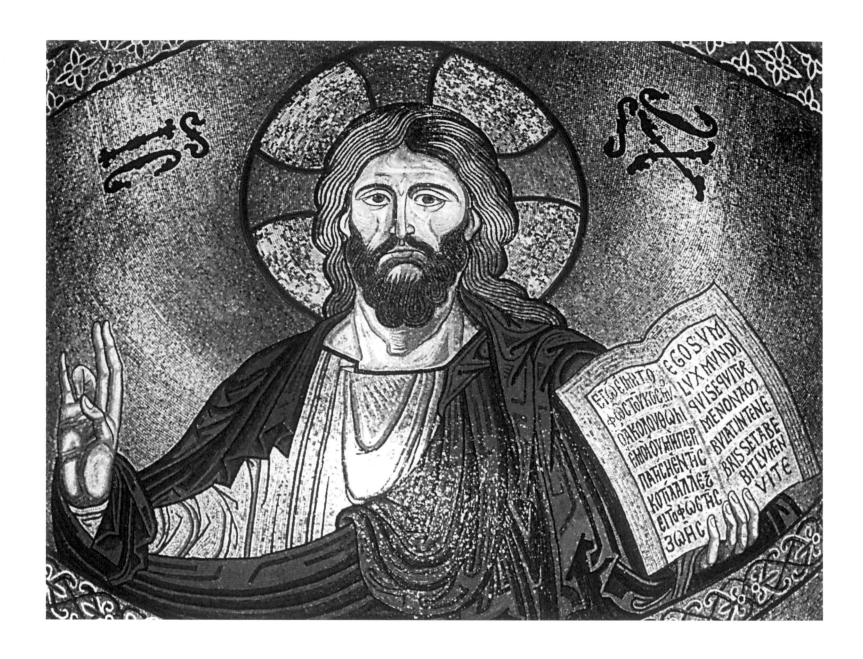

Christ Pantocrator, c. 1148. Mosaic.
Apse, Cefalu Cathedral, Sicily (Italy),
started in 1131.

Dome of the Genesis Cycle, c. 1120.
Mosaic.
Narthex, St Marco Basilica,
Venice (Italy).

and in Sicily, in the churches of Cefalù and Monreale, where it almost completely replaces painting, it reaches its culmination. Byzantine artists were called to Italy, where they did not only decorate the churches, but were also encouraged by thoughtful clergy to train young locals in their art. One such patron of the arts was abbot Desiderius of Monte Cassino, who ruled as Pope Victor III from 1086. The mural paintings of around 1075 in the church of Sant'Angelo in Formis near Capua demonstrate his influence, and also prove that the Byzantines' apprentices had only adopted the purely external execution of art from their masters. The first panel paintings of the Middle Ages to appear on Italian soil were still wholly Byzantine. From the middle of the twelfth century, a feeling of independence started to grow, which finally overcame the rule of the Byzantine spirit of art after a struggle of one hundred years.

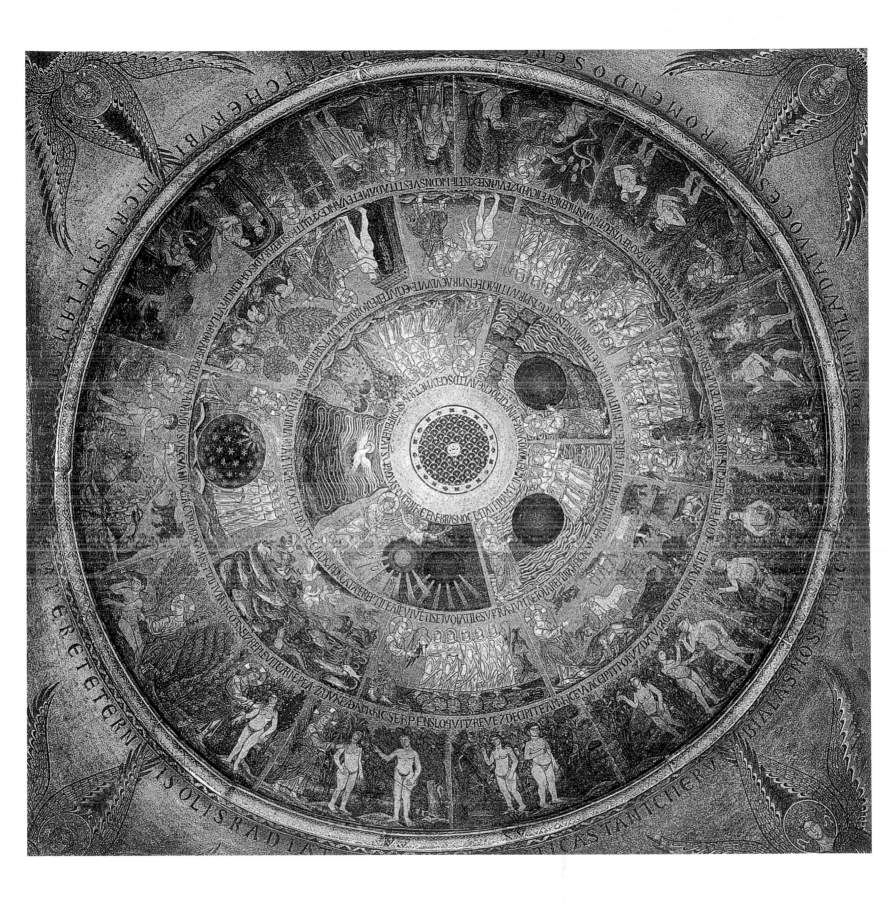

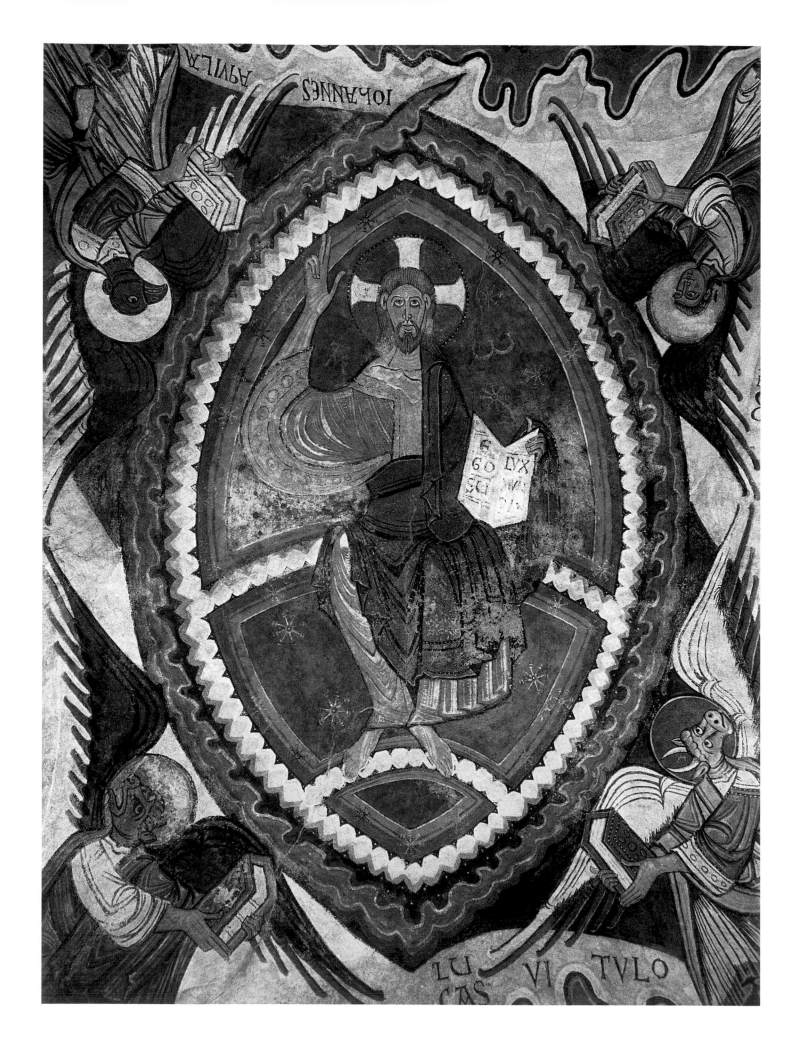

Conclusion

The Romanesque era ended with the twelfth century. The style revealed a great freshness and versatility even during the last years of its reign. Really of German origin, it was gradually replaced by the Gothic style, which pushed into the eastern neighbours from France, and whose fundamental features probably developed in the northern part of France, in the region of Paris.

A precondition for the change from the Romanesque to the Gothic style was the strengthening of the bourgeoisie and the ensuing flourishing of towns. The bourgeoisie searched for an expression of their wealth and the power based on it, and found it in the construction of high-rising places of worship, which would proclaim a town's prosperity and size far afield. As the French way of life had gradually penetrated European culture, in courtly manner and knightly chivalry, in dress and language, and even poetry, Gothic architecture now came to power in all lands, into which French culture had found its way. It corresponded on the one hand to the towns' thirst for power, and on the other hand to the practical need for light and spacious churches in view of their continued growth. In addition to this, there was a religious reason. The ever deeper piety, which formed the moral foundation for medieval man and the desire for heavenly salvation, was externally manifested in the towers soaring towards the heavens and in the pillar formations, which lifted the interior ceiling vaults to dizzying heights. This "yearning for height", this "longing for the Heavens" was certainly one of the determining motivating forces for the change from the Romanesque to the Gothic, which spurred the development of Gothic architecture's vertical as opposed to the more horizontal tendencies of Romanesque architecture.

Yet one must not attribute too much influence to this spiritual element in the formation of the Gothic style. Purely technical rather than aesthetic considerations were always the priority of craftsmanship. As architects invented a new system for ceiling vaulting in France for purely practical reasons, they continued forward on this path of practical considerations. The medieval builders knew already that a structure could only develop into an organic work of art from the inside out. Thus, the formation of the exterior, insofar as it was not a condition of constructive necessity, was their last worry, or left to the stonemason, who had to work according to the plans of the Chief Church Foreman, today an architect. It is because of this that the tall pointed towers, which makes every Gothic church aesthetically complete, were often only completed on the smaller buildings during the period of this style.

Furthermore, during the nineteenth century, Romanesque art perpetuated itself though Neoromanesque.

Christ in Glory, Mausoleum of the Kings, c. 1100-1120.
Fresco.
Basilica of San Isidoro, León (Spain), 1063-14th century.

Neo-Romanesque Style

Neo-Romanesque Style was born thanks to historical circumstances. Indeed, the Congress of Vienna danced and worked for nine months, from September 1814 until June 1815, and made the necessary decisions for the reorganisation of Europe after Napoleon's abdication. This heralded the end of microstates in Germany. Prince von Metternich led the Congress, and more than two hundred European states participated. During the Congress, though, the issues concerning Germany were largely excluded, but it still led to the formation of the German Confederation, which initially consisted of thirty-four principalities and four towns, but by 1866 ultimately of thirty-nine individual states. This was succeeded by the formation of the German Empire by the Northern German Confederation. Previously at the end of the period of Romanticism the creation of a unified, representative, German style had been contemplated, in particular for public buildings, which was now intensified. Three architects were in charge, drawing from several style periods from the past two thousand years, and developed the Neo-Romanesque style. It was a mix of Early Christian, Byzantine and Romanesque elements.

The driving force was not least technology. After all, following George Stevenson's first attempts at the steam locomotive in 1814, which had originally been developed for mining, had already been introduced in England for regular passenger transportation in 1825. The English were followed by the Belgians, and development in Germany began ten years later with the first official line between Nuremberg and Fürth. This new technology required representative train stations, and thus created a new field of work for the architects, to which they were now fervently dedicated. Churches and theatres, town halls and secular buildings were also erected in this style, which was considered truly German, until the beginning of the nineteenth century.

Outstanding examples of this mixed style, which is also called Historicism or Eclecticism, include among others the train stations in Berlin (Hackescher Markt) and Magdeburg (1882). Among the churches, there is the Kaiser-Wilhelm-Gedächtniskirche (Emperor William Memorial Church) in Berlin (1891-1895), of which only the tower remained after its destruction during World War II, and the synagogue in Dresden (1838-1840), which was erected by Gottfried Semper and destroyed by the Nazis. Among the smaller churches there is the Ludwigskirche in Munich (1829-1844), the St-Petri-Kirche in Bonitz in eastern Germany, and the St-Michaeliskirche in Kleinleitzkau.

Among the secular buildings, there is a police station in Hamburg Speicherstadt, post offices and Neuschwanstein Castle (1861-1891), which was begun by King Ludwig II and is very popular with tourists.

This artistic expression soon spread to other countries such as France and its Cathedrale of Saint-Front in Perigueux (p.195). Most of these buildings demonstrate the round arch style, which is typical of the Neo-Romanesque style. By the end of the nineteenth century, the Neo-Romanesque style had become a thing of the past, and was ultimately replaced by Neo-Renaissance and Impressionism.

View of the chevet, Cathedral of Saint-Front, Périgueux (France), after 1210.

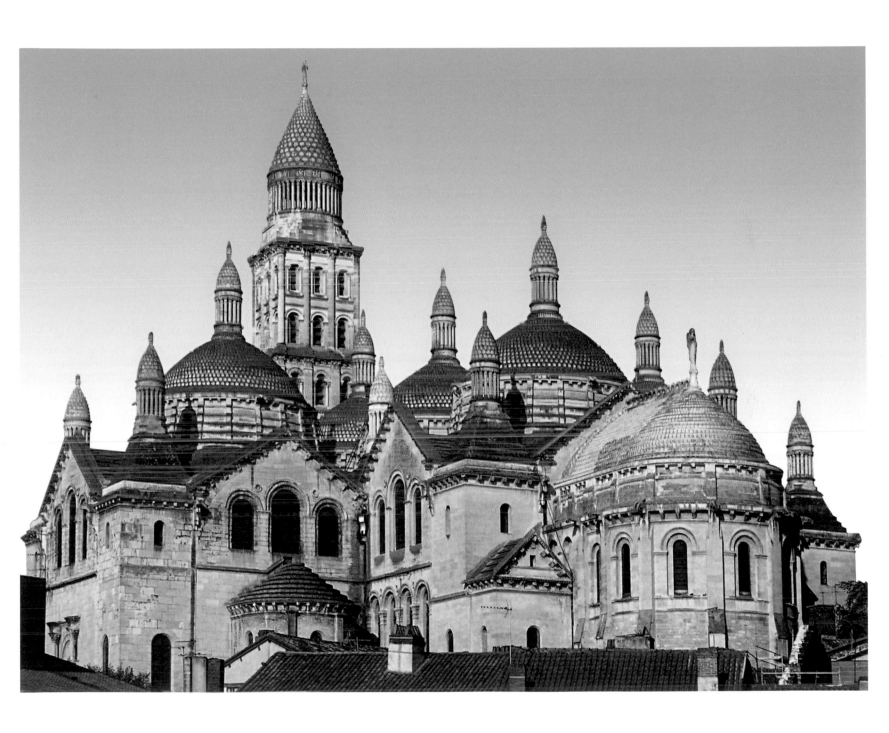

Bibliography

Meyers Konversationslexikon, Volume 13, Fourth Edition, 1885-1892, Leipzig and Vienna

Rosenberg, Adolf, Handbuch der Kunstgeschichte, Velhagen & Klasing, 1902

PM. Enzyklopädie, 2006

Internet Research:

- Biblioteca Augustana.de

- Biographisch-Bibliographisches Kirchenlexikon, Traugott Bautz, Publisher, Editions: Hagenau 1528;

 edited by J. Haupt, Vienna 1864; edited by J. Seemüller, Strasbourg, 1878

- Catholic Encyclopedia.de

- Literaturwelt.com

- Meyers Lexikon online 2.0.de

- Ökumenisches Heiligenlexikon.de

- Textlog.de - Historische Texte

List of Illustrations

Architecture and architectural sculpture

Austria
Gurk, Gurk Cathedral 46

France
Arles, Cathedral of Saint-Trophime 66
Autun, Saint-Lazare Cathedral 83, 84, 85
Caen, Benedictine Abbey of Saint-Etienne 65
Canigou, Saint-Martin-du-Canigou Abbey 98
Cluny, Abbey Church of Saint-Pierre-et-Saint-Paul 72, 73, 74
Codalet, Abbey Saint-Michel-de-Cuxa 6
Conques-en-Rouergue, Abbey Church of Sainte-Foy 68, 69
Dijon, Cathedral Saint-Bénigne 136
Fontevraud-l'Abbaye, Abbey Church of Fontevraud 70, 71
Issoire, Saint-Austremoine Abbey 91
Jumièges, Abbey Church of Notre-Dame ("Jumièges Abbey") 63
Marmagne, Abbey of Fontenay 79
Moissac, Saint-Pierre Abbey 105, 124, 133, 135
Narbonne, Abbey of Fontfroide 94
Notre-Dame-du-Mont-Cornadore, Saint-Nectaire Church 90
Paray-le-Monial, Notre-Dame 77, 78
Périgueux, Cathedral of Saint-Front 195
Poitiers, Church of Saint-Hilaire-le-Grand 86
Rosheim, Church of Saint-Pierre-et-Paul 88
Saint-Benoît-sur-Loire, Fleury Abbey 93
Saint-Gilles-du-Gard, Abbey Church of Saint-Gilles-du-Gard 67
Saint-Guilhem-le-Désert, Gellone Abbey 96-97
Saint-Savin-sur-Gartempe, Abbey of Saint-Savin-sur-Gartempe 87
Souillac, Abbey Church of Sainte Marie 139
Le Thoronet, Abbey of Thoronet 95
Toulouse, Basilica Saint Sernin 101, 102, 136
Tournus, Saint-Philibert Church 8
Vézelay, Basilica of Sainte-Marie-Madeleine 80, 81, 82, 134

Germany
Bad Hersfeld, church ruins of Hersfeld Abbey, transept and apse 20
Bamberg, Bamberg Cathedral 35
Brunswick, Fortified Castle of Brunswick (Burg Dankwarderode) 44-45
Büsum, St Clemens Church 34
Cologne, Church of St Maria in the Capitol 32-33, 130
 Church of the Holy Apostles 30
Freiberg, Freiberg Cathedral ("Cathedral of St Mary") 129
Freising, St Mary and Corbinian Cathedral 132
Gelnhausen, Imperial Palace 47
Gernrode, Church of St Cyriacus 9, 10
Hildesheim, St Michael's Abbey Church of Hildesheim 12, 15, 16, 17, 126
Hirsau, Hirsau Abbey 21
Jerichow, Jerichow Abbey 41
Limburg, St George's Cathedral 37

Maria Laach, Maria Laach Abbey	28
Maulbronn, Maulbronn Abbey	38, 39
Mainz, St Martin Cathedral and St Stephan church	23, 24, 26
Oberzell, Church of St George	40
Quedlinburg, Church of St Servatius	135
Ratzeburg, Ratzeburg Cathedral	42
Rottenbach, Abbey of Paulinzella	18, 19
Speyer, Cathedral of St Mary and St Steven ("Imperial Cathedral of Speyer")	25, 26, 27
Worms, Cathedral of St Peter ("Worms Cathedral")	29

Italy

Cefalu (Sicily), Cefalu Cathedral	62
Florence, Basilica di San Miniato al Monte ("Basilica of St Minias on the Mountain")	58
Milan, Basilica of Sant'Ambrogio	48
Modena, Modena Cathedral	51
Palermo, Palatine Chapel	55
Parma, Parma Cathedral, the Campanile and the Baptistery of Parma	56
Pisa, Cathedral, baptistery, and campanile, Piazza dei Miracoli ("Square of Miracles")	52–53
Rome, Basilica of St Paul Outside the Walls (or St Paul without-the-Walls)	59
Baptistery of St John Lateran	60–61
Spoleto, Cathedral of the Santa Maria Assunta	54
Verona, Basilica di San Zeno Maggiore	131

Poland

Gniezno, St Aldabert Cathedral	127

Spain

León, Basilica of San Isidoro	110, 111
Santiago de Compostela, Cathedral Santiago de Compostela	106, 108, 109
Salamanca, Cathedral of Salamanca	113
Silos, Monastery of Santo Domingo de Silos	137

Scandinavia

Borgund, Urnes Stave Church	122

United Kingdom

Durham, Durham Cathedral	114
Norfolk, Castle Acre	118
Rievaulx, Rievaulx Abbey, monastery and conventual church	119
Ripon, Fountains Abbey	120, 121
St Albans, Cathedral and Abbey Church of St Alban	116, 117

Illuminated Manuscripts

Bestiary (or *Bestiarum vocabulum*), *Adam Naming the Animals*	179
Book of Common Prayer of Rheims (Missale Remenense), *The Announcement of the Shepherds*	177
Book of Gospels (Tetraevangelium), *Bible according to St John*	170
Book of Gospels (Tetraevangelium), First Table of Contents	171
Book of Kings, Bible with prologue (Biblia Sacra cum prologis)	176
Ecclesiastical History of the English People (Historia Ecclesiastica Gentis Anglorum), Introductory page with initial history, The Venerable Bede	169
Gospel of Grimbald, St Matthew	174
Gospels of Otto III	172
The Gospels of St Bernward, "Bernward offering the manuscript"	173

Mosaic / Painting

Biblical cycle — 186
Christ in Glory — 183, 192
Dome of the Genesis Cycle — 191
Healing of a Lame Man — 182
Heavenly Jerusalem and Christ in Glory — 185
Overall view of the wooden ceiling — 187
Christ Pantocrator — 190
Trinity, Virgin Mary, Saint John — 184

Sculpture

Altar — 156
Antependium adorned with vegetal representations and symbolic animals — 141
The Annunciation to the Shepherds — 138
Baptismal font, **Renier de Huy** — 144
Baptismal font — 145
Candlestick: Woman on horse — 162
Christ at the Cross — 150, 153
Christ detached from the Cross also known as *"The Courajod Christ"* — 151
Christ Nailed to the Cross and Twelve Apostles — 163
Crucifixion, reliquary of Calminius (or *Saint-Calmin*) — 166
Elias Bishop's Throne — 142
Enthroned Mary and Child from Rarogne — 146
Enthroned Virgin with Child — 147
Gold Majesty of Saint Foy — 155
Gold Altar — 167
Harpies facing Each Other — 137
The Kiss of Judas and The Crucifixion, **Niccolò** and **Guglielmo** — 140
Madonna and Child — 147
Madonna and Child, also known as *Notre-Dame-la-Brune* — 147
Madonna di Aculo — 148
Pulpit, **Nicodemus da Guardiagrele** — 143
*Recumbment Statues of Richard the Lionheart
 and Eleanor of Aquitaine* — 149
Reliquary of Santo Domingo de Silos — 158-159
Reliquary of the Magi, **Nicholas of Verdun** — 161
Scenes from the Birth of Christ — 133
Verdun Altar, **Nicholas of Verdun** — 164-165
*Virgin in Majesty flanked by representations of
 the Annunciation and the Baptism of Christ* — 139
Virgin of Ger — 148
Virgin of Montserrat, also known as *La Moreneta* — 154

Stained Glass

Samson and the Gates of Gaza — 180
Stained Glass Window of the Passion — 181

Tapestry

Battle around a Motte (top), *Harold vowing to
 William the Conqueror to help in
 the Conquest of England* (bottom) — 188

9/10 0
11/16 (6) 11/16